Gothic Art
Glorious Visions

Gothic Art
Glorious Visions

Michael Camille

PERSPECTIVES

PRENTICE HALL, INC.

Acknowledgments

Gothic art would never have been part of my life were it not for two people who, like St. John's angel guide kept saying "Look and See!" – my first Art history teacher Audrey Collingham, and my last Art history teacher, Professor George Henderson. I would also like to thank the many museum curators and manuscript librarians who opened their doors and books for me during the research for this book.

Frontispiece Claus Sluter Philip the Bold, page 112 (detail)

Unless otherwise indicated, MS numbers and details for illustrations in this book are given in the Picture Credits.

Series Consultant Tim Barringer (Yale University)
Series Director Eve Sinaiko
Senior Editor Jacky Colliss Harvey
Designer Karen Stafford, DQP, London
Cover Designer Miko McGinty
Picture Editor Susan Bolsom-Morris

ISBN 0-13-183060-0

This book was produced by Laurence King Publishing Limited, London

Printed and bound in China

Contents

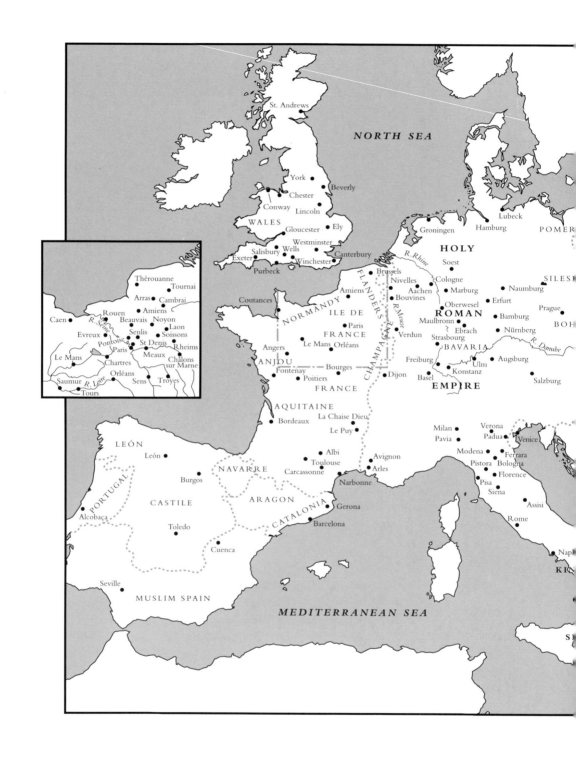

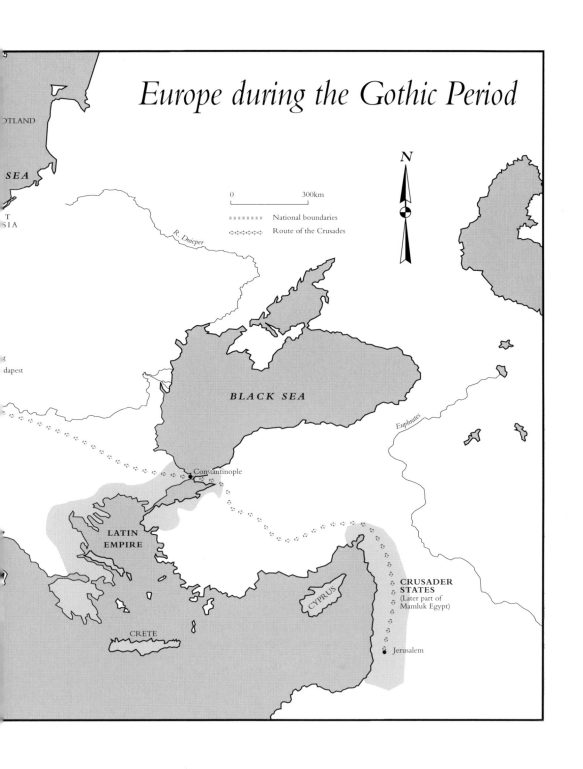

Europe during the Gothic Period

OTLAND

SEA

T
SIA

0 300km

⬛⬛⬛⬛⬛⬛ National boundaries
⬡⬡⬡⬡⬡⬡ Route of the Crusades

N

g
dapest

R. Dnieper

BLACK SEA

Euphrates

Constantinople

LATIN
EMPIRE

CYPRUS

CRUSADER
STATES
(Later part of
Mamluk Egypt)

CRETE

Jerusalem

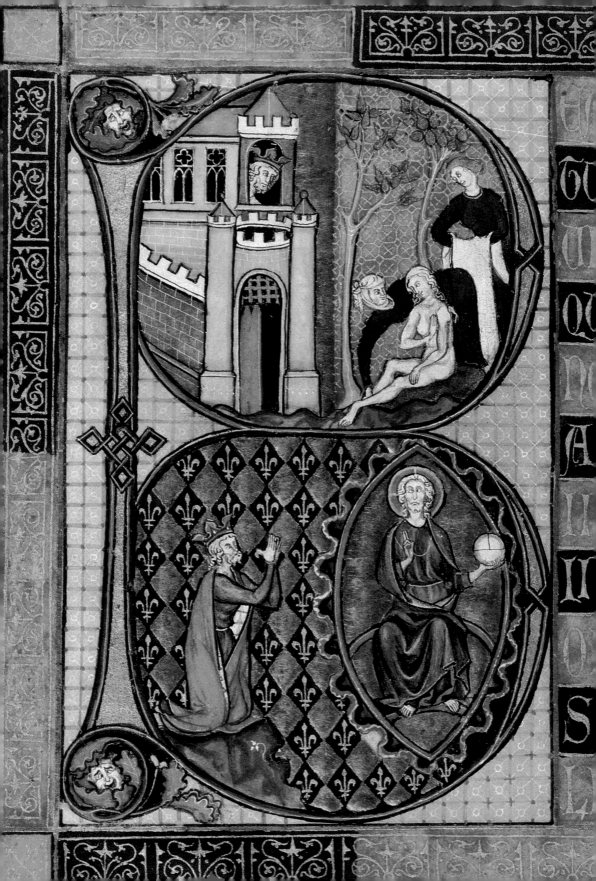

New Ways of Seeing Gothic Art

1. Corporeal versus spiritual vision. King David looks down upon Bathsheba bathing and up to God, from the St. Louis Psalter, Paris, c. 1260. Illumination on parchment, 5 x 3½" (21 x 8.9 cm). Bibliothèque Nationale, Paris.

"Gothic" is a label with its own complex history (FIG. 2). Although we use this term to describe buildings and objects whose forms are based upon the pointed arch produced from the middle of the twelfth to the end of the fifteenth century in some parts of Europe, the word was actually unknown during this period. It was Renaissance humanists who first used it as a derogatory term to describe what they saw as the "barbaric" architecture produced between the decline of classical civilization and its glorious rebirth in their own time. The word – and the style – came back into fashion only during the late eighteenth century, first among antiquarians who sought to preserve the ruins of the past, and later among architects such as A.C. Pugin (1768–1832), and religious revivalists such as his son, A.W.N. Pugin (1812–52), who, in his *True Principles of Pointed or Christian Architecture* of 1841, saw it as an answer to current social and cultural crises. A year later construction of the final part of Cologne cathedral, begun in the thirteenth century, was at last under way and the following decades saw hundreds of churches, schools, and even factories built in the revived Gothic style all over Europe. With the rise of cultural nationalism and evolutionary theories of historical progress, architectural historians in France, England, and Germany all claimed their own countries as the place of origin of the Gothic style.

Gothic soon came to define not just an artistic style, but a whole historical epoch – "the Gothic Age." For French Romantic writers like Victor Hugo (1802–85) it was a great age of faith. For English critics like John Ruskin (1819–1900) it was a socialist golden age of the craftsman before the onset of industrialization. For German Expressionist artists and critics at the beginning of the twentieth century, the later, tortured forms of Gothic seemed to prefigure their own modern *angst*. Viewed through so many different prisms in the past, it would be hard indeed to define what Gothic means in postmodern culture today.

2. AUGUSTUS CHARLES PUGIN (1768-1832) Frontispiece to *Specimens of Gothic Architecture*, London, 1821-23, 9½ x 7" (24 x 18 cm). Private collection.

This engraving is based on Pugin's drawing of a doorway to Henry VII's Chapel, Westminster Abbey. Early interest in things Gothic was stimulated by their destruction and the efforts of men like A.C. Pugin and his more famous son, A.W.N. Pugin, to create a "Gothic Revival" in contemporary building.

Opposite above

3. Perspective section of a nave bay of Amiens cathedral after Eugène Emmanuel Viollet-le-Duc, *Dictionnaire raisonné de l'architecture française du XIᵉ au XVIᵉ siècle*, Paris, 1859-68.

This shows all of the architectural inventions associated with the High Gothic style: rib vaulting, which was not new, but was used to articulate each bay; flying buttresses, which allowed the walls to be higher and thinner; the pierced triforium and enlarged clerestory, which eliminated the earlier gallery or tribune level; and window tracery, which let the wall dissolve into light.

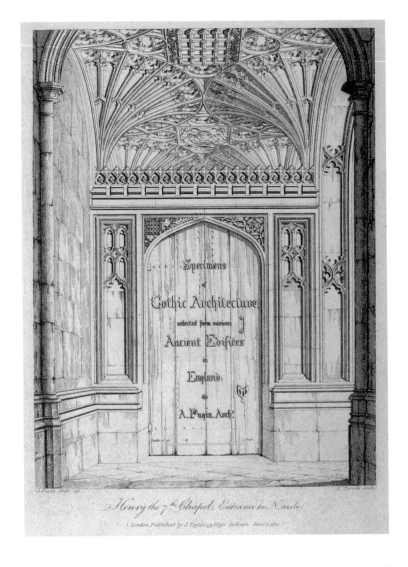

Henry the 7ᵗʰ Chapel. Entrance to N. aisle.

London. Published by J. Taylor, 59. High Holborn. June 1, 1811.

There are currently two major approaches to the study of Gothic art and architecture, both inherited from the nineteenth century. The first, which is rationalist and secular, was pioneered by the historian and restorer Eugène Emmanuel Viollet-le-Duc (1814–79), who saw the great cathedrals as products of progressive technology and functional engineering. His carefully drafted cross-sections of cathedrals like the one at Amiens are still used by architectural historians to analyze the different architectural elements of a great church, from the bases and piers of each bay to the curved ribs of its high vault (FIG. 3). The second approach to Gothic art, which is more mystical and literary, is also a system of classification, not of the masonry elements of a

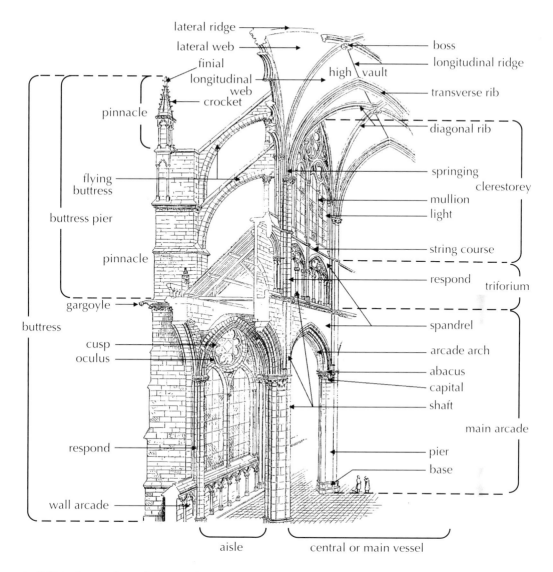

lateral ridge — boss — longitudinal ridge

lateral web

finial

high vault

longitudinal web crocket

transverse rib

pinnacle

diagonal rib

springing

clerestorey

flying buttress

mullion

light

buttress pier

string course

pinnacle

respond

triforium

gargoyle

spandrel

buttress

cusp

arcade arch

oculus

abacus

capital

shaft

main arcade

respond

pier

base

wall arcade

aisle central or main vessel

building, but rather of the symbols that make up its meaning – an approach that has come to be known as iconography. This is best exemplified by the writings of the French scholar Emile Mâle (1862–1954), who sought to "read" cathedrals, like that at Amiens, as though they were "books in stone." Both these methods are valuable, but in separating form and meaning the first tends to reduce the objects of inquiry to cross-sections and plans and the second to written programs and texts. This book takes a different approach, arguing that Gothic art is best understood, not through the abstract eye of the engineer or the text-bound gaze of the iconographer, but rather through the eye as the medievals understood it – a powerful sense-organ of perception, knowledge, and pleasure.

The Gothic Look

When people at the end of the thirteenth century looked around them as they stood in the nave of Amiens cathedral (FIG. 4), they were neither seeking to label architectural components, nor deciphering symbols. They were the enraptured witnesses to a new way of seeing. They experienced its thin walls, wide windows, and soaring vaults as constituting a new kind of architectural space, to be discussed in detail in chapter one. Amiens, like all cathedrals, was built for the performance of the yearly cycle of the liturgy. This crucial ordering of time in Gothic art is explored in chapter two. The interior of Amiens as we see it today is bare compared to the cluttered appearance it would have presented to the medieval visitor. Its painted columns would have been draped with tapestries and its windows filled with thousands of figures in stained glass which have been mostly destroyed. The chapels and altars would have been crammed with statues, altarpieces, and reliquaries (cases or shrines to hold sacred relics), which were the real goals of the pilgrim's gaze. This saturation of Gothic space with images is the subject of chapter three. Still visible in the nave of Amiens, however, is the richly carved band of flowers and leaves that runs, like a window box, along the bottom of the triforium, or gallery above the nave arches. At the same time as it provided a means to grasp the unseeable, Gothic art provided a new focus for the representation of nature, discussed in chapter four. Ambitious structures like Amiens cathedral are often thought to be the work of a mass of selfless, anonymous masons and artisans. But at the center of the nave a magnificent labyrinth maze, laid down in 1288, spells out the names and praises the skill of its three master-masons, Robert de Luzarches and Thomas and Renaud de Cormont. The rise of this creative self-consciousness, in which the artist's own perception played an increasingly important role, is the theme of the concluding chapter.

Looking at Gothic art as the embodiment of medieval visual experience is, of course, only one way of presenting a coherent view of more than three hundred years of image-making and viewing. The difficulty in discussing Gothic, as compared, say, to Romanesque art and architecture, is that many more works survive. Gothic was the first historical style totally to permeate the world of things. Not just found in architecture, its pointed arches and tracery patterns appeared on everything from spoons to shoes. It is also the first truly international style, spreading throughout Europe. Gothic artists were in this sense the first to create what we would call today "fashion." The art and architecture of this period

4. Amiens cathedral, begun 1220. Looking east from the nave.

This soaring canopy of space, built by Robert de Luzarches (fl. 1220-35), simultaneously draws the beholder forward through a clearly articulated sequence of bays and upward through a superbly systematic treatment of storey-linking shafts into the vault. With an interior height of 142 feet (43 m) and a surface area of over 26,000 square feet (8,000 sq. m), it is the largest Gothic cathedral in northern Europe.

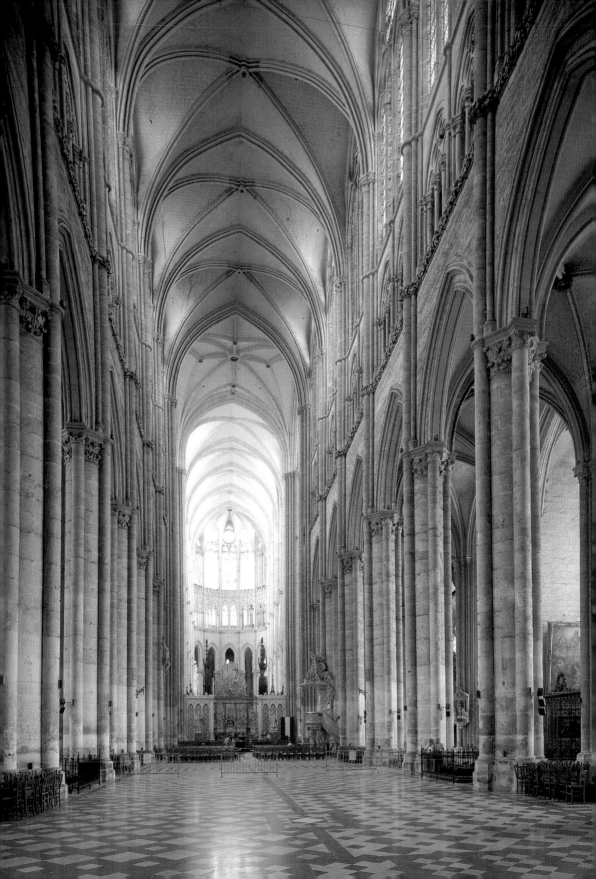

has to be seen not as a reflection, but as an integral part of the vast historical transformations that were reshaping culture and society.

The first and most important of these is the growth of towns, cities, and trade. The traditional tripartite picture of medieval society which was described as being composed of three orders, those who prayed (clergy), those who fought (nobility), and those who ploughed (peasants), gave way to a much more complex social structure which included merchants and craftspeople. Constructing not only churches and chapels, this new class created networks of communication and encouraged the circulation of goods, for example between Italy and Flanders in the fourteenth century, which had a real impact upon artistic production. The period which saw the development of Gothic coincides not only with this crucial economic growth but also with the growing ambitions of secular rulers. The King of France and the Holy Roman Emperor even challenged the authority of the Pope. They soon realized the importance of creating splendid propaganda images to consolidate their power.

Historians have described the thirteenth and fourteenth centuries as a period of increasing weakness of the church, threatened not only by royal claims to authority, and having to incorporate popular new spiritual groups, like the Franciscans and Dominicans, but also (and most evidently) by the Great Schism (1378–1417), when there were two competing Popes, one in Rome and the other in Avignon. But this decay of ecclesiastical institutions should not be taken as a sign of the secularization of society. In fact this period saw a demand for ever more intimate involvement in spiritual matters among lay folk, much of it using images. From baptism to burial the local parish church structured people's lives, and it is impossible to understand Gothic art without an awareness of how this Christian ideology increasingly sought to control minds as well as bodies. It is also important to jettison the old cliché that the thirteenth century, the period of the building of the great cathedrals, represents a cultural highpoint and everything is downhill from then on. Rather than see the culture of the later Gothic period (the fourteenth and early fifteenth centuries) simply in terms of relentless misery and artistic decadence in a society weakened not only by religious and political strife but also by the Great Plague of 1348–49, it is now understood to be a lively phase of intellectual expansion which leads into, rather than being totally distinct from, the period we call the Renaissance.

Gothic art was and continues to be a technology for engaging beholders in certain forms of visual communication. It is user-friendly, compared to earlier and later visual regimes. Medieval

cathedrals, like computers, were constructed to contain all the information in the world for those who knew the codes. Medieval people loved to project themselves into their images just as we can enter into our video and computer screens. In this respect Gothic artists, such as the Italian Giotto (c. 1267–1337), were the first to experiment with what we call "virtual reality."

At the same time as seeing these continuities with our own experience, we must also be aware that vision has a history. Only by an effort of imagination can we understand perceptions that took place in a sensory universe quite different from our own. We can never quite see through the eyes of another historical period, but we can nevertheless attempt to experience images and buildings from the viewpoint of the particular person or group for whom they were made. This is a way of avoiding the all-seeing, God's-eye view of the past and, instead, locating vision in a particular time and place.

On entering a great church or cathedral, each medieval visitor would have noticed quite different things, depending upon his or her knowledge and expectations, but many would have followed the model of St. John, as depicted in illustrations of the Book of Revelation, in which the angel urges him to "Look and see!" (FIG. 5). What draws John's visionary gaze heavenward are the undulating arcs of drapery and the criss-crossed arms of the angel. Similar to the meandering lines in this drawing are the ribs of the so-called "crazy-vault" at Lincoln cathedral (FIG. 6). The pleats of matter in both the manuscript "illumination," and the vast vault of the church are constructed to lead the eye through a restless path of line, light, and shadow. Unlike the restless, convoluted forms found in earlier, Romanesque pattern-making, however, these forms are based on geometrical principles. Their movement not only conforms to an underlying order, but takes place in a single direction. It has an aim. This comparison between part of a building and part of a book suggests that for the Gothic period it is indeed possible to discern what art historians have called a "period eye" – a way of seeing shared by audiences and artists across a variety of media.

5. The angel shows St. John the Heavenly Jerusalem, from an English Apocalypse, c. 1250 (detail). Illumination on parchment, whole page 10²/₃ x 7²/₃" (27.2 x 19.5 cm). Pierpont Morgan Library, New York, MS 524, fol. 21 recto.

Modes of Vision

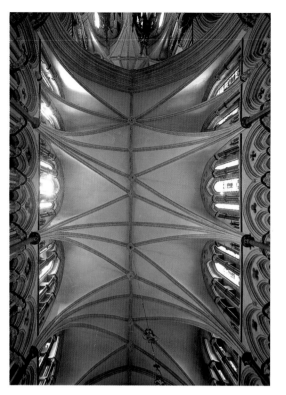

6. The "crazy vault," St. Hugh's Choir, Lincoln cathedral, designed c. 1192, rebuilt after 1239.

In addition to a ridge rib running along the central fold, the unusual diagonal and traverse ribs of the sexpartite vault, instead of converging on a central point and forming a series of distinct compartments, stretch out in a syncopated asymmetry. The contemporary author of the *Metrical Life of St. Hugh*, clearly enthralled, compared the vault to "a bird stretching out her broad wings to fly – planted on its firm columns, it soars to the clouds."

We get one such point of view when we open the St. Louis Psalter, which was painted for one specific pair of eyes – those of Louis IX, King of France (r. 1226–70). Reciting the psalms was a way of training the king's mind upon God, and the illuminations helped to fix his gaze in the right direction. This is evident from the *B* initial that begins the first psalm (see FIG. 1, page 9). In the top half of the letter King David stares down from a window in a tower and spies upon the naked Bathsheba, who is bathing below. Looking provided possibilities for sin, just as much as for salvation. In the lower half of the letter Louis is shown an example of a higher, spiritual mode of vision. Here his Old Testament counterpart, set against a diamond-pattern of royal fleurs de lys, kneels in repentance before God, who is enthroned, surrounded by a fiery mandorla or almond-shaped halo. This indicates that God is not physically present to the royal beholder, but an object of higher vision. Abstract shapes and wavy lines were the means by which medieval artists distinguished different levels of reality within a picture. One of the problems for the modern beholder of Gothic art is understanding and differentiating these complex visual cues.

In the late twelfth century Richard of Saint-Victor (d. 1173), prior of the Parisian abbey of the same name, wrote a commentary on the New Testament Apocalypse, or Book of Revelation, in which he separated "spiritual" from "corporeal" levels of seeing in formulating four distinct modes of vision. Corporeal vision was divided into two levels. The first involved opening one's eyes to "the figures and colors of visible things in the simple perception of matter." The second corporeal mode also involved viewing the "outward appearance" of something but, in addition, seeing its "mystical significance." Seeing one image in terms of another in this way was not peculiar to Gothic art, but it became an increasingly important way in which images were made tools for knowledge. The third level was that of spiritual perception, which, according to Richard of Saint-Victor, meant the discovery of the "truth of hidden things...by means of forms

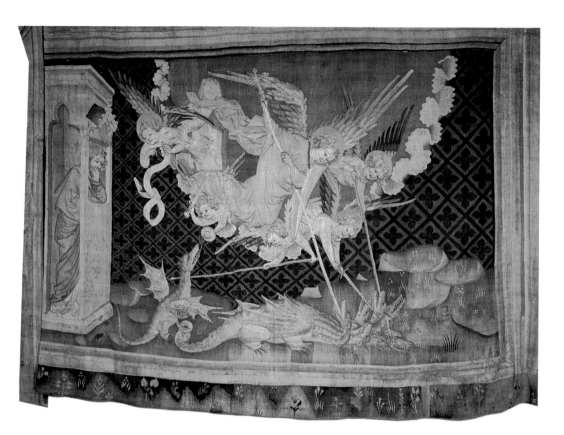

and figures and the similitude of things." This level best corresponds to the revelation experienced by St. John in the Apocalypse. The fourth level was the mystical mode, which entailed the "pure and naked seeing of divine reality" as described in I Corinthians 13:12: "for now we see through a glass, darkly; but then face to face."

These categories were not just theological distinctions. They were directly related to the kinds of images that artists made and that their patrons wanted to see. The most popular picture-books of the thirteenth century were those that illustrated St. John's vision of the Apocalypse. Kings, queens, bishops, and wealthy churchmen pored over these lavishly illuminated books precisely because they could identify with the evangelist, whose spiritual vision had witnessed God face to face at the end of time. The standard Apocalypse cycle, containing numerous scenes, was first developed in England (see FIG. 5). Those scenes were later used in creating other art forms, like the monumental tapestry woven in Paris in the late fourteenth century for Louis d'Anjou (r. 1384–1417; FIG. 7). One element that was increasingly emphasized in both manuscript and monumental versions was St. John

7. St. John's spiritual vision of Revelations 12: the great battle in heaven, from the Apocalypse Tapestry, Paris, c. 1380. Height 14'1" (4.3 m). Chateau d'Angers.

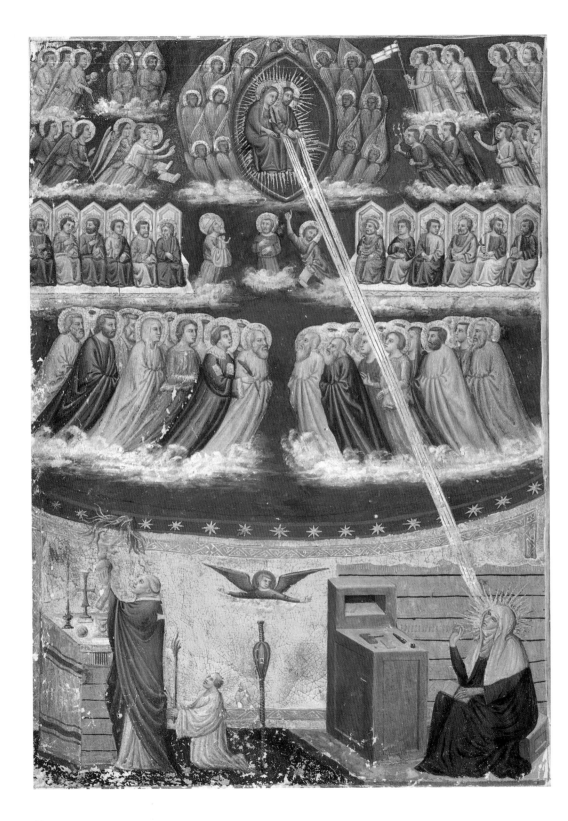

New Ways of Seeing Gothic Art

himself, standing as a spectator within each of the scenes. He served to mediate the visionary experience for the beholder, sometimes looking through a window onto the action, but always registering an active response to what he is seeing.

St. John's dynamic figure embodies one crucial difference between our current notion of vision and how it was thought to work during the Middle Ages. Whereas we tend to think of vision in passive terms, as the reflection of inverted images upon the retina, medieval people thought of it as a supremely active power. Whether they were scholastic philosophers making diagrams of light rays in their optical treatises, or farmers worried about their cows being bewitched by the "evil eye," sight was a potent force. Philosophers like Thomas Aquinas (1225–74) and his teacher Albert the Great (c. 1200–80) believed that it was so powerful a sense that it could leave its tactile imprint upon matter. Pregnant women were warned not to look at anything ugly, lest they give birth to a monster. One could literally be infected by a venomous look. Or one could fascinate (which in those days meant to bewitch) one's enemies through image-magic, a crime of which Pope Boniface VIII (r. 1294–1303) was accused in 1303. Visions discussed by medieval writers included not only the corporeal ones of everyday sight, or the spiritual ones experienced by St. John, but also the extraordinary appearances of portents, dreams, visitations from the dead, and demonic possession. In a world thick with presences, unseen as well as seen, images of things were far more powerful than they are today.

This was especially true of the Sacrament of the mass, the center of every Christian's life, which became an increasingly theatrical experience, culminating in the spectacle of the elevation of the consecrated host (bread or wafer) by the priest. The model for all visual transformations was that of the sacrament itself. According to the edicts of the Fourth Lateran Council of the Roman Church of 1215 this was "a unique and wonderful changing" of the eucharistic bread and wine into the body and blood of Christ. Mystics like St. Catherine of Siena (1347–80) and St. Bridget of Sweden (c. 1300–73) were directly inspired by their visions of the Eucharist. In a full-page miniature in an Italian manuscript of the life of St. Bridget, depicting a performance of the mass, the saint has a direct line of sight to God. Two beams of light shine down from the hands of the Virgin and Christ, who are enthroned on the highest heavenly plane, and join into one single stream before entering the eyes of the seated saint (FIG. 8). Images like this, which recorded the visionary experiences of mystics, allowed ordinary Christians access to things beyond their own powers of sight.

8. St. Bridget's mystical vision of God, from the *Revelations of St. Bridget of Sweden*, c. 1400. Illumination on parchment, 10½ x 7½" (26.8 x 19 cm). Pierpont Morgan Library, New York, MS 498, fol.4v.

9. King Evelac's marvellous vision, from *L'estoire de Saint Graal,* c.1316. Illumination on parchment, 2¹⁄₃ x 3¹⁄₄" (8.3 cm). British Library, London.

The astonished king brings in two candles in order to see the strange nocturnal apparitions better and here he grabs the hand of a servant, who has begun to faint in fear, as though he were the angel showing St. John the vision of the Apocalypse.

It was not only religious life that was transformed by this new emphasis upon visual experience. In the courts of Europe, too, images played an increasing role in both public propaganda and private pleasure. Rulers seeking to extend their authority in their expanding territories made themselves increasingly visible to those below them in statues and spectacles. Nobles used the increasingly sophisticated visual sign system of heraldry to distinguish their blood-lines and to mark lucrative marriage-alliances. Court life was, by its very nature, a world of artificial appearances. The ethos of courtly love was also based upon a theory of vision. Poems and pictures described the lover struck in the eye by the arrow of the god of love or bewitched by the enchanting vision of the beloved. In this secular arena, in contrast to the religious sphere, women tended to be the objects, rather than the subjects, of vision. But we should not make too much of a distinction between the looker and the looked-at. The two major forms of public entertainment of the period – mystery plays and chivalric tournaments – were spectacles in which there was no distinction between the audience and the participants.

The interaction between image and viewer can be seen not only in the Gothic Apocalypse, but also in illustrations to courtly tales of chivalric love, or romances. Perception here was not framed all that differently from its more mystical manifestations, as can be seen in one of the miniatures in a lavishly illuminated volume of Arthurian romances made for a wealthy patron in St. Omer or Thérouanne in French Flanders (FIG. 9). Here, at the beginning of the story of the quest for the Holy Grail, the artist depicts the strange things that were seen during the night by a pagan king called Evelac, not in a dream but in a waking vision. At the climax he sees a beautiful child enter a room without opening the door, an effect subtly evoked with transparent layers of paint. This vision differs from the usual marvels and monsters of medieval romance, for as the king is going to bed a voice speaks to him: "Evelac, just as the child entered your room the Son of God passed into the Virgin Mary." The pagan ruler is thus converted to Christianity. The miniature is a representation of the Virgin's miraculous conception, so often represented in symbolic terms in religious paintings. It suggests that we should not make a rigid distinction between secular and religious experiences. There were not sacred and profane modes of vision in Gothic art, only different degrees by which audiences could be transported to a higher, spiritual realm, through the stepping stones of the senses.

Seeing and Knowing

In the opening years of the thirteenth century, when the new cathedrals of Chartres and Notre Dame in Paris were being built, a new institution was emerging, one which replaced the monastery as the major center of medieval learning: the university. Students flocked from all over Europe to attend the university of Paris, where the writings of Aristotle on natural science, at first controversial, soon became the core of the curriculum, newly available in Latin translations from the Arabic versions of the original Greek. It is important to remember that these new urban institutions came under the jurisdiction of the church, and that many of the most famous teaching masters at Paris, Oxford, and Bologna belonged to the new preaching orders of the Franciscans and Dominicans. Aristotle presented a radically different model of perception from that outlined by St. Augustine or the four levels that Richard of Saint-Victor had described. He placed vision at the top of the hierarchy of the five human senses, and emphasized that knowledge could only be obtained through perception of the visible world. For an Aristotelian like Roger Bacon (c. 1214–c. 1292), who

10. The Virgin Mary and Christ in St. Bridget's mystical vision, from the *Revelations of St. Bridget of Sweden*, c. 1400 (detail of FIG. 8). Illumination on parchment, 10½ x 7½" (26.8 x 19 cm). Pierpont Morgan Library, New York, MS 498, fol.4v.

studied at both Oxford and Paris, "the whole truth of things in the world lies in the literal sense…because nothing is fully intelligible unless it is presented before our eyes."

How did Gothic images present themselves to people's eyes? During the Middle Ages there were basically two quite different theories of how the eye grasps an object – extromission and intromission. Extromission viewed the eye as a lamp that sent out fiery visual rays, which literally lighted upon an object and made it visible. This essentially Platonic theory had been most common during the earlier Middle Ages, when it was tied up with popular beliefs, like the malefic powers of the evil eye. There were problems with it. It did not explain why, if our eyes and not something outside them are the source of vision, we cannot see in the dark. Nor could it account for the phenomenon of the after-image, which lingers long after one has observed a bright object.

The alternative theory, called intromission, reversed the argument: the image, not the eye, sent forth rays. Partly because Aristotle seems to have favored this notion, it was the one ascendant in the thirteenth century, eloquently espoused by experts on the geometrical foundations of optics, who became known as "perspectivists." Intromission described how the object itself emitted "species" into the air, which were then carried to the eye in straight lines or rays along a visual pyramid whose vertex was the eye and whose base was the thing seen. The eye's receptive status was often made evident in images of people experiencing visions, where the rays were depicted as flowing from the divine object to the experiencing subject (FIG. 10).

John Pecham (c. 1235–92), like Roger Bacon, wrote treatises on optics. For both these scholars the more vision was related to geometry the more reliable it was thought to be. The straight lines of light, at the very center of the visual cone, were con-

11. Diagram of the eye from John Pecham's *Perspectiva communis*, c. 1320. Ink on parchment, whole page 7 x 4⅓" (18 x 11 cm). Bodleian Library, Oxford.

"Species," or rays from the object of sight, fall on the convex spherical surface of the eye at the pupil, which is the first circle on the left, and then move through the three humors of the eye and along the optic nerve to the right.

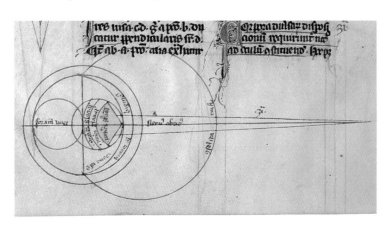

sidered more reliable than those rays which were refracted as they passed from one medium to another, and appeared bent, as a stick does when it is placed in water. Pecham was Archbishop of Canterbury, and like many Franciscan scholars he sought to use his scientific knowledge to gain a greater understanding of the Scriptures. He carefully noted the anatomy of the eye (FIG. 11), and, following the Arab scholar Alhazen (965–c. 1040), labeled its four layers and three humors. He emphasized that the power of sight lay in the glacial humor, which he described as like glass, and sensitive to light.

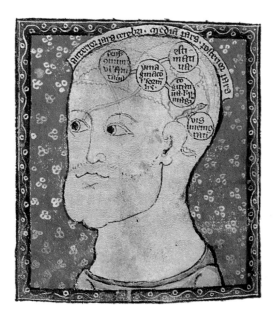

Vision was not completed in the eye, however. One only perceived something when the "species" traveled to the brain, where the internal senses were located. The system of five cells or ventricles, drawn in a Cambridge diagram of the early fourteenth century (FIG. 12), presents the scheme of the influential Arab philosopher Avicenna (980–1037). It illustrates how the visible species passed first into the "common sense," or *sensus communis*, which apprehended appearances, located at the front of the brain. Next came the cell of imagination, the *ymaginatio vel formalis*, which retained these forms; above it, the *estimativa* judged them. Further back, linked to the first kind of imagination, was a second kind, labeled *cogitativa*, which composed and combined images, as when one imagined fantastic or hybrid creatures. Finally, at the back of the head was the storehouse of memory, the *vis memorativa* with its little flap, the "worm of the cerebellum," which opened to let the images flow in and out. This was why, it was thought, people trying to recall something often tilted their heads backward, to allow things to flow from the chambers of the imagination into the anterior cell of memory. This diagram shows that medieval people conceived of what we think of as largely psychological processes in very physical and material terms.

The intromission model of vision, coupled with this receptive notion of comprehension, changed not only the way that artists thought they saw, but the images that they made and the ways that people looked at them. For this system gave the object as well as the viewer a dynamic role in perception. It set up a crucial distance between subject and object, seer and seen, which simultaneously "objectified" the thing seen and "personalized" the subject

12. Diagram of the brain with its five cells, according to Avicenna, c. 1300. Illumination on parchment, whole page 8½ x 5½" (21.7 x 14.2 cm). University Library, Cambridge.

The staring eyes of this figure are only the first step in the process in which seeing leads to knowing, as the "species" travel through these "internal senses" in the perceiving subject to become objects of the higher mode of cognition.

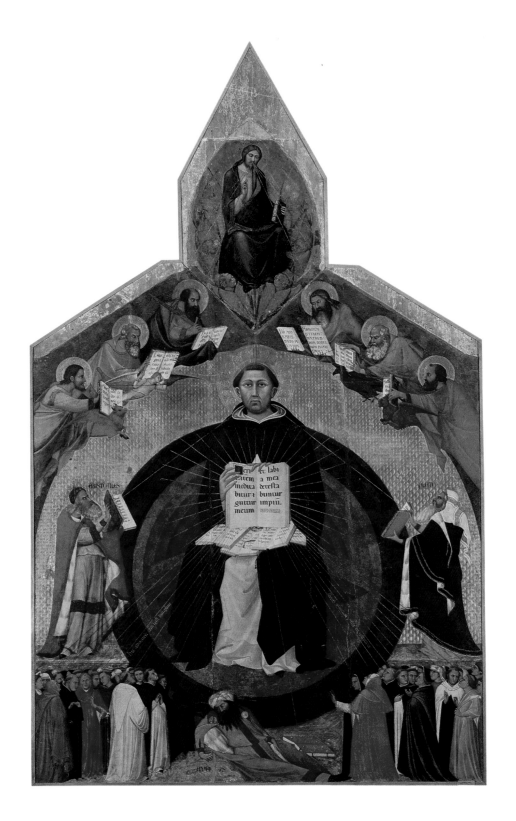

looking at it. To see something now meant gaining direct knowledge of an object in the external world.

These issues of optical truth and the geometry of visual rays were not totally divorced from artistic practice. They can be seen in a panel painting made for the Dominican church in Pisa representing the triumph of St. Thomas Aquinas (FIG. 13). God inspires the saint from above by means of ruled geometric golden lines of light. More lines splice through the shimmering paint to touch the books of Moses, St. Paul, and the four evangelists alongside. Also aiming their open books like ray-guns are Aristotle and Plato, who stand on the lower level, representing Thomas's debt to classical learning. But there are enemies to be defeated in this battle of the books, like the Arab philosopher Averroës (1126–98), who argued that rational knowledge was superior to faith: he lies defeated below. A single ray of light pierces the heretic's book as it lies, face downwards, on the ground. Also in this lowest region are groups of laymen and clerics, bathed in the rays of learning that emanate from the open book on the saint's chest, inscribed with the biblical phrase, "My mouth shall speak truth and wickedness is an abomination to my lips." This panel is situated halfway between an earlier oral culture and modern visual culture. Although the Dominicans emphasized preaching in the battle against heresy, the word of God is communicated here through visual order. The image has become dogma, and light the sign of learning.

This picture establishes the direct relationship between vision and knowledge for which the Dominican Aquinas had argued in his *Summa Theologica.* Just as we still use the phrase "I see" to mean "I understand," for Aquinas the word *visio* meant more than just vision. "This term," he writes, "in view of the special nature and certitude of sight, is extended in common usage to the knowledge of all the senses and it is even made to include intellectual knowledge, as in Matthew 5:8: 'Blessed are the pure in heart, for they shall see God.'" The Pisa altarpiece, like most Gothic images, was not considered primarily as a work of art by its contemporaries, but as something far more powerful and instrumental, because of its capacity not just to reflect the world, but to reshape it in God's image.

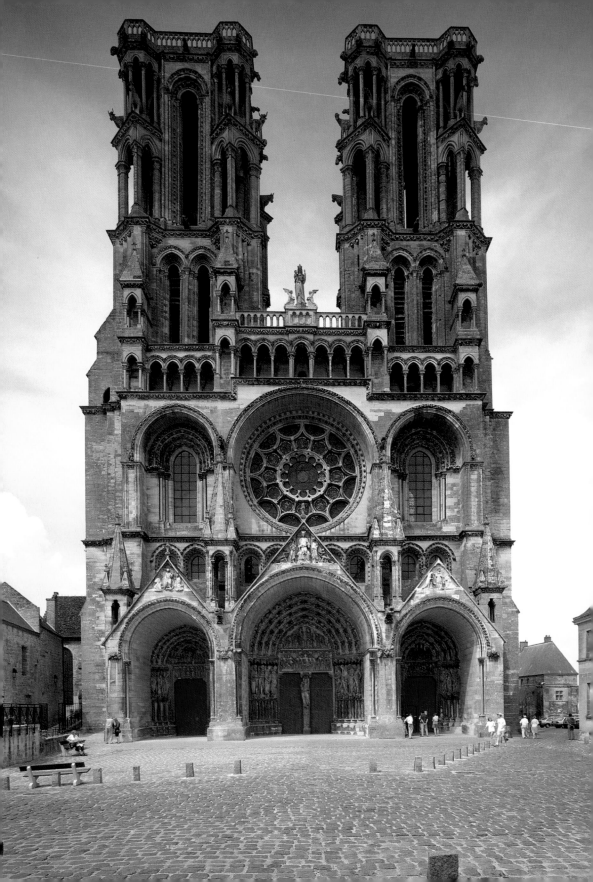

ONE

New Visions of Space

14. Laon cathedral, west front, c. 1190–95.

On the lowest level, the three buttresses that divide the building vertically are masked by enormous cavernous porches with gables. Above them, three more openings and a central rose window flanked by two pointed lancets are set within deep, richly carved archivolts. Multiple arches are repeated at the third level, where the two massive towers terminate with an outward twist at their obliquely set corners.

T he west front of Laon cathedral rises upwards from the steep hill on which it is perched in lucidly stepped stages, as a bold and open interface with heaven (FIG. 14). Half a century after the building of the earliest Gothic front at the royal abbey of St. Denis, near Paris, the builders of Laon combined the same elements – three portals, a central rose window, and two massive towers – to create the most harmonious and, at the same time, most magnificent Early Gothic west front. At the summit are the curling horns of sixteen oxen, thought to commemorate the animals that, in a local legend about the building of an earlier church on the site, miraculously appeared to haul the stones. That such heavy, intractable beasts of burden, known to every peasant, could be held up by this seemingly weightless mass, adds to the illusion of the miraculous. Laon's heavenward thrust, however, like that of most great cathedrals, stops short, its two spires never having been completed as planned. The cathedral was originally intended to have no fewer than seven towers – more than any other cathedral of the period – but only those of the western transepts were built at the time (FIG. 15). The ambitious external effects of Laon, both realized and unrealized, give us a sense of what most Gothic cathedral planners were aiming for – a new vision of space.

Space was not the abstract concept it has become in modern art. The word meant "interval" or "extent" and referred to something that could be tangibly apprehended and measured. Though its symbols might point to the next world, a cathedral's confident manipulation and mastery of space were means of affirming control over this one. It has been estimated that eighty cathedrals were built in France between 1180 and 1270, part of the

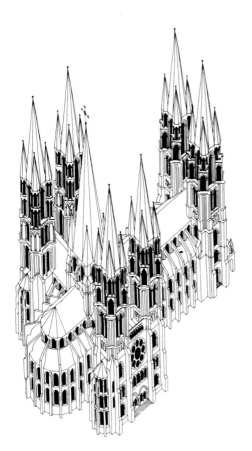

15. Laon cathedral, reconstruction of the late twelfth-century scheme.

massive geographical and political expansion of the royal domain under King Philip Augustus (r. 1180–1223), which made it the wealthiest country in the West. If people of the time referred to what we call Gothic architecture as anything, it was with the term *opus francigenum*, "French work," or sometimes as the "new style." That novelty was perceived as a positive force in this period was itself a new phenomenon, and along with what contemporaries described as the new poetry, the new music, and the new philosophy, Gothic architecture represented a break with tradition.

Even from the outside Gothic churches were built to communicate. They were constructed as advertisements in stone, heralding the promised glories of things to come. Inside, what the builder of the first Gothic space, Abbot Suger, called "the new light" helped to create more complex interiors, not only in cathedrals, but also in smaller churches and chapels. Gothic art also became important in the expanding towns and cities of Europe and exerted its influence on the structuring of new forms of public and private space.

The Heavenly Jerusalem

Standing before the west front of any Gothic cathedral, even those who were unable to read would have recalled from sermons the climactic vision of the Apocalypse described in Revelation 21.

> And I John saw the holy city, new Jerusalem, coming down from God out of heaven, prepared as a bride adorned for her husband…And he carried me away in the spirit to a great and high mountain: and shewed me that great city, the holy Jerusalem descending out of heaven from God.
> Having the glory of God, and her light was like unto a stone most precious, even like a jasper stone, clear as crystal.
> And [it] had a wall great and high, and had twelve gates.

One of the largest and most splendid of English Apocalypse manuscripts lays out this very vision in shimmering gold and colors, dwarfing the tiny internal viewers, St. John and the angel (FIG. 16). No actual church could be as literal a transcription of the Heavenly Jerusalem as this image. Nevertheless its "wall great and high"

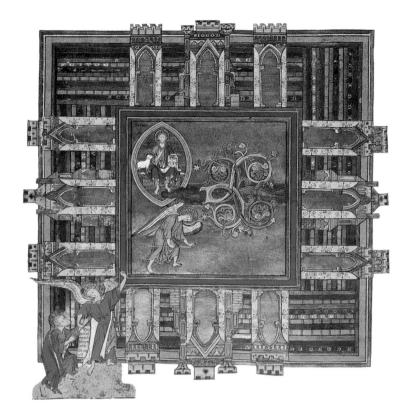

16. Trinity College Apocalypse, c. 1255. Illumination on parchment, 17 x 12" (43 x 30.4 cm). Trinity College, Cambridge.

"And I John saw the holy city, new Jerusalem, coming down from God out of heaven" (Revelation 21:2).

and its crystalline appearance, "pure gold, like unto glass" and adorned with jewels, give us a good impression of some of the rich polychrome surfaces which once articulated the now dull and weathered portals of cathedrals.

Considering that most people lived squashed together in dark, smoke-filled huts, it is not surprising that cathedrals seemed so spectacular. They displayed the wealth and power of the Church Triumphant on earth and were financed at enormous cost to local communities. They were not without their critics. Some churchmen, notably Peter the Chanter (d. 1197), who was himself a canon of the cathedral of Notre Dame in Paris, ridiculed his contemporaries for building such architectural excesses, which he compared to the Old Testament tower of Babel. The early Gothic churches of the Ile-de-France have been linked to the power and wealth of the Capetian kings, especially Philip Augustus. But more often it was the wealthy bishops and cathedral chapters (the collegiate bodies of canons, presided over by the dean) themselves who were the driving force behind building schemes. This was certainly the case in England, where powerful bishops constructed peculiarly English alternatives to French churches, not only in

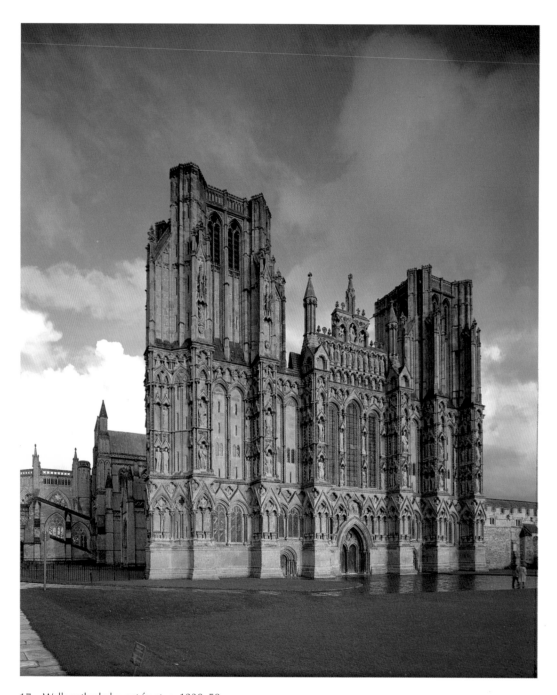

17. Wells cathedral, west front, c. 1230–50.

By extending the western towers outside the line of the nave walls and bending the arches and quatrefoils around the corners of the buttresses, this scheme emphasizes the geometrical complexity of the space and forms, not so much an entrance for the people who went into the church through another door to the north, but a screen onto which were projected visions of political as well as supernatural power.

architectural but also in social terms. At the cathedrals of Salisbury and Wells, for example, the sacred enclaves, including housing for canons and the bishop's palace, are quite separate from the surrounding urban area, in contrast to the cathedrals built in France and Germany, where the heavenly city was more integrated with the earthly one.

Wells cathedral, constructed under the bishopric of Jocelin, also has a very different kind of west front from that of French Gothic churches, although it still succeeds in evoking the "many mansions" of the Heavenly Jerusalem (John 14.2; FIG. 17). Its designers were working in a different visual tradition, one which preferred varied pattern to consistent logic. The emphasis in the front is not upon the depth of the portals, as in the French cathedrals, but upon the screen-like canopies that house 297 life-size sculptures (there were originally 384) representing a vast Last Judgment. The enthroned statues of the lay benefactors are placed on the north side, while the ecclesiastical donors are on the south, forming the pillars or buttresses of the Church Triumphant. The whole scheme came to life on Palm Sunday, when a procession dramatizing Christ's entry into Jerusalem entered this western door to the singing of heavenly choirs (in the form of choirboys dressed an angels) whose voices emanated through specially designed holes behind the stone angels in the quatrefoils at the lower level. Gothic architecture has to be seen as part of this ever-changing spatial performance of the liturgy.

The Gothic building-boom has partly to be seen in terms of the renewal or rebuilding of old structures that had been destroyed by fire – like Canterbury in 1174, Chartres in 1194, and Rheims in 1211. But the very first Gothic building, St. Denis (1140–44), just outside Paris, was according to Abbot Suger, the man behind the scheme, a response to the need for more space to accommodate the growing number of pilgrims. Competitiveness between bishops, cathedral chapters, and even towns meant that an excuse was often sought to build a new church on a lavish scale. At Chartres the relic of the Virgin's tunic miraculously survived the fire of 1194. This was seen as her instigation to erect an even bigger church

18. The image as a focus for donation. Miracles of the Virgin Window, Chartres cathedral, c. 1220.

This scene, recalling the earlier "cult of the carts" when the populace had supposedly carted stones to help in the building of the old cathedral, depicts a newly installed fund-raising statue of the Virgin on the main altar and urges the beholder to give generously.

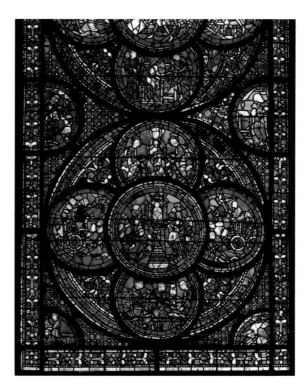

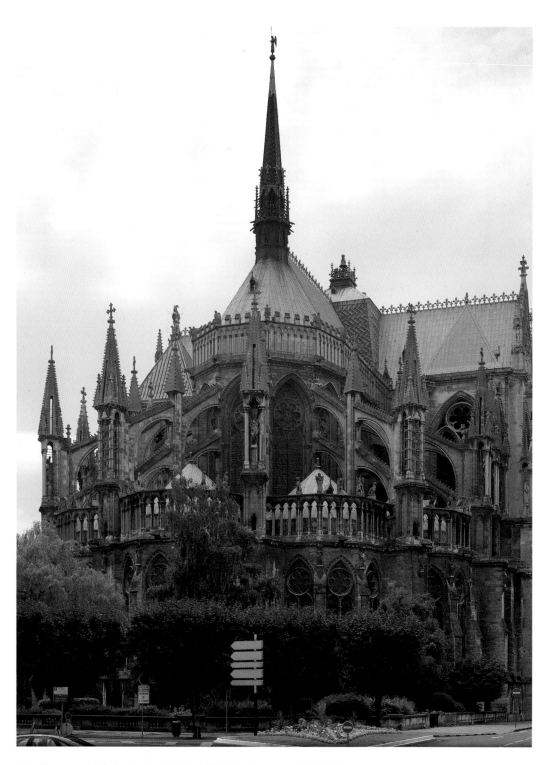

19. Rheims cathedral, exterior of choir with flying buttresses, 1211–41.

in her honor. In one of its many stained-glass windows local people are shown bringing gifts to the new silver-sheathed statue that was placed on the main altar along with the relic (FIG. 18). Although this statue is a Romanesque type of enthroned Virgin and Child, its new setting and function transformed it into a Gothic image. Many of the great churches are, in a sense, such image-tabernacles writ large. The cult of the Virgin was a major stimulus to the erection of Gothic churches and chapels, her image proliferating more than any other, except for the crucifix. They were built to house relics or statues that attracted pilgrims. The body of Mary was a symbol of the Church itself, for through it the tangible bond between God and humanity had been established. Just as, in this geometrical design, the roundel above that of the statue on its altar represents its prototype – the Virgin enthroned in heaven – so too the cathedral itself was an icon, representing the sacred reality that lay above and beyond it.

From the outside, the choir of Rheims cathedral, which was rebuilt following the fire of 1210, displays the new synthesis of technical elements: flying buttresses (masonry arches springing from piers to support a vault), thinner walls, and tracery windows, all deployed to create the effect of lightness and soaring verticality (FIG. 19). Technological advances, however, do not explain cultural change and especially not art-historical development. They simply provide tools which people use according to their imaginative needs. The east end of Rheims seems to be about to take off, aided by the fluttering wings of gigantic angels, perched under the openwork tabernacles of the pinnacled buttresses. Monstrous beasts, called chimeras, crouch like sentinels on the blind arcade. Below, life-size angels are placed between the choir's tracery windows. These sculptural elements emphasize that this eastern part is the most sacred and elevated of all of the cathedral's spaces (FIG. 20).

Erecting such a magnificent image of the Heavenly Jerusalem placed great strains on the inhabitants of the earthly city. The con-

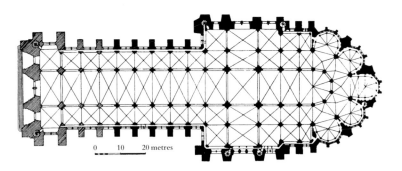

20. Plan of Rheims cathedral.

21. Atlas figure, Rheims cathedral (northern clerestory of the choir), before 1233.

struction of Rheims cathedral was paid for by heavy taxes. The cathedral clergy offered indulgences to those who contributed to the building fund, part of an aggressive fund-raising campaign that alienated the burghers. In 1233 the building came to a halt when the people of the town attacked the archbishop's palace, forcing the bishop and chapter to flee. The Pope placed an interdict on the town and the king passed harsh sentences on the rebels, delaying the completion of the choir, which was not consecrated until 1241. Cathedrals were not always the symbols of social harmony that we sometimes imagine. One person's glorious vision could be the instrument of another's oppression. While the canons might have viewed the spires and pinnacles of their new choir as affirmations of their spiritual aspirations, those burghers whose houses were burned and whose nearby property was confiscated might have viewed this whole eastern end as a triumph of tyranny. If the angels between the tracery windows seem effortlessly to sustain the ethereal stones of the choir, the Atlases, straining to hold up the massive blocks of stone above, seem, in the words of Pope Innocent IV, "crushed by the insupportable debts" that burdened the town (FIG. 21).

Our view of Gothic architecture of the thirteenth century is so overwhelmed by the massive scale of the great cathedrals that we forget that there were smaller churches and that they, too, transformed their environments. A good example is the church of St. Urbain at Troyes, started by Pope Urban IV (r. 1261–64) on the site of his father's cobbling shop (FIG. 22). This precious little church turns the architectural vocabulary that half a century before at Rheims had signaled the might of ecclesiastical authority – flying buttresses, tracery windows, and crocketed (ornamented with buds or curled leaves) pinnacles – to more playful ends. Its exterior presents the effect of a wall sliced vertically into thin slivers of stone, so that every element – the buttresses, the windows, and the gables over them – seems to be detached from the walls. There is no glass in some of the tracery, no weight for the flyer to support, sometimes no wall at all – just thin air. Every carefully cut edge of this giggling Gothic fantasy, whose whimsical insubstantiality continues on the interior, reveals something quite different from the scholastic logic that we tend to think controls French Gothic architecture. This is the importance of the faculty of the imagination, that capacity to build castles in the air, which was discussed by experts on the imagination.

Opposite
22. Church of St. Urbain, Troyes, begun 1262. View from the southeast.

34 *New Visions of Space*

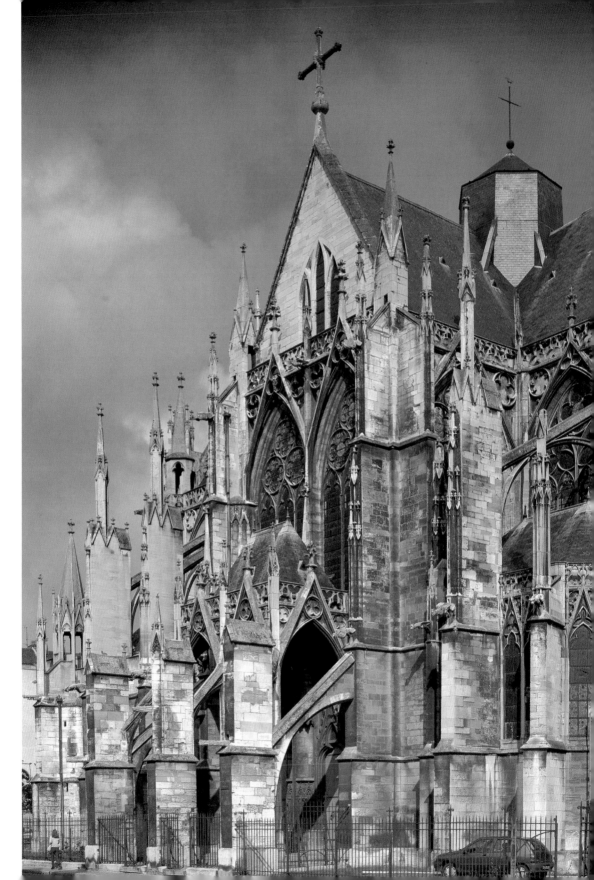

23. Strasbourg cathedral, plans for the west front.

On the left is Scheme A, c. 1260–70, and on the right, Scheme B, c. 1277. The latter is more fully worked out and closer to the existing front in its multiple pinnacles and towers.

The history of Gothic architecture is often described in terms of phases. The first experiments that took place around Paris from about 1140 to 1200 (when the Romanesque still prevailed in the rest of Europe) are usually referred to as Early Gothic. The next phase, the High Gothic, describes those buildings erected from about 1200 to 1260, including the great cathedrals of Chartres, Rheims, and Amiens. St. Urbain is usually taken to exemplify the next, more mannered, phase, called Rayonnant. It, too, began around Paris and from about 1260 to 1300 exploited more linear, transparent effects. But in many ways St. Urbain, in its complex ambiguity, anticipates the final phase of Gothic, the Flamboyant style of the later fifteenth century. English Gothic is seen to have followed its own path of development: the quite distinct Early English beginnings, the aptly named Decorated style of 1250–1340, and finally the vertical screen-like forms of the Perpendicular, from the mid-fourteenth century. Such labels have a limited use, however, especially if we want to understand how contemporaries viewed these amazing structures, not as styles but as spaces.

The Gothic master-mason did not conceptualize his building as a modern architect does, in terms of plan and elevation. Very few architectural drawings survive from the Gothic period. At

24. Strasbourg cathedral, drawing of the west facade, c. 1365. Ink on parchment, approx. 13' long (4 m).

Drawn on six parchment sheets glued together, this may be the work of more than one artist. Gothic is a multi-purpose, multi-media style and one can imagine a design like this being taken over and used in the creation of a metalwork shrine or even an altarpiece frame, serving other craftsmen over several generations. This mobility of models was crucial to the rapid and wide transmission of Gothic art throughout Europe.

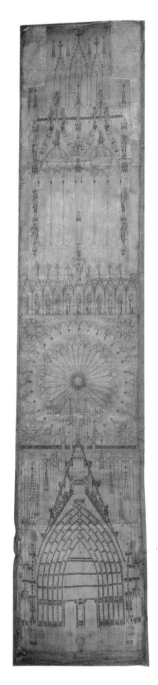

Soissons and at Rheims inscribed geometrical designs have been discovered on the stones themselves, suggesting that planners conceptualized the building process on site, rather than on paper or parchment. Once the structure of one bay had been worked out, the rest followed suit, so that only those parts of the building like the west front, that were erected over long periods, or whose design could not be extrapolated from earlier phases, called for detailed design deliberations. A remarkable series of drawings has survived from different periods in the creation of the west front of Strasbourg cathedral, which was begun, following French Rayonnant models, by German master-masons in c. 1277. They probably represent different proposals, from which the patron might choose, rather than working drawings (FIG. 23). Another more detailed drawing for Strasbourg survives. It dates from later in the fourteenth century and has been associated with the great family of central European master-masons, the Parlers. It is partly executed in delicate colors and instead of being a functional "working drawing" is a scheme to work out the placement of statues in niches (FIG. 24). Sculptors clearly had to work in close cooperation with architects. (They were often one and the same person, as is the case with the Parlers.) For just as each piece of rib or tracery was created to fit into a specific place, so too were more complex sculptural elements, carved below in the workshop and then hauled into place. The sculptor had to adapt the demands of objective proportion to those of the subjective eye of the beholder, who might be looking at it from far below. He often sculpted the features broadly, and with distortions, to accommodate the steep angle of vision. The Strasbourg tower was never completed, but the statues from the gallery of kings on the west front of Amiens and those high up on the exterior of Rheims suggest that, well before the Renaissance, Gothic sculptors were aware of the problem of viewpoint.

Like the Virgin and apostles on the lowest tier of the Strasbourg drawing, most figures in Gothic art were set within an architectural

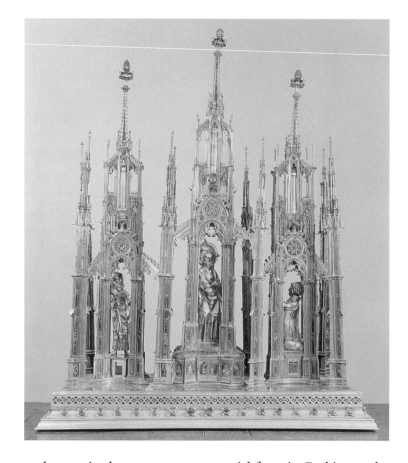

25. Three Towers Reliquary, 1370–90. Chased and gilded silver, enamel, and gems, height 36¾" (93.5 cm). Aachen Cathedral Treasury.

Whereas Romanesque reliquaries were in the shape of chests or churches protecting their sacred contents, Gothic reliquaries became like shop-windows, allowing one to gaze on the most priceless commodities in the culture. This reliquary also gives us an idea of the vertiginous effects sought by later Gothic architects, who built churches and chapels around such bodily fragments.

Opposite

26. Gloucester cathedral, tomb of Edward II, 1330s. Alabaster and stone.

enclosure. As the most common spatial form in Gothic art, the pointed arch and its three-dimensional version, the canopy, implied security. Providing a locus, a place for viewing, it functioned something like the frame in modern painting. More importantly, it allowed the viewers to position themselves in relation to the representation within. Very rarely in Gothic sculpture does one find a totally freestanding isolated figure without an overhead canopy – except for gargoyles, whose very isolation in space, jutting out into the street beyond, signals their ungodly ejection from the church as well as their function as gutters for rainwater. The envelope of the arch thus not only contains and protects the figure, it elevates it, no matter how lifelike it has become, within an eternal, ecclesiastical order.

Enclosing arches were used in many parts of a church, on altar screens, choir enclosures, tombs, bishops' thrones, and they were made in multifarious media varying from marble to oak. Everything was suspended below the glacial verticality of pinnacles and points. The arts of the goldsmith, especially during the

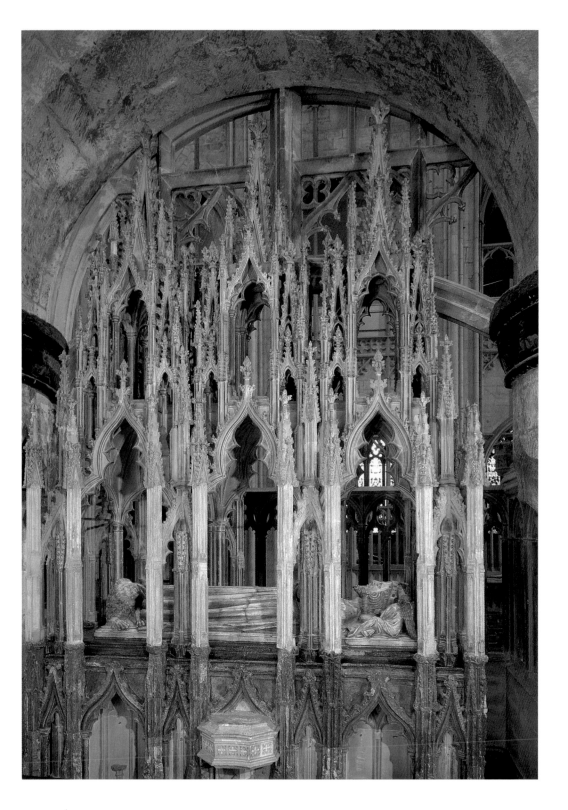

Rayonnant period in France and the Decorated style in England, led the way in evolving these ever-more-convoluted spatial envelopes. A reliquary in Aachen, probably Flemish and known as the Three Towers Reliquary, reverses the usual relation between outside and inside in Gothic art in a way typical of this "avant-garde" medium. It places the relics on the exterior of the structure and the statues within (FIG. 25). Transparent tubes of rock crystal, which make up the spires, display fragments of St. John the Baptist's hair-shirt, Christ's sweat-rag from the crucifixion and the rod from his flagellation, as well as part of a rib of St. Stephen, each identified by a written label. Inside are three superbly cast figures, St. John the Baptist, Christ, and a donor dressed in the vestments of a deacon, who kneel towards the standing Saviour at the center. This reliquary is thus structured as a visionary experience. At famous shrines like those of St. Thomas at Canterbury, St. James at Santiago de Compostela, and of the Three Kings at Cologne, the pious pilgrims, kneeling like the deacon here, might experience visions of the total body whose fragmented pieces they had come to venerate.

Canopies, crocketed finials, and sharply pointed pinnacles were means of representing the image of the Heavenly Jerusalem, whether in the micro-architecture of a reliquary or the massive stones of a church that took two lifetimes to build. The tomb of Edward II at Gloucester has its alabaster effigy set within stunning stone cages of pinnacles and ogee arches (arches composed of two double-curved lines that meet at the apex; FIG. 26). The body of the deposed monarch, which had been so ignominiously penetrated at his murder, is presented as calm, whole, and inviolate. The king's body has been transformed into something like a saintly relic because of this shrine-like structure which encloses it.

From its beginning the Gothic style was more than just architecture. Although it was church-builders who first sought to remake the world in heavenly terms, these effects could only be achieved by a combination of all the arts, in a multi-media extravaganza. What is clearly being celebrated in the writings of Abbot Suger at St. Denis is the combination of architecture with sculpture, stained glass, goldsmithing, and painting. Gothic was the creation of a complete space, a total environment that transported the abbot to what he called "some strange region of the universe which neither exists entirely in the slime of the earth nor entirely in the purity of Heaven." What stirred Suger was not just the soaring space of his new Gothic choir, but the shimmering light of precious stones that adorned the high altar and the colors that shone in its stained-glass windows.

Celestial Light

Entering the celestial city of Chartres cathedral, even on a bright sunny morning, one immediately feels the effect is of overwhelming darkness, even gloom. Only slowly, as our eyes adjust to the dark, do the luminous pools of blue and red from the stained-glass windows begin to emerge, suggesting a vision of that other world "garnished with all manner of precious stones" (Revelation 21:19; FIG. 27). Though stained glass had been in use for centuries and some of the old cathedral's glass still survives at the west end of Chartres, the medium was given new emphasis in the thirteenth-century building. By removing the gallery, or tribune level, and,

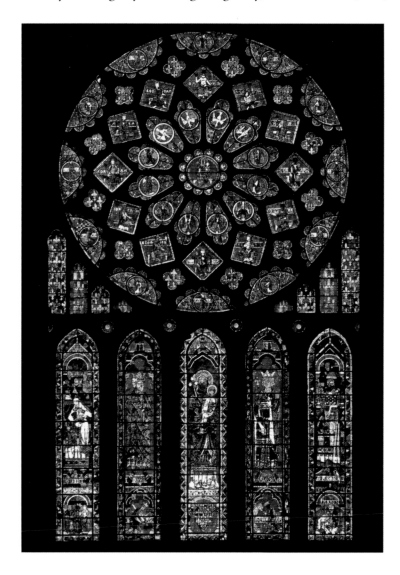

27. Chartres cathedral, north transept, interior rose window and lancets, c. 1220.

In the center of the rose sits the Virgin, dark and ineffable, surrounded by doves and angels. The five great lancet windows below show how the designers, who had to set each piece of glass within a lead armature, made allowances for these figures to be readable from a great distance. The tall prophets, and St. Anne and the Virgin in the center, are all created out of broad masses of red, blue, and green glass. The royal house of Capet also weaves its genealogy into this scheme, the corner spandrels showing the yellow fleurs de lys and castles on a red ground of its donor, Blanche of Castile, the Queen of France and mother of Louis IX.

with the aid of flying buttresses, enlarging the windows of the clerestory level, the whole interior became a frame for its dazzling display.

The north transept rose window is another glowing vision of the Virgin, who is placed at its center with the Christ-child on her knee. She is the window through which Christ, the Light of the World, entered the terrestrial realm. But, as in all early stained glass, it is not so much the transparent qualities of the medium that are made manifest, but its dense, deeply colored materiality of ruby reds and sapphire blues, its jewel-like capacity to emit light rather than merely refract it. Glass was most often associated with the intense colors of gems, which Abbot Suger saw as possessing "sacred virtues." The purest form of light, that seen by mystics, was a manifestation of divine grace, but in its material form light was described by a rich Latin vocabulary. The word *lux* referred to the source of light such as that emitted from luminous bodies like the sun. Light which was multiplied in space was called *lumen* and light which was reflected off objects was called *splendor*. When Abbot Suger described the enlarged upper choir at St. Denis as "pervaded by the new light" (*lux nova*), he was imbuing the stained-glass windows there with the capacity to make light manifest. Whereas twentieth-century taste tends to associate the shiny with the gaudy glow of kitsch, nothing was more beautiful to a medieval beholder than this colored brightness.

Gothic art has often been associated with the metaphysics of light, particularly with the theology of Pseudo-Dionysius, a supposed fifth-century Christian mystic whose ideas about God as an "incomprehensible and inaccessible light" were revived in the twelfth century. This is specially evident in the writings of Abbot Suger, who sought to link this mystical author with St. Denis, the patron saint of his own royal abbey. However, the appreciation of what we might call the "aesthetics" of light was not uniform throughout the Gothic period. A profound change occurred between the stained glass of Chartres, which embodies the kind of opaque, almost dark, mystery described by Abbot Suger, and the stained glass of the later thirteenth century, which allows far more actual light to penetrate it. This later glass makes the walls of the church seem not so much garnished with a mosaic of precious stones as disappearing altogether in diaphanous radiance. There was a similar tranformation in taste toward the refractive properties of highly transparent stones like crystal and diamonds, at the very time that the perspectivist philosophers were exploring the refraction of light through transparent media in the humors of the eye itself. This urge to make spaces more visible by allow-

Opposite

28. The creation of light and the spheres, from a Book of Hours, c. 1340–50. Illumination on parchment, 6³/₄ x 4¹/₈″ (17 x 10.5 cm). British Library, London.

Here, by contrast with the previous image, the center, where earth rests, is the darkest, lowest point in the universe and divine light streams down from outside the created cosmos.

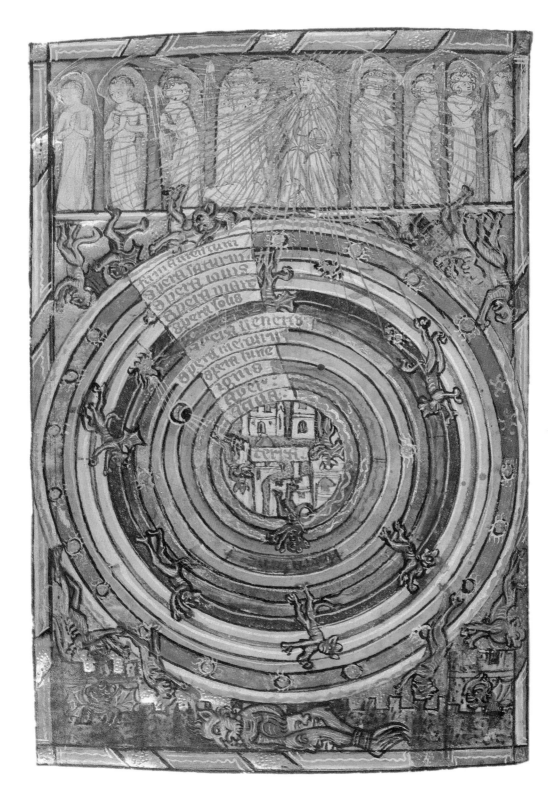

ing more light in can also be seen in the changing techniques of making stained glass, such as the use of silver stain, which developed around 1300. White becomes an important color in later stained glass.

We can also see this increasing ethereality of light in other media, like enamelwork and manuscript illumination, where transparent layers of lighter color replace the deeper blues and reds of the thirteenth century. In a depiction of God's creation of light in an English Book of Hours, we can see this change toward transparency, both in the form and the subject-matter of the image. Fiery rays of light emanate from the figure of God, who stands

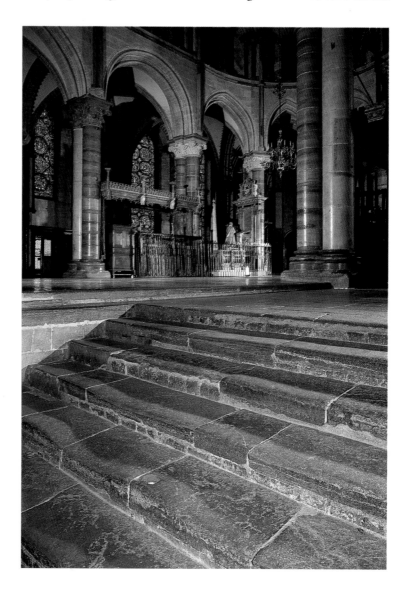

29. Canterbury cathedral, south aisle, looking up into the Trinity chapel, c. 1220. Steps worn by pilgrims' feet and knees lead up to the cult site.

in the middle of a series of white, luminous angelic forms (FIG. 28). Robert Grosseteste (c. 1168–1253), Bishop of Lincoln, who combined Neoplatonic ideas about light with Aristotelian observations about its transmission, wrote an account of the creation of light which, like this picture, linked it to the creation of angels. The medieval artist, like the philosopher, thought in terms of dialectical contrasts. So here the creation of the purest light is combined with the first dark heresy against God. The rebel angels tumble into the darkness below and become more and more monstrous the farther away from the light they fall. In the middle of the page are the turning spheres of the medieval cosmos, with the earth as its static center, surrounded by the other three elements, water, air, and, the most elevated, fire. At the bottom of the page Satan lies chained in the darkness of hell. Even without any theological or metaphysical training, the woman who owned this little Book of Hours was provided with a primer in medieval visual theory. Light is associated with the elevated and dark with the base, each element having its color, each sphere its place.

For most beholders of Gothic art, however, light was something more tangible still. At Canterbury cathedral the new architecture was part of an important spatial experience for pilgrims, who moved from the darkness toward the light when they were guided from a cult site down in the crypt up two levels to where the relics of St. Thomas à Becket (1118–70) were displayed in the new Trinity chapel. The shimmering metalwork shrine built in 1220 was destroyed by King Henry VIII in 1538, but its setting still remains. The eyes of the past have not made marks nor left visible traces as have the bodies, feet, and knees of the countless pilgrims who over the centuries have worn away the steps leading to this space (FIG. 29). But we can still imagine startled eyes adjusting to the brightness of the space after the dimness below. Along with the rich variety of Purbeck marble columns in the east end these stained-glass windows were part of a carefully choreographed pilgrimage route within the cathedral. They represented the miracles that occurred on this very site when the lame walked and the mad were calmed through the intervention of the recently martyred saint. The kneeling and prostrate figures depicted here are literally guides to those pilgrims seeking a repeat performance. Canterbury cathedral displays the accretion of architectural styles typical of English great churches. It has a Romanesque crypt, Perpendicular nave, Early English choir, and horseshoe-shaped extension in the form of the Trinity chapel, with its extra corona, called "Becket's crown." But all was held together in a unified visual experience by the saint's cult.

30. Upper chapel of the Sainte Chapelle, Paris, 1241–48.

The king's viewpoint was from within the south recess to the right of the raised canopy, which was where the precious relics (destroyed in the French Revolution) were displayed. He faced scenes from the Book of Kings in the stained glass opposite. The queen, seated adjacent to him, observed Old Testament heroines like Esther. From the viewpoint of this photograph the effect is one of shimmering translucence, making it difficult to isolate and "read" any single element of the narratives in the glass.

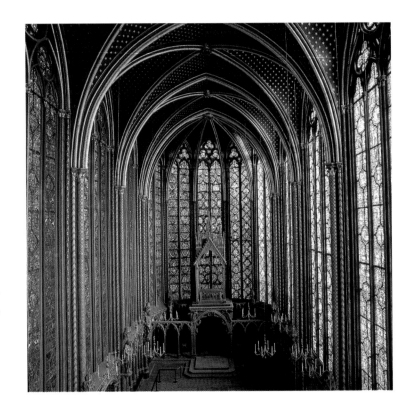

In the royal palace complex on the Ile de la Cité in Paris, Louis IX built his own gigantic reliquary for displaying the relics of Christ's passion, including the crown of thorns, which had been bought from the Latin emperor of Constantinople (FIG. 30). In the upper chapel, masons, sculptors, and painters created an interior that reflects light like a multifaceted diamond. The shimmering walls of stained glass, the gilded statues of the twelve apostles on the piers and the narrative medallions painted on glass and silver grounds so as to catch every gleam of light give today's viewer some idea of the chromatic brilliance presented by Gothic interiors, most of which have now been "toned down" to suit the more austere tastes of subsequent centuries. Louis, who died on a crusade, wanted to make Paris the new holy land, or *locus sanctus*, and the sumptuousness of this interior was meant to add luster not only to the sacred relics but also to the line of Capetian kings.

Sixty years later, in a private chapel on a much smaller scale, the Italian painter Giotto used a different combination of media, not to transport viewers to a heavenly realm, but to bring the divine down to their level (FIG. 31). The Arena Chapel contains 36 consecutive narrative scenes of the life of Christ and the Virgin, framed within an illusionistic structure that places the viewer in

31. GIOTTO DI BONDONE
(c. 1267–1337)
The Pact of Judas and an
illusionistic chapel,
1305–10. Fresco. Left altar
wall, Arena Chapel, Padua.

Giotto's consistent pattern
of illumination, modeling
his painted figures so that
the light from the window
on the west wall seems to
strike each painted body,
can be seen as a rational
application of the function
of light within the Gothic
tradition. The framing
elements, painted to appear
as though they were stone
panels inset with mosaic,
are also an attempt to re-
create the effects of
expensive marble-cutting,
then popular in Rome. The
illusion is thus not simply
one of human action, but
also of splendid decorated
surfaces.

the very center of the chapel. Within a Gothic interior like the
Sainte Chapelle in Paris, one is constantly moving to obtain dif-
ferent refractions of light, as though turning a gemstone, whereas
here there is an optimum position for viewing the sacred story
in a systematic order. Also, the light which creates the scheme
is not reflected from gold, gems, or semi-transparent materials, but
is evoked in paint. In Italy stained glass had not supplanted the use
of fresco as the major space-defining medium. The reason for this
was light itself: the hot sun of the south demanded massive
areas of cooling wall. If Giotto was still painting with light, it was
not the divine *lux* that emanated from precious stones and stained
glass, but the material effects of *lumen* as it bounced off the
forms of his painted bodies.

This interest in representing the light of the world itself can
be seen in the illusionistic chapels that Giotto painted in the Arena
Chapel on both sides of the altar wall. This is an imaginary Gothic
space, lit by a lancet window – a high, narrow window crowned
by a pointed arch – and a wrought-iron lantern suspended from
the apex of the vault. Light entering the church was often asso-
ciated, as we have seen at Chartres, with the Virgin Mary, whose
life-story winds around these walls. This vaulted space can thus be
seen as an image of the pure and enclosed body of Mary and
the sanctity of the church. Space is never just what it seems,
even with as superb a space-maker as Giotto. In the Arena Chapel
he reveals himself to be an artist in the Gothic tradition at the very
point where, in other respects, his art looks forward. According
to the contemporary poet Giovanni Boccaccio, Giotto was the
"one who brought light back to art," but this light also has to
be seen through the eyes of the man for whom the chapel was
built. Enrico Scrovegni was a wealthy land-developer and son
of an infamous usurer. The iconography of the painted scheme has
been related to his need to expiate the guilt of his father, in scenes
like "The Pact of Judas," in which the dark devil is identified with
money. But in choosing the most advanced painter of his time
to paint his chapel, Scrovegni was surely also seeking some-
thing more. The unified space and light, which render things to
graspable and materially present to the observer, can be linked
to his acquisitive view of space as private property, not as symbol.
The empty chapels, with their strong outer barriers, are not
only sacred symbols, but safes cut into the wall.

If Giotto's light in the interior of the Arena Chapel seems
ahead of its time, that in the chapel of the Holy Cross at Karlstein
castle, near Prague, built to house the relics and regalia belong-
ing to the Holy Roman Emperor Charles IV (r. 1355–78), seems

to look backwards (FIG. 32). Whereas Giotto's chapel seems to open up space to the light of day, the emperor's is like a jeweled cave. Star-shaped mirrors decorate the vaults, while various richly patterned marbles and gemstones are set into the walls below a gallery of 130 icon-like saints. These holy persons, painted by the Bohemian artist Master Theodoric, loom out at the beholder, bursting from their frames, their fat hands grasping sculpted shields and heavily embossed books. Whereas Giotto evoked three-dimensional effects in paint, Master Theodoric constantly breaks the illusionistic surface with real objects, which he pins or nails onto the panel like a modern collage. It has been suggested that the multi-media *splendor* visible in this space and in Charles's adjoining private oratory at Karlstein embodies the emperor's vision of himself as the new Constantine. Perhaps he sought to create what he imagined were "Byzantine" effects transposed into a Gothic mode. Certainly nowhere else in Europe is the claustrophobic opulence of sacro-political power made more manifest.

32. Karlstein castle, chapel of the Holy Cross, c. 1365.

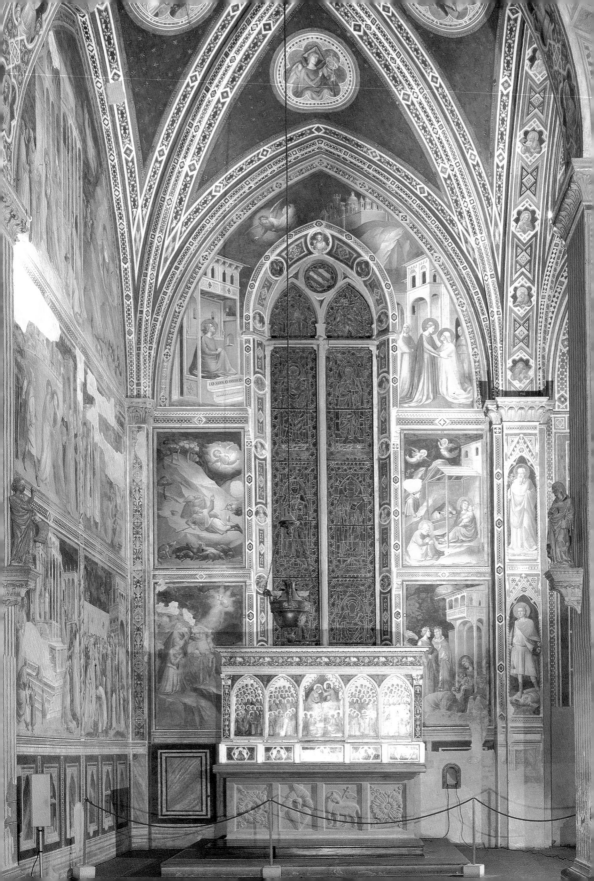

Although Gothic architecture had first been introduced into Italy by the Cistercians, it was the very different kinds of churches which were built to serve far larger groups by the new mendicant orders of Franciscans and Dominicans which presented a new vision. These opened up their interiors to light and to new types of images. The naves of these spaces were simple, compared to their northern Gothic equivalents. They were used mainly for preaching, but they were also built to be constantly adaptable, especially to the addition and decoration of private chapels where wealthy merchant families were commemorated. Typical is the basilica of Santa Croce in Florence, built by the Franciscans in 1296, with its slender, widely spaced piers and the Baroncelli Chapel, painted by Giotto's godson and pupil Taddeo Gaddi (c. 1300–c. 1366), between 1330 and 1334 (FIG. 33).

The use of several foci of light makes this space more complex than it first appears. Stained glass, occasionally used to great effect in Italian churches, was originally placed here in the tall lancet window depicting the scene of the stigmatization of St. Francis. Taddeo was obsessed by light in this chapel, partly, it has been suggested, because he was nearly blinded when trying to observe a total eclipse of the sun in 1332. He painted the chapel so as to capture the effects of actual southern light coming through the lancet window. Taddeo placed a series of mystical experiences, one above the other, at the left. At the top is the Annunciation of the Virgin, traditionally associated with the propagation of light because Mary conceived Christ without any material rupture of her body. In the annunciation to the shepherds below, another, more sudden, incandescent flash of light shocks the shepherds from their sleep. The three Magi on the bottom tier kneel before another vision, this time of the infant Christ, glistening like a star before them. Light here is identified with revelation and patterned to coincide with the light streaming through the actual window.

Another important new visual element in the Baroncelli Chapel is the altarpiece. This is a polyptych of the Coronation of the Virgin painted by Giotto and his assistants. Originally, it was not in a classical rectangular frame, but in a structure with pointed canopies that echoed the shape of the stained-glass window above it. It has its own visual hierarchy: predella panels containing single figures provide a base for the main panel, above, with its densely crowded haloed figures. Different image-types demand different pictorial styles. The altarpiece, painted in tempera (where egg or another viscous liquid other than oil is used as a medium for the powdered pigment) on panel with gold and rich, incised patterns on the dozens of haloes (which we should not forget

33. TADDEO GADDI (c. 1300–c. 1366) Baroncelli Chapel, Santa Croce, Florence, 1330–34.

34. Soest, Pfarrkirche St. Maria zur Wiese, begun 1331.

Typical of later stained glass, these windows allow more light to penetrate the interior, using yellow and white silver stain rather than the earlier dense blues and reds.

are signs of spiritual radiance), is in a far more conservative mode than the more naturalistic narrative scenes in the frescoes around it. This is not only because painting in tempera produces different effects from fresco-painting. Just as important was the fact that the way in which one looked at an altarpiece was different from the way in which one looked at a wall-painting. The wall was part of the world and thus lit like it, by the sun; the panel, which was placed on the consecrated altar, emitted its own light. Before it the flickering candles and vessels used in the ceremony of the mass would share in the shining.

Hundreds of churches dedicated to the Virgin were built throughout Europe in the fourteenth century, differing greatly according to local traditions and materials. In the north, churches like that of Our Lady of the Pastures at Soest (begun in 1331) is typical of the expansive hall-like spaces, whose massive lancet windows light the interior with its focal points of altars and images (FIG. 34). In the north of Europe the altarpiece itself rather than wall-painting carried more narrative weight and it developed into a more complex shrine-like structure, frequently with sculpture and with folding wings that opened and closed as required by the liturgical calendar. The Annunciation painted by Melchior Broederlam (c. 1381–1409) is part of the left outer wing of the altarpiece made for the chapel of Philip the Bold, Duke of Burgundy, at the Chartreuse de Champmol, near Dijon. His version of the Annunciation takes place in a deeply receding, multi-faceted interior, one space opening up into another just as the altarpiece itself is hinged to open and reveal new vistas (FIG. 35). Broederlam exploited the unusual shape of the picture field, dictated by the fact that it had to fit the outer wing of the central shrine of an altarpiece that contained sculptures. The golden rays coming from God's mouth follow the sharp angle of the frame at the left. Here architecture also plays a symbolic as well as a space-defining role. The domed pink structure in the distance, with its Romanesque round arches, represents the Old Testament, while the hall attached to it, surmounted by Gothic traceried forms, represents the New Testament. The bare, rocky landscape in which the Visitation of the angel can be seen taking place plunges upward and outward, deep into space.

The thrill of this image to a medieval beholder was what was called its *varietas*, or pictorial richness. Its spaces drew one into a layered system of symbols, from the lily, a sign of virginity, which stands in the foreground, to the distant tower. The rapidly receding corridor on the left represents the enclosed space of

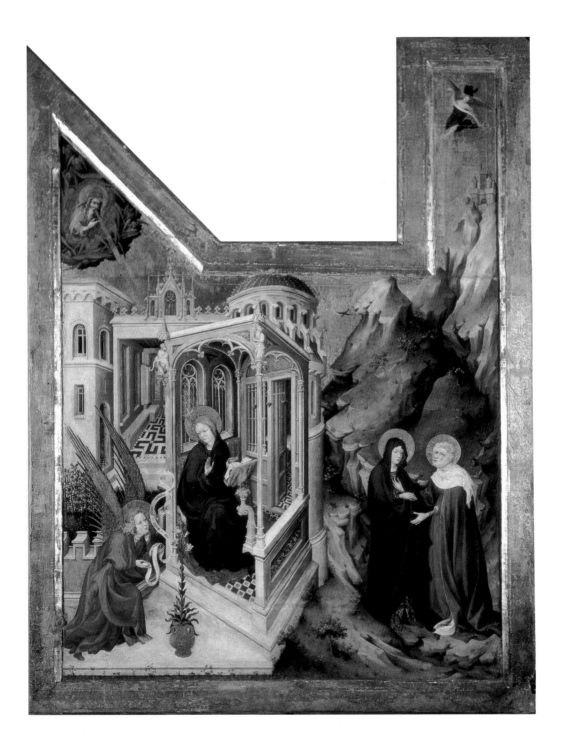

35. MELCHIOR BROEDERLAM (c. 1381–1409)
Annunciation, 1395–99 (detail). Tempera on panel, each panel 5′5¾″ x 4′1½″ (1.67 x 1.25 m). From the outer
wing of an altarpiece made for the Carthusian monastery of Champmol, Dijon. Musée des Beaux Arts, Dijon.

36. Church of St. Lawrence, Nuremberg, 1445–72.

Whereas most parish churches have lost their Gothic images, to either the Reformation or changing artistic fashions, this one has kept its medieval appearance, despite its becoming Protestant in 1525, partly because so much of local memory and patrician wealth had been invested in it.

the Virgin's purity. Its opening up represents, not so much the rationalistic conquest of territory by the scientific eye attuned to perspective, as the idea of her impenetrable body, which, like transparent glass, or an enclosed garden, remained perfect unto itself. The rays shining down through the tracery of the Gothic window are likewise a material manifestation of the Word – direct from God's mouth – made incarnate within her body. One of the favorite objects associated with the Virgin, as we have seen at Chartres and in the Arena Chapel, was the window. Here again, but in the medium of panel painting, she is the "window of heaven," the *fenestra coeli* "through which God shed the true light on the world."

Just as this represented space is densely packed, so too were the actual spaces of fifteenth-century churches crammed with things. In the German empire, the hall church developed into a single, light-drenched space which made it easy to see the devotional loci that were also monuments to their patrician patrons. The church of St. Lawrence in Nuremberg, for example, has a polygonal plan with piers flowing uninterruptedly up into the star-vaulting, its outer wall broken only by two tiers of tracery windows (FIG. 36). These light the images displayed inside. The

great stone tabernacle built to house the consecrated host, which nearly reaches the vault to the left of the altar, was the work of Adam Kraft (c. 1455–1509) and was commissioned by the Nuremberg alderman Hans Imhoff the Elder in 1493. Another citizen of Nuremberg, Anton Tucker, later commissioned a wooden Annunciation from Veit Stoss (c. 1445–1533), which is suspended from the vault. Both these works have been cited as examples of the art of the northern Renaissance. That is to see them in isolation. As they function within the interior of the church, they are part of the Gothic tradition.

The impact of Gothic is to be seen more in the thousands of smaller parish churches and chapels that were built throughout Europe than in the great churches and cathedrals. Gothic was never a single, uniform style. It took on multiple variants and quite different forms depending on local traditions. One example will have to suffice. On the island of Gotland, off the coast of Sweden, is the small parish church of Lärbro, built at the end of the thirteenth century with far less money than those royal, ecclesiastical, and burgher buildings we have looked at thus far (FIG. 37). The north wall of the chancel shows that even with limited resources people

37. Lärbro church, Gotland. North wall of the chancel, with wall paintings of a dragon, an evangelist holding a consecration cross, and a crucifixion, c. 1280.

Scandinavian churches have retained their atmospheric, object-filled interiors better than those in most other parts of northern Europe.

56　　*New Visions of Space*

sought to make their spaces Gothic. A winged dragon – a Roman-esque or perhaps even a pagan vestige – lingers on the base of the arch, its tail spiraling out from its three-dimensional head. Christianity came as late as 1026 to Gotland. So here religious art was still part of the process of conversion. There was neither the money nor the local skill to create an architecture of light stone members, and yet some of its effects were sought by a community who had links with the rest of Europe through Hanseatic trade. Twelve painted apostles, like those carved at the Sainte Chapelle, are here painted in simple earth colors, holding their foundation crosses to mark the consecration ceremony. Although the parishioners could not afford to get an Adam Kraft to create a sculpted tabernacle for their host, they could still honor its sacred substance through the painted illusion of a crocketed gable over the cupboard in which it was kept. Even more importantly, the truth to which the host pointed, Christ's crucifixion, is painted above. The Virgin standing alongside, her heart pierced by an arrow to represent her sorrow and compassion with her son, is another instance of a recently developed theme, making its way north. Here, in the long evenings of summer, the light plays on the soft plaster and accentuates the pointed wall-openings. In count-less smaller parish churches throughout Europe, the Gothic image was a similarly simple, minimally colored wall-painting.

Earthly Vistas

How did people conceptualize the world in which the Gothic style spread so rapidly in the thirteenth century? In a contemporary psalter, a full-page image of the world places Jerusalem at its center (FIG. 38). According to the prophet Ezekiel 5:5, "Thus saith the Lord God; This is Jerusalem: I have set it in the midst of the nations and countries that are round about her." Jerusalem was also the center of the Crusades, still being fought to regain posses-sion for Christendom of the Holy Land from Muslim rule. Jerusalem was the spiritual goal that pilgrims most longed to reach, how-ever, because it marked the most important Christian site in the world – the place of Christ's crucifixion. Orienting maps by plac-ing what we call east, not north, at the top, derived from the fact that Christ, like the sun, was expected to rise in the east at the Last Judgment. Maps like this one, showing Christ's dominion over space, though on a much larger scale, were sometimes placed in churches. One is still kept, for example, in Hereford cathedral. In 1236 King Henry III ordered a *mappa mundi* to be painted on the walls of his palaces at Westminster and Winchester, suggesting

38. Map of the world from a psalter, c. 1260. Illumination on parchment, 6³⁄₄ x 4⁷⁄₈" (17 x 12.4 cm). British Library, London.

Europe appears in the lower left part of the circle, with cities like Rome and Paris, while Asia is to the right, where the monstrous races thought to exist at the edges of the earth are stacked. Africa takes up the whole upper portion of this fixed and labeled world. Jerusalem is set as the center, or "navel," of the world, as it was sometimes called. The top and bottom are contrasted so that God and the angels, above, are in control, while beyond the bottom edge two dragons, whose tails turn into semi-naturalistic leaves, confront each other.

39. Conwy castle, Gwynned,
Wales. The outer ward looking
west, c. 1283-92.

To the left is the bow-shaped great
hall, which would have had a
wooden beam roof. The viewpoint
here is from the more secure inner
ward, where the royal apartments
were situated.

that for temporal rulers such images held a clear territorial meaning. Placing what were thought of as the monstrous races at the earth's edges, such maps mingled biblical, mythological, and geographical legends with actual spatial relations. Despite their symbolic structure, such maps are testaments to the increasing compartmentalization and visual organization of real space that took place during the Gothic age.

A major consequence of territorial expansion for both the French and English kings and their nobles was castle-building. As they conquered new territories and guarded their borders, monarchs laid out a system of defences as carefully plotted as any of the lines on the psalter map. A castle was a building made for looking out of, for gaining a vantage point. But, like the great churches, castles also developed so as to emphasize their exterior appearance, with a system of signs that came to stand for the power of those people who held them. Just as the purpose and meaning of the church were established by certain symbolic structures – pointed arches, buttresses, pinnacles – the safe stronghold carried messages by architectural forms which began as functional aspects but soon became part of its symbolic meaning. These forms included the massive circular towers or *donjons*, the system of moats, and the jagged battlement crenellations (for which, in the thirteenth century, one had to obtain a royal license).

Conwy castle was begun in 1283 by Henry III's son, Edward I (r. 1272–1307), to secure his conquest of Wales, and though ruined today, it still gives a powerful sense of the spatial dynamics of royal authority (FIG. 39). Its strategic position on an estuary provided vantage-points for looking out over vast tracts of land to spot an oncoming enemy. Conwy has internal vantage-points too, allowing the king to witness the celebration of the mass in his own private room above the chapel and opening up vistas, like that from the outer ward which looked over the castle to the walled town beyond it that was built at the same time. Looking at the ruins of medieval castles today, one can only imagine the visual richness they once enclosed. The great halls and the royal chambers would have been decorated with banners and textiles, the wooden beams brightly painted, and the guards and attendants color-coordinated in embroidered livery.

The monastery was the major site of Romanesque art and architecture. For Gothic art it was the city. In France and the Holy Roman Empire, where the wealth of the crown and the bishops depended increasingly upon trade, it was in the great walled towns that Gothic art flourished. We have so come to associate the pointed arch with sacred buildings that we forget its ubiquity, not only

40. Marketplace with arches at Montpazier, a new town founded by King Edward I of England in 1285.

Bastide towns (from the French *bâtir*, to build), like colonial cities planted in the New World much later, were constructed to provide maximum exploitation of the inhabitants, and should not be thought of as burgeoning democracies like Italian cities of the era.

in castle architecture, but in new urban structures. The great cathedrals rose amid the hustle and bustle of market towns and depended upon urban commerce to finance their building. Marketplaces themselves had pointed arches, as was the case with the arcades, or *couverts* as they were called, of Montpazier, a new town founded by King Edward I in 1285 (FIG. 40).

Typical of the *bastide* towns set up by the English in their conquest of Gascony, in what is now southwest France, Montpazier is laid out on a grid with a marketplace and church on either side of the central axis. Such a systematically planned urban space was as much a combination of the symbolic and the practical as any cathedral. At the four corner entrances to the market square two arcades met at sharp angles. Called *cornières*, these provided shelter for stalls and places of surveillance from which access to the market could be denied to interlopers without trading rights. In some towns the erection of public buildings like town halls and market halls came under communal control. Such was that still visible at the important North Sea trading port of Lübeck, whose dark glazed bricks and imposing pierced arcades, though heavily restored, exemplify civic Gothic splendour(FIG. 41). The medieval

town, although it stood for freedom from the feudal obligations of the land, was the most policed of all medieval spaces. Demarcated by different powers and jurisdictions, a street could belong to a local monastery, a bishop, the local count, or the commune. Every architectural element, every gate or boundary stone, was a sign of social control. A contemporary allegory of the game of chess, where pawns representing different urban trades vie for control of space, compares a chessboard, with the restricted movement of its pieces, to the layout of a town.

The most celebrated of all cities in the thirteenth and fourteenth centuries was undoubtedly Paris, with the royal palace and the Sainte Chapelle at its center, the massive cathedral of Notre Dame on the Ile de la Cité, the great markets and residences of the aristocracy on the right bank, and Europe's greatest university on the left. A manuscript of the life of St. Denis (FIG. 42), the first bishop of Paris, is set against the contemporary urban context, full of the bustle of fishing boats on the Seine and the mercantile activity that made Paris the first "art" city in Europe. Road-pavers are shown laying down stones, creating the arteries by which goods and services flowed through the capital. That it was a great city

41. Rathaus, Lübeck, begun c. 1250.

Like a cathedral the town hall, standing on two sides of the marketplace, was a focus of civic pride for centuries. The high, spire-topped turrets of the north side, with its two huge holes to lessen wind resistance, are the earliest elements. On the adjacent side the more elaborate pierced walls date from c. 1440.

42. St. Denis entering the city of Paris, from the *Vie de Saint Denis*, 1317. Illumination on parchment, 9½ x 6⅜" (24 x 16 cm). Bibliothèque Nationale, Paris.

The pinnacled buttresses on either side of this full-page miniature encase Paris within a spiritual and ecclesiastical framework, suitable to this narrative of the first bishop of the city, St. Denis. The crenellated battlements depicted within the scene, however, emphasize the physical reality of the city's defensive walls, which were crucial to security and prosperity.

was signified by the great walls that circled it. "Parisus paradisus" it was called – the Heavenly Jerusalem brought to earth, not as a sacred space, but as a place of exchange. "Here you will find the most ingenious makers of all sorts of image, whether contrived in sculpture, in painting, or in relief," wrote the Parisian scholar Jean of Jandun. Paris was already the fashion center of Europe. The very concept of fashion – following a particular style in dress, for example – developed at this time among those people wealthy enough to cultivate an "image" and Paris, then as now, was where you went to see fashion displayed in the streets.

Of the magnificent royal palace on the Ile de la Cité, where the St. Denis manuscript was presented to Philip V in 1317, only the Sainte Chapelle survives. It is, indeed, difficult to get a sense

of these great Gothic audience halls. That at the Palace of West-minster in London, also dating from the late thirteenth century, was destroyed by fire in the nineteenth. Even though it was built much later, by Benedict Ried (c. 1454–1534), the combined throne-room and jousting hall in Hradčany castle, Prague, is the finest great chamber still extant (FIG. 43). The unique undu-lating ribs that flow in swirling, flame-like curves from floor to ceiling create a single space of breathtaking audacity, typical of the secular ruler's urge to enthral with the Gothic fantastic.

The most extensive surviving monuments of Gothic secular decoration are in the great Italian city-states. The frescoes of Ambro-gio Lorenzetti (fl. 1319–48) in the Palazzo Pubblico of Siena are among the most pictorially and politically complex images of

44. Ambrogio Lorenzetti
(fl. 1319–48)
The Good City Republic,
1338–40. East wall, Sala
dei Nove, Palazzo
Pubblico, Siena.

Standing in the room one is
never able to see the whole
scheme of Good and Bad
Government straight on as
one sometimes sees it in
reproductions. It is viewed
more from below and at an
oblique angle, which adds
to the powerful effect of the
foreshortened city wall that
divides the urban space on
the left from the countryside
on the right.

the period (FIG. 44). The nine "good and lawful merchants" of
Siena who formed the ruling council sat under the fresco of "The
Virtues of Good Government" on the north wall of this room.
Inscriptions in the rhyming vernacular addressed them directly
– to look to the left at "The City State Under Tyranny" and then
to the right where "The Good City Republic" was painted: "Turn
your eyes to behold her, you who are governing." The secure city
has a new orientation, with the striped stones of its cathedral now
placed high in the corner. In the center is the brilliantly fore-
shortened wall of Siena, showing off the skill of the painter.
No longer a hierarchical space of levels or concentric circles, Siena
has walls that divide a social space in which citizens move freely,
from those dancing before the ordered porticoes within to those
harvesting in the fields beyond. Yet this is still a rigorously con-
trolled space, in which social roles are clearly demarcated. The
organization of these fields into geometrical plots, pastures, and
meadows is an outcome of agrarian policies organized from within
the city. We are, in that sense, looking at the countryside from the
city dweller's point of view – which increasingly became the artist's
point of view also. The multiple perspective exploited by Loren-
zetti here also means that the farmers in the fields can plant and
harvest in the same season. The frame ties the whole into as
idealized and systematic a philosophical view of the world as
any cathedral facade, except that here the urban liberal arts of arith-
metic and geometry are placed beneath the city and the plane-

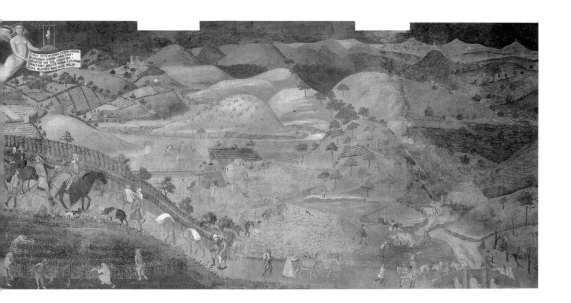

tary movements of astrology below the countryside. The vista that stretches out beyond the gates of the city has been called one of the first "landscapes" in western art. But this is a space viewed not for its aesthetic but for its economic and political value.

Across the Alps, those urban merchants who formed a new class of art patrons tended to model their tastes on the royal mania for display. This is evident in the mid-fifteenth-century house of Jacques Coeur(1395-1456), who until his political downfall was financier to the kings of France and controller of a trading empire that stretched from Scotland to Palestine. A great traceried window and a flamboyant tower are placed over the double entrance gateway, one for horses and a narrower one for pedestrians (FIGS 45 and 46). The canopy and niche above the main entrance once held an equestrian statue of the king, while Jacques's own equestrian image graced a matching portal on the inside, making him ruler within his own domain. The most startling aspects of the facade still visible today are the two fake balcony windows, from which life-size statues of a male and female servant lean out to peer down the street. The real windows are two tiny openings above them, which allow light to enter the twin oratories of their master and mistress within. Unlike the four-part tracery window that lights the chapel itself, these illusory windows do not reveal but conceal what lies behind them.

The elaborate outer facade screens off a private courtyard around which are organized, on the first floor, the major public

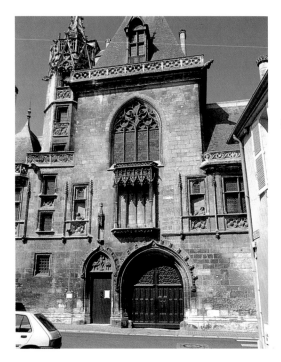

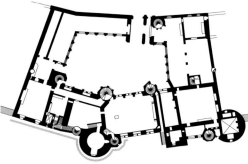

Above
45. Plan of the ground floor of the house of Jacques Coeur, Bourges, c. 1443.

Left and below
46. Street front of the house of Jacques Coeur, Bourges, c. 1443, and a detail (below) of the two carved figures of servants.

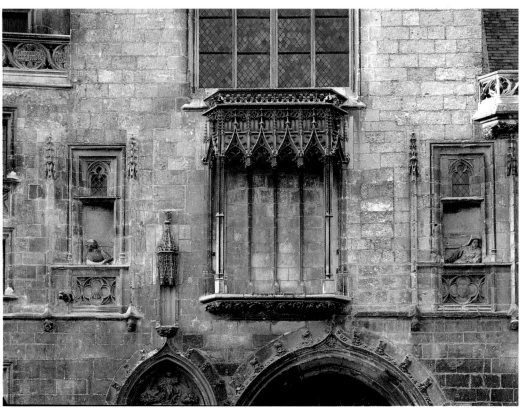

spaces of dining hall and porticoes where merchants could display their goods and, on the second, Coeur's private chapel and living space. This interplay of public and private areas is part of this fun house of mirrors, where great fireplaces are carved and painted with Jacques's cockleshell, the sign of his patron saint (St. James), alternating with a heart (*coeur*). The interior lacks grandiose halls and state rooms. It is made up of numerous smaller spaces, each with a designated function, suggestive of the transition from a public, aristocratic space to a private, domestic environment. Bedrooms lead to service corridors for the vast array of servants who fetched and carried from the lower kitchens. Whereas a castle, constructed around the communal hall, allowed little in the way of privacy to its inhabitants, this house has its secret side. This new interest in privacy is intimately suggested in a miniature, made by a Parisian illuminator in c. 1410, which shows a couple having intercourse in bed. Although their lower bodies are discreetly hidden by a curtain, two voyeurs have a more direct view as they watch them through an internal window. The bed was the only really private space in the medieval home. Elaborately canopied and decorated, it was often one of the most prized and expensive of household objects. The bed scene shown here illustrates the chapter on human reproduction in a popular encyclopedia of the period, the *Livre de la Propriétés des Choses* (FIG. 47). Allowing the viewer to take a peek within an opened-up building, it shows the same interest in the interplay of public and private space that is visible in domestic architecture of the period.

If space and objects already seem to have become private property at the house of Jacques Coeur, it is worth going back a little to the turn of the fifteenth century, to an aristocratic patron whom Jacques was probably emulating – Jean Duc de Berry, brother of King Charles V (r. 1364–80) and one of the richest men in France. By crippling his subjects with the highest taxes in France Jean amassed great wealth. He owned two residences in Paris and no fewer than seventeen castles in his duchies of Berry and Auvergne. He is often described as one of the first art connoisseurs, as if taking pleasure in beautiful things for their own sake redeems his vicious vanity, at least in the eyes of art history. His tastes were typical for his time. Inventories made at his death in 1416 show that his collection included, in addition to antique cameos, tapestries, clocks, jewelry, and illuminated books,

47. Private space. A miniature from the *Livre de la Propriétés des Choses*, c. 1410. Illumination on parchment, whole page 15¾ x 12½″ (40.2 x 32 cm). Herzog-August-Bibliothek, Wolfenbüttel.

This miniature is by someone close to the Boucicaut Master, a Parisian illuminator who introduced more complex lighting and space into manuscript illumination. The two internal spectators here are not the witnesses to divine revelation but to human reproduction.

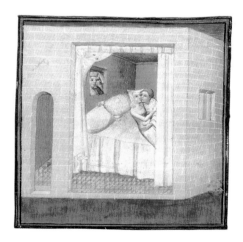

a vast collection of hunting dogs, one of Charlemagne's teeth, drops of the Virgin's milk, and the bones of a giant dug up near Lyons in 1378. Many of these curiosities were stashed at his favorite chateau, Mehun-sur-Yèvre, built near Bourges in the late fourteenth century, where he also kept live swans and bears, his personal emblems, based upon the name of one of his mistresses. By 1393 the castle had become so famous that his brother, Philip the Bold, sent his own court sculptor to study "the works in painting, figure sculpture, and carving" to be seen there.

Called by the chronicler Froissart "the most beautiful house in the world," Mehun-sur-Yèvre, like so much secular building from the Gothic period, is now ruined. Its delicate pinnacles and white towers can still be seen, however, in the Duc de Berry's most famous prayer book, *Les Très Riches Heures,* painted by the Limbourg brothers (fl. 1400–15; FIG. 48). The Limbourgs certainly presented an unusual portrait of their patron's favourite castle, since this page illustrates the riches of the world that Christ refused when he was tempted by the devil in the wilderness. Christ can be seen at the very top of the picture looking down. The viewer, the duke himself, also gazes upon his castle, with its menagerie of exotic animals. The image invites the duke to identify all the riches of the world with his own possessions, surely not, like Christ, in order to reject them, but rather to enjoy them. The Heavenly Jerusalem has finally come to earth, but in the form of an illusory Gothic object of desire – the modern "work of art" – whose representation exists mainly for the pleasure of the individual beholder.

TWO

New Visions of Time

For medieval pilgrims visiting Chartres cathedral, space and time were inextricably linked. They would have measured the church's distance from their village not in miles, but in terms of days' travel. They would have heard the liturgical divisions of the day from the bells chiming in its great towers, and they would have seen by the light on the richly cut and patterned columns, canopies, and statues of the west portal, that another day was drawing to a close (FIG. 49). On long summer evenings the statues at the west glowed in the setting sun, calling to mind not just the end of that particular day, but the end of time itself in the Last Judgment. Today, the eroded granular surface of these limestone figures seems emblematic of the effects of the passage of time upon objects; originally, when brightly painted, they embodied a more dynamic notion of temporality, one in which time measured not so much loss, as movement towards the fulfillment of salvation history. For medieval viewers time had a beginning and an ending, a purpose and a plan, which were organized by God from outside time. The modern viewer often misunderstands medieval pictorial narratives, not because the visual forms are so different, but because they were meant to be seen within a totally different temporality, an eschatological framework in which past, present, and future were often combined.

Each of the three portals, or doorways, on the west front of Chartres is tied together by figural sculpture (FIG. 50). On the splayed sides of the doorway are tall jamb figures and over these are arched tympana (the triangular spaces enclosed by classical pediments) framed by elaborately carved archivolts (the under-curves of arches and their moldings). All these elements had been present in Romanesque sculpture in different regions of France. What was

49. Chartres cathedral, west portals, c. 1150.

The effect of light on the lower columns of the jamb statues, which look back to Romanesque patterns.

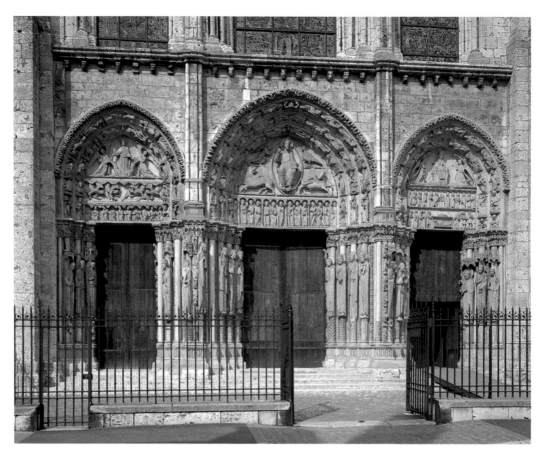

50. Chartres cathedral, west portals, c. 1150.

The complexity of the sculptural program, spanning the three doorways, means that it cannot be viewed quickly. The idea of instantaneous vision was alien to the medieval sensibility, which pored over objects in a long meditational mode.

new was their integration into a single coherent scheme. This was the work of a team of sculptors in the middle of the twelfth century. The result was so impressive in its clarity and cohesion that the portals were retained when Chartres was rebuilt, and two new transept portals added, after the fire of 1194. This conscious integration of past images into a new structure had occurred at St. Denis in the 1140s and was an important aspect of Gothic art. For just as the past was not rejected, but incorporated into the present, new Gothic forms did not obliterate those of the past, but were often added to them.

Time is presented in the Chartres portals as multilayered. Past, present, and future coexist simultaneously in the visual integration of the three doorways. This movement of time is first implied vertically as we follow the columns upward. On the jambs are Old Testament kings, queens, and prophets who prophesied Christ's coming. Their taut, stretched bodies seem to support the scenes of the New Testament above, as well as leading the way into the heavenly city. On the next level are the hundreds of smaller

figures carved in a narrative frieze that runs along the whole width of all three portals at the level of the capitals. This tells the story of the life of the Virgin and of Christ in a horizontal strip, beginning at the center, moving to the right, and then turning back to the outer left of the three portals and toward the middle again. This arrangement suggests the cyclical flow of earthly events. Above this are the three tympana, each of which represents a different aspect of God's plunge into human time.

The tympanum above the north, or left, door shows Christ and six angels above a row of human figures staring upward. It has been the subject of much controversy. Traditionally, it has been identified as Christ's ascension, the moment of his departure from the world. It has also been interpreted as the creation at the beginning of time and, most recently, as Christ-to-come, eternal but not yet visible as the son of God. These last two suggestions share the notion, which I think is correct, that this tympanum represents past time – more specifically, the period between the fall of man and Christ's incarnation to redeem him. This fits well with the signs of the months carved in the surrounding archivolts, which represent the cycle of human labor set in motion by Adam and Eve's expulsion from the Garden of Eden.

51. Chartres cathedral, tympanum above the right-hand door of the west portals, c. 1150 (detail of FIG. 50, page 72).

Christ is also the center of the tympanum above the south, or right, door, where he is placed in the lap of the Virgin Mary, who is seated at the "Throne of Wisdom" or *sedes sapientiae* (FIG. 51). In the two lintels below, Christ appears in scenes of the Presentation in the Temple and the Nativity, both focusing attention on the mystery of the Incarnation. This tympanum thus represents the present time of grace. Around it are placed the seven liberal arts, personified as women, with their ancient male exponents, such as Aristotle, placed beneath them as writers. These archivolts embody the wisdom and learning that is possible in this world (and which could be gained at the cathedral school of Chartres). Two of the signs and labors of the months at the inner left of the archivolt have often been described as misplaced blocks, but their presence underlines the continuity of the cycle of human labor into the present. For, according to Hugh of Saint-Victor, "the year is the present time between the advent of the Lord and the end of the world."

The middle tympanum shows Christ in Majesty as he will appear in the future, a future that Christians looked forward to as the Second Coming (FIG. 52). He is surrounded by the four symbolic beasts, representing the evangelists, and the twenty-four elders, as described in the Book of Revelation. His deeply carved figure has a greater serenity than earlier Romanesque majesty types, which

52. Chartres cathedral, central tympanum of the west portals, c. 1150 (detail of FIG. 50, page 72).

renders his humanity visible. This elevated and timeless image of the Redeemer is, ironically, the most accessible of all the figures in the portal, both in his human scale and in his direct gaze. The other smaller figures are distinguished, too, by the direction of their looks; those in the time before grace do not behold Christ, whereas the apostles beneath him and the angels around him all enjoy the glorious vision of the deity, as does the spectator standing below, who mimics their upturned gaze. Although for medieval people the end of the world was always nigh, one of the important new directions taken by Gothic artists was to see eternity in terms of the here and now. The three times that we are used to describing – past, present, and future – exist in the constantly unfolding present, which is the real time of the Gothic image.

Time Past

When Abbot Suger described the new work undertaken at St. Denis between 1140 and 1144, which transformed his dilapidated abbey into the first Gothic building, he hardly considered stone sculpture worth a mention. In his account it is not the statues of the west portals but the choir and its stained-glass windows which he considers "new." One of these he describes as "urging us onward from the material to the immaterial." That language is expressive of twelfth-century notions of transcendent light. But Suger is also describing a crucial temporal dynamic. In the second roundel up of the window a veil is taken off the face of Moses, with the inscription, "What Moses veils the doctrine of Christ unveils." Below this scene is another depicting the transition from the Old to the New Testament: darkness and obscurity give way to light and clarity. Christ himself covers the face of a female figure representing the Synagogue and crowns that of another representing the Church (FIG. 53). This way of thinking, called typology, was already well established in the visual arts and was not "invented" by Abbot Suger, as used to be believed. In typology history is viewed as God's plan and the Old Testament becomes an elaborate code prefiguring the events of the New. Although typology was a way of reanimating the past, and making it relevant to current ideological concerns, it was not interested in viewing events in time as a development, or a narrative. It was interested solely in archetypal references to salvation. For Gothic artists this provided a useful, if unspoken, justification for reusing older models, for copying and redeploying the same compositional patterns in different contexts. Just as the New Testament was

53. Abbey church of St. Denis, anagogical window, 1140–44.

The complex imagery of these windows was part of a scheme devised by Abbot Suger which he described as being comprehensible "only to the literate." With stained-glass windows the direction of reading is not from top to bottom, nor from left to right as one might scan a written page, but from the lowest point. Medieval narratives move upward, just as Suger describes the mind ascending to God through what he called "anagogical vision."

54. NICHOLAS OF VERDUN (c. 1140–c. 1216)
Left wing of the Klosterneuberg altar, 1181. Gilded copper and enamel, height 42¾" (108.5 cm).

The typological structure of this program plays with correspondences across time. The scenes from Christ's life that are the main focus and that run along the center – the Annunciation, Nativity, Circumcision, and Adoration of the Magi – are chronologically later than the Old Testament scenes above and below them.

the fulfillment of the Old Testament, Suger viewed his "new" Gothic church, not as a radical break with the past (our notion of novelty), but as something emerging from it.

This is the case with one of the most splendid typological schemes in medieval art, the so-called altar of Nicholas of Verdun (c. 1140-c. 1216), made for the monastery of Klosterneuberg, near Vienna. It was completed in 1181 as an ambo, a kind of pulpit from which readings of the Bible were performed, and to which its imagery made reference, but it was later enlarged and converted into a folding altar (FIG. 54). The scenes are arranged not chronologically, but according to a typological system. They are divided into three horizontal registers. The top one depicts prototypes from the Old Testament period before the law (*ante legem*). The bottom register portrays the events of the next biblical era, the period under the law (*sub lege*) from the handing down of the law by Moses to the end of the Old Testament. The fulfillment of this divine scheme is portrayed in the scenes from Christ's life which take place in the middle row, in the time of Grace (*sub gratia*). Thus the fourth vertical row on the left wing begins at the top, where Abraham gives tithes to Melchizedek. At the bottom, the Queen of Sheba brings gifts to King Solomon. What both of these events prefigure is portrayed in the central image, which shows the Adoration of the Magi.

As at St. Denis, inscriptions play a crucial role in conveying these associations. The writings of earlier theologians are thought to lie behind the whole scheme. But it is not the theological *figurae*, as these typological images were called in their day, but the physicality of the figures created by Nicholas of Verdun which make this magnificent work so powerful. Nicholas, who came out of the tradition of metalworking practiced in the Meuse valley, in what is today Belgium, combined niello (metal alloy) and enamel techniques, which enable the figures to stand out in gold against limpid pools of blue enamel. He imbues these scenes not with the feeble veracity of having happened once upon a time, but with the rich resonance of forever happening. The compositions of the three gift-giving scenes, for example, are subtly transposed, so that only the central, theologically superior Christological moment moves from left to right – forward in time, as it were – while its two prefigurations are depicted as moving to the left. The dramatic movement of human bodies seems to have been choreographed by God's divine plan. Like his enamels, Nicholas of Verdun's art looks backward as well as forward, being an amalgam of Byzantine and Romanesque influences. But he transforms these, with drapery copied from antique sculpture and powerfully

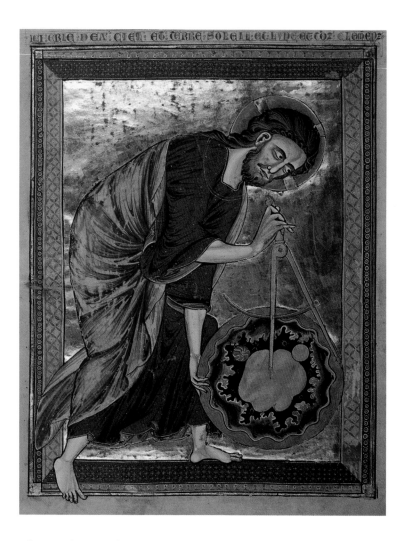

observed muscular movements, into a style that heralds what has been described as a mini-"renaissance" of classical forms, around the year 1200, transitional between the Romanesque and Gothic styles.

Abbot Suger had described his monumental typologies as being "understandable only to the literate." It is not, therefore, surprising that the most ambitious typological schemes of the thirteenth century occurred in the medium of manuscript illumination. The *Bible Moralisée* was a vast picture-Bible, produced under royal patronage in Paris, in which each biblical event was paired with one explaining its moral significance. A copy in Vienna, which is unusual in having French, not Latin, captions, opens with a superb full-page image of God the geometer, architect of all things, constructing the cosmos with his compass (FIG. 55). The

55. The first four days of Creation, from a *Bible Moralisée*, c. 1220–30. Illumination on parchment, height 13½" (34.4 cm). Österreichische Nationalbibliothek, Vienna.

God the divine geometer creates the universe on the verso page and the first four days of creation are on the recto. Here, in the format of the book, one reads the pictures in the same left to right, top to bottom way that one reads a text, except that each of the four roundels in the biblical narrative which starts on the right-hand page has beneath it an allegorical or interpretative image which often refers to contemporary religious issues and political events.

amorphous mass in his left hand, flanked by the sun and moon, represents the unformed matter, or chaos, from which, as crafts-man, he shaped the universe. Just as time was expected to end, its beginning was clearly marked by this cosmic moment. The fact that God's creative act was associated with the technology of artis-tic production is of enormous significance for artistic practice in this period. In earlier medieval scenes of the creation, the universe was depicted as coming into being through the pointing finger of God's speech-gesture, as realized through God's word ("Let there be light"). Here God has to bend his back in the hard work of world-making.

On the facing recto page, time is set in motion in the first scene, in which God creates day and night. Each narrative roundel is paired with a pictorial interpretation below it, and both are

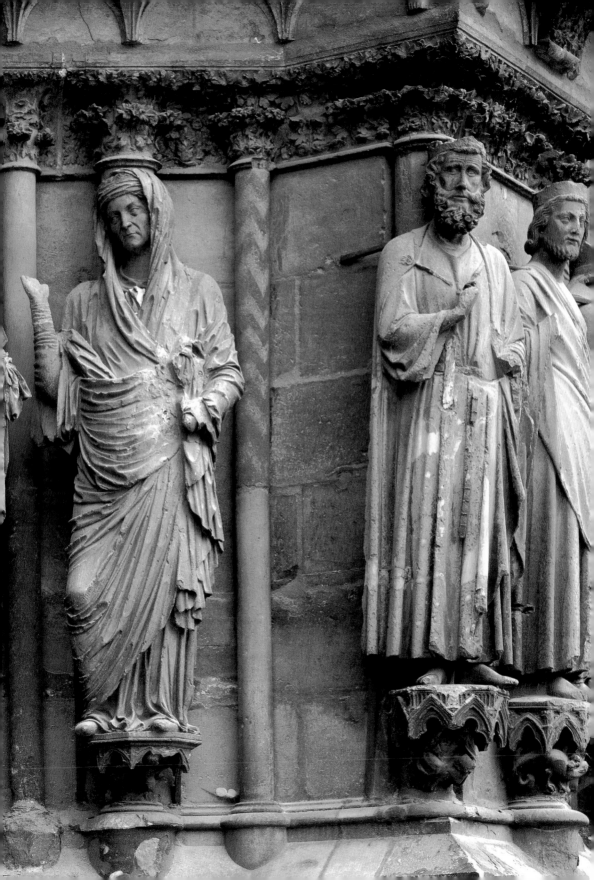

explained by adjacent captions. These texts were written after the pictures, reversing our normal expectations of Gothic art as one based upon preexistent words. The paired scenes are not strictly typological, as in the Klosterneuberg altar, but often draw more complex parallels between events. For example, in the fourth scene God creates the sun, moon, and stars. In the interpretation below, the sun signifies God's divinity, which is represented by the open book of the Holy Scriptures, and the stars signify the clergy. God's creation of the world in these scenes is consistently interpreted as his establishment of the church. The messages are often highly contemporary, being historical, political, and institutional rather than spiritual. The *Bible Moralisée* has been described as a massive pictorial campaign against heretics, especially the Jews, who are hideously caricatured on other pages. Typology, in reinventing the history of the Jews for Christian purposes, also served as a stimulus to their persecution. Here, at its beginning, the *Bible Moralisée* presents glorious visions of the church that later turn into horrific visual propaganda.

The characters represented in many Gothic images were people from the distant biblical past. Artists often depicted them, however, as though they existed in the present. This is not because image-makers were naive or made historical errors. They simply did not see a vast gulf separating themselves from the time of Christ and the saints. They were participants in biblical history, not mere observers of it. This can be seen on the west front of Rheims cathedral, where the jamb statues, instead of being isolated as the ancestors of Christ had been at Chartres, interact with one another in telling the story of Christ's life. On the right jamb of the central portal is the Annunciation to the Virgin by the angel. Next to it is the Visitation, the meeting between the Virgin and her cousin Elizabeth, the mother of St. John the Baptist, who, feeling her baby leap in her womb, was the first to announce the divinity of the child that Mary was carrying (FIG. 56). The raised arm of the older woman is a gesture of astonishment at this profound moment of recognition.

Modern scholars have been interested not so much in the story that these four statues narrate, as in the temporal sequence of their production. They exhibit three distinct stylistic phases of Gothic sculpture. The Virgin of the Annunciation is considered the earliest, carved c. 1230 by one of a team of sculptors who had previously worked at Amiens, where he had evolved a quicker method of cutting stone into smooth, static surfaces. Radically different is the work of the carver who created the two adjacent figures of the Visitation group. He shares with the metalworker, Nicholas of

Verdun, a massively crumpled classicism, but he is also a superb delineator of the aging face and body of Elizabeth, who conceived her son in her old age. The angel nearest the door, usually dated some fifteen years later, was moved from its position as an escort on the left portal to this central position. This angel has been seen as the latest and most "Gothic" figure of the group: its ethereal body and radiant smile make it quite different from the two outer figures. Clearly, the consistency we expect in a visual narrative was not so important for thirteenth-century viewers (FIG. 57). They would not have seen Elizabeth here as an "older" image (but rather an image of an older woman) nor would they have noticed the antique references in her clinging drapery. The "naturalistic" and classicizing impetus that is evident in sculpture and painting at this time is to be seen not as the rediscovery of a series of antique models but as the searching by carvers for whatever sources they could find to give their figures presence. The narrative image was not a moment frozen in time, as we think of it today; it was elongated, stretched out into an ever-present now. This was certainly true of Christ's crucifixion and the intimate interactions between angels and mothers on the Rheims facade.

St. Augustine described memory as "the present of things past" and in this respect most medieval art is an art of memory. This was considered a physical and material process. You may remember the diagram of the brain and its clearly labeled storehouse of memory (see FIG. 12) in the introduction to this book. If you cannot remember the diagram you can always turn back to it. But for medieval people, who lacked access to books, training themselves to remember important images and objects was a basic part of education. They remembered complex things using a visual system called artificial memory, which recalled objects through their systematic spatialization, association, and order. Artists' images had to be both arresting and clearly organized if they were to be stored away properly. Striking painted and sculpted narratives, like those at Rheims or the more geometrically organized narratives in stained-glass windows, were a means of imprinting sacred stories upon the minds of beholders.

For St. Thomas Aquinas one of the most important functions of images in a church was their stimulating the beholder's memory. Founders of churches were increasingly commemorated in monuments both outside and inside. The west choir of the church at Naumberg in Germany, built at the same time as the Sainte Chapelle in the 1240s, contains life-size statues of the members of the Meissen family who had been its founders and benefactors more than two centuries earlier. The intense naturalism of

Above and top
57. The heads of the figures of Elizabeth and the angel of the Annunciation from the west front of Rheims cathedral, c. 1233 and c. 1245-55 (detail of FIG. 56, page 82).

these figures attests to the artist's urge to make people from the past memorable in the present. The same may be said of another of the great "historical" images in German Gothic sculpture, the Bamberg Rider (FIG. 58). Now located on the side of a pier in Bamberg cathedral, but probably originally from the exterior, we do not know exactly who he is meant to represent. He has been identified over the years as one of the Magi, St. George, or as one of several secular figures such as the first Christian emperor, Constantine, King Stephen of Hungary, or Emperor Conrad III. The two most plausible suggestions are that he represents Emperor Henry II (r. 1014–24), who had founded the bishopric of Bamberg in 1007, or the Holy Roman Emperor Frederick II (r. 1220–50), who was also a benefactor. The Bamberg Rider's youthful, idealized countenance is, indeed, more like that of a knight in German epic literature than a contemporary military leader, but the fluidity between past and present in medieval representation makes it difficult to be sure. Rather than worry about who he is, it is more fruitful to understand what he represents – the powerful union of the Holy Roman Empire and the church. The imperial associations are not only with the classical equestrian statues of the distant past, but also with contemporary rituals like the *adventus*, which was the ceremonial entry of the ruler into the city on horseback. Whereas we think of monuments as commemorating dead people, the point of erecting such a statue was to make it a "living memory" whose imperious gaze would be constantly visible to its subjects.

The increasing use of written records in the thirteenth century and the compilation of monastic, royal, and even town chronicles, go hand in hand with this increasing interest in the capacity of images to record and preserve memory. The thirteenth-century monk of St. Albans, Matthew Paris, illustrated his chronicles with lively marginal drawings. The French kings ordered their own elaborate account of the descent of the French nation from the Trojans in the *Grandes Chroniques de France*. Recording historical events, which had been a monastic preserve for centuries, increasingly became part of court culture and professional chroniclers created idealized accounts supporting the policies and claims of their superiors. A splendid copy of the *Grandes Chroniques*, made for King Charles V (r. 1364–80) between 1370 and 1380, is such a court product. It contains a full-page picture of a state dinner that took place in 1378, when the Holy Roman Emperor, Charles IV (r. 1355–78), brought his son Wenceslaus to Paris (FIG. 59). The text before the miniature refers to it as a record, pointing out that at the feast itself "the grouping of figures and their positions were

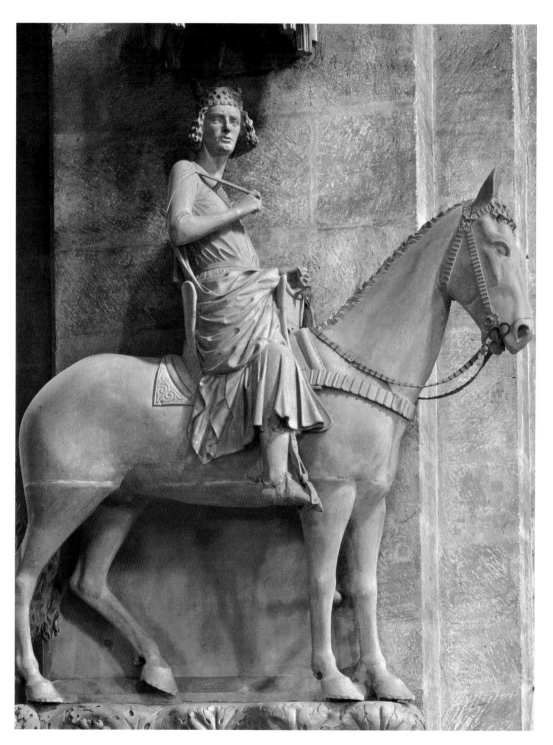

58. The "Bamberg Rider," Bamberg cathedral,
interior pier. c. 1235–40. Stone, height 7'9" (2.3 m).

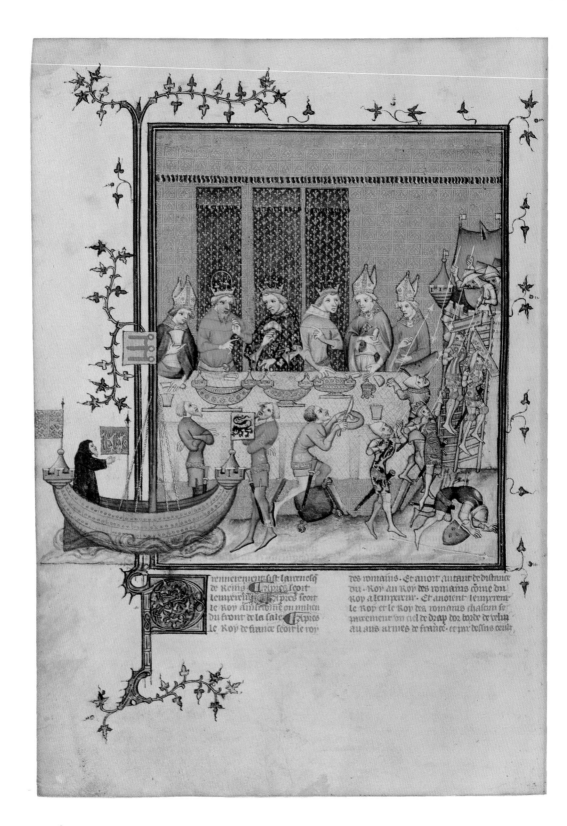

as is described below and in the miniature (*en l'ystoire*) hereafter portrayed." The word for painted picture, "ystoire," could mean history, story, or picture in the Middle Ages. What makes this picture especially interesting is not only that it records the positions and figures of the six diners, the three royal ones carefully placed against fleur de lys hangings, but that it also shows us an historical pageant that was performed on the occasion for their entertainment. This was a play about the great French crusader Geoffrey of Bouillon and his conquest of Jerusalem during the First Crusade, which had taken place nearly three hundred years earlier. Such entertainments, mounted with elaborate costumes and scenery, were a regular part of court life. Charles V hoped that this particular pageant would stimulate a new joint crusade against the Muslims. The illusion here is created for the page, not the stage. There is no attempt to re-create the scene from the viewpoint of its participants, that is, with the play happening in the distance. Rather it is pictured in the foreground, mingling with the servants who are preparing the feast before the table. Past and present, fiction and reality are interwoven, just as they are in the text of the chronicle itself.

Whereas today we separate the realms of history and literature, in the Gothic period romances were written about the exploits of the French crusaders, just as they were about King Arthur or Alexander the Great, as though they were the same kind of events. Kings and nobles sought to record the deeds of their ancestors as battling knights and crusading champions in wall paintings and tapestries because it was a way of bringing the past into the present and consolidating their own power. Historical images filled the palaces and courts of Europe with exemplars of heroism, not only from biblical and Arthurian history, but also from classical legend. Ancient historians like Livy were especially popular with King Charles, who had many Latin texts translated into French. In a miniature illustrating a poem she completed in 1403, Christine de Pisan, Charles's biographer and court poet, is depicted viewing history in the form of wall paintings that decorate the *Salle de Fortune* (FIG. 60). Christine describes how she remembers seeing within Fortune's great castle a hall painted with the deeds of heroes of the past. The illuminator has based the depiction on the way frescoes were often arranged in these domestic settings. This particular painting within a painting shows two knights fighting on horseback, complete with underlying inscriptions in two tiers along the side walls of this elegantly barrel-vaulted space. That this is the Castle of Fortune is significant. It suggests the mutability of all earthly things, coming, as they do, under fortune's sway.

59. The Emperor and King Charles V watch a spectacle of the First Crusade, from the *Grandes Chroniques de France*, c. 1380. Illumination on parchment, 13¾ x 9½" (35 x 24 cm). Bibliothèque Nationale, Paris.

The siege of Jerusalem enacted before the royal diners flows from the reader's left to the right. The boat in which the crusaders have arrived, with Peter the Hermit (whose preaching had generated much support for the Crusade) still in it, hangs from the bar-border, half out of the frame. This suggests that what has spilled over from the margins into the "real time" of the picture is in a different order of reality, being both a play and a performance of past time.

60. Christine de Pisan views history as wall-paintings, from the *Salle de Fortune*, Paris, c. 1410. Illumination on parchment, whole page 13¾ x 10″ (35 x 25.5 cm). Bayerisches Staatsbibliothek, Munich.

Sadly, most of the secular painting of Christine's time has fallen foul of fortune. Much of it was destroyed during the very wars that these images glorified. But their destruction was also due to the fact that subsequent generations tended to value the representation of the eternal truths of the church above the self-advertising secular chronicles of the local nobility. But both sacred and secular views of past time shared the conception of images as memory-places which not only remembered the deeds of the past but urged people to emulation and action in the present.

Time Future

When people looked forward in the thirteenth century they did not see a future, only an end: the Last Judgment, when Christ would come in glory to judge the living and the dead. The Gothic vision of the end of time is transformed into something quite different from its appearance in Romanesque churches like those at Autun or Conques. A new emphasis is given to the body of resurrected individuals with whom beholders could identify. "But behold," St. Paul cries in Corinthians, "I shall show you a mys-

tery...and we shall all be changed, in a moment, in the twinkling of an eye: for the trumpet shall sound and the dead shall be raised incorruptible." The tympanum of the west portal of Bourges cathedral presents the mystery on three levels (FIG. 61). On the lowest level, the resurrected, newly united with their flesh, clamber out of their graves. The more sensuous, classical poses of the figures to Christ's left, which seem more attractive to us today – resplendent nude bodies that twist and turn with the postures of antique bronzes – are sent to the cauldron of hell in the second register. Antique drapery had been a means of elevating the mother of God at Rheims cathedral (see FIG. 56); but here at Bourges classical corporeality is a sign of the fallen flesh. The blessed on Christ's right, by contrast, line up in a more orderly fashion to enter the trefoil arch of heaven, where Abraham holds souls in a cloth. Smiling like the angels at Rheims, the blessed at Bourges retain a verticality and symmetry. They also get to keep their tonsures and crowns, and thus their monastic, clerical, or royal status. Not only was the past represented as if it were happening in the present, so was the more ominous future.

61. Bourges cathedral, west front tympanum, *Last Judgment*, c. 1270.

Although space and time will be abolished at Doomsday they cannot be dispensed within images of Doomsday. In spatial terms, left and right in this image were seen as Christ's left and right as he sits in judgment in the topmost register. In the middle register, those who are on his right are the saved, while those on his left, or sinister side, are led to hell. There is a temporal sequence, too, beginning with the lowest register where the dead first rise from their graves.

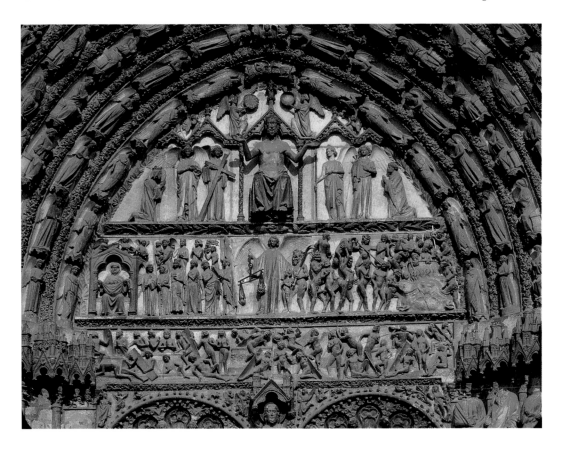

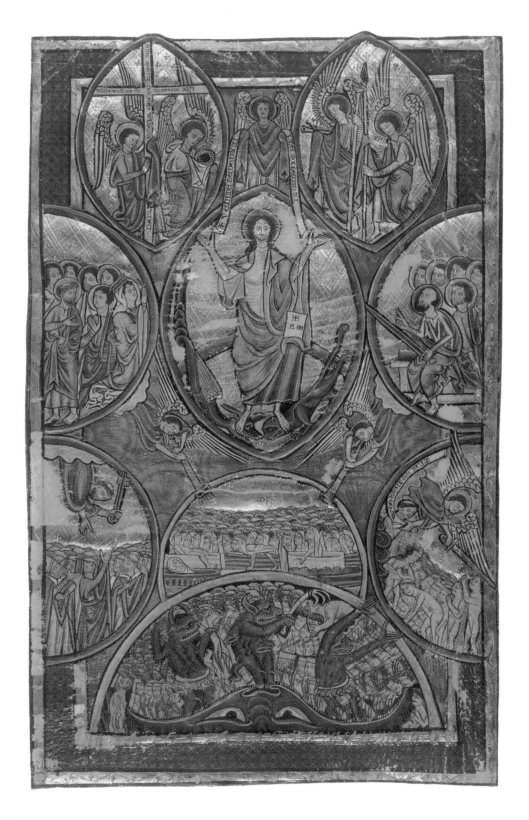

That such monumental visions of the end of time had an impact upon the individual can also be seen in an instance of artistic self-consciousness rare for this period. In a full-page image of the Last Judgment, the Oxford illuminator William de Brailes (active c. 1230–60), by making himself part of the event, constructed his own view of the end of time (FIG. 62). It has been suggested that his anxieties arose from his married status. Although he has a tonsure in the picture, William was only a clerk in minor orders and not a fully-fledged priest. Grabbed at the last moment by an angel with a sword from among those on Christ's left side, he holds out a scroll with the words "W. de Brailes made me" (*W. De Brailes me fecit*). Perhaps he hoped his role as image-maker would save him from the mouth of hell, in which hundreds of souls are being crammed.

Another place where one finds individuals facing their future in Gothic art is in tomb sculpture. Corpses were commonly buried facing east, so that they could sit up in their graves and behold their maker where he was to appear at the end of time. The Last Judgment is carved on the marble tomb of Ines de Castro, who was assassinated by order of King Alfonso IV of Portugal (r. 1325–57) in June 1355 because of her liaison with the crown prince, Don Pedro. When Pedro became king of Portugal he placed her tomb next to his own in a transept of the abbey which bears the inscription "Till the end of the World." At that moment Ines can push off the heavy lid to her sarcophagus like one of the little figures in her tomb (FIG. 63). Created by Spanish sculptors who it is believed worked from French models, the tomb is an unusually fluid and curvilinear composition compared to northern judgments. Christ sits enthroned like an earthly king with little angels holding the instruments of the Passion over a balcony behind him. On the curving road that separates salvation from damnation, the blessed are led up through a portal into a heaven that, with its domed top, looks like a contemporary Hispano-Moorish palace.

In contrast to the "casts of thousands" clambering out of their graves in visions of the Last Judgment in manuscripts and monumental sculpture, a male member of the Bardi family, painted by the fourteenth-century Italian artist Maso di Banco, kneels on his sarcophagus, quite alone on the desolate plain of the

63. *Last Judgment* on the tomb of Ines de Castro. Abbey church of Santa Maria, Alcobaça, after 1355 (detail).

The draped feet of the serene effigy that surmounts the tomb are ready to begin the uphill climb into the Heavenly City represented below them, and even the supporting monsters with human faces look up expectantly toward the light and the end of time.

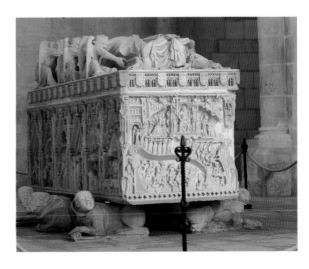

afterlife (FIG. 64). His sarcophagus is decorated with marble reliefs of the Man of Sorrows and the Bardi arms, while the image of Christ as judge, displaying his wounds and surrounded by angels, is painted in fresco on the wall above. This donor seems to get his own private Judgment. Next to it and even closer to the altar, a female member of the same family has had herself painted within a similar but smaller structure, by Taddeo Gaddi. Even more audaciously, she is a witness at Christ's entombment, looking up to where his body is laid within a tomb that surmounts her own. What look today like strange combinations of different times – fourteenth-century donors, Passion events, and future judgments – are representations of the donors' meditative or visionary expectations. A Franciscan text popular at this period called the *Meditations on the Life of Christ* encouraged people to visualize themselves as present at major events in Christ's life, to project themselves into history. These unusual images of the Judgment at the Franciscan church of Santa Croce in Florence suggest that, with the help of art, it was also possible to travel forward in time.

Time played a fundamental role in the elaborate decoration of private chapels. First, there was the new period of time, created by the church, between death and judgment. Purgatory, often imagined as lasting for hundreds of thousands of years, could be shortened through prayers, offerings, and masses sung in these chapels. Man could not control or own time because it was considered to be God's property. Hence the church condemned money-lending, or usury as it was called, because gaining profit at interest was a function of the accumulation of time. The usurer, like all sinful mortals, sought ways of giving his ill-gotten gains back to God. Much of the art and architecture of the later Middle Ages was created in order to buy back time in the hereafter. If time could not be bought, space could, and wealthy merchant and patrician families, like the Bardi, invested substantial parts of their fortune in images that would, they hoped, ensure their future salvation.

Time Present

According to the inscription around the holy face in a diagram of the Ten Ages of Man, God knows no past or future but only the omnipresent now: "I see all at once. I govern the whole by my plan" (FIG. 65). What God's gaze oversees in this diagram is the passage of a man's life from his mother's lap all the way around to the Gothic grave at the bottom of the page. So an image served the medieval art of memory. This is one of a series of diagrammatic images – teaching such things as the seven sacraments, the

64. MASO DI BANCO (attrib.) (fl. mid-fourteenth century)
Tomb with fresco of the resurrection of a member of the Bardi family; and

TADDEO GADDI (1300–66)
Tomb with the entombment of Christ, c. 1335–41. Fresco, 13′7³⁄₄″ x 7′3³⁄₄″ (4.1 x 2.2 m).
Bardi di Vernio chapel, Santa Croce, Florence.

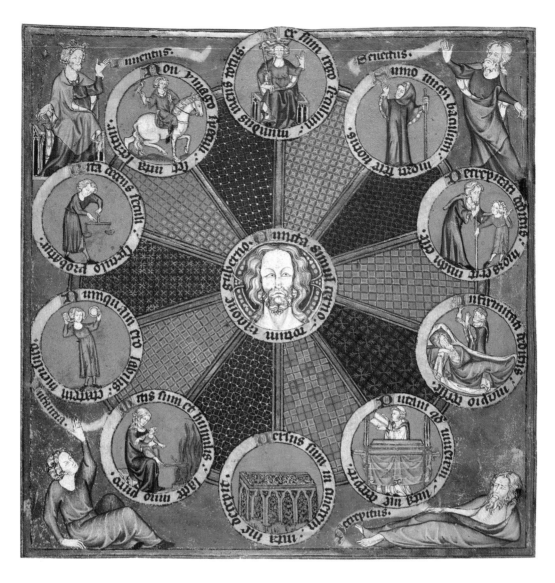

65. The Wheel of the Ten Ages of Man, with God "all-seeing" at the center, from the Psalter of Robert de Lisle, before 1339. Illumination on parchment, 13¼ x 8¾" (33.8 x 22.5 cm). British Library, London.

The circle was a major way of representing cyclical time and was applied to the year as well as to the larger span of a human life. As we move away from clock-faces to digital timekeeping today, we tend to see time moving in terms of numbers. For medieval observers time was ordered spatially rather than numerically. The king, who stands here at what we used to call "twelve o'clock," would have suggested the high-point of the day, because of the position of the sun in the sky.

66. Amiens cathedral, west front, north portal, c. 1220–30. June to November, calendar scenes with zodiac signs above them.

Here there is also a sense of circular movement, following the sun's movement through the sky from east to west. On this left, or north (cold), side of the doorway, the summer months give way to winter. The next six months, on the opposite southern side, move away from the door as spring rebirth begins again.

seven deadly sins, and the twelve articles of faith – which prefaces a psalter made for the English baron Robert de Lisle. In contrast with another popular circular image of time, the Wheel of Fortune, the spokes of this wheel are all fixed on God. The ages of man were often combined with the ages of the world, so that people at this period spoke of their world as grown old, like the figure of decrepitude lying, in the lower right, in a state of moral and social decay and awaiting the final conflagration at the end of time. Robert de Lisle, aware as he looked at this image of the circle's inexorable turn, joined the Franciscan order late in his life in the hope that wearing a religious habit might secure him salvation.

The most all-encompassing circle of present time was that of the year. At Amiens cathedral the north portal on the west front is dedicated to a local saint, St. Firmin, whose legends are carved in the tympanum. Below the tall jamb figures, along the lowest level of the socle, are depicted the so-called twelve labors of the months, accompanied by their respective zodiac signs (FIG. 66). The year begins on the inner right side with December – a peasant killing a pig – below the sign for Sagittarius. On the other side we see the warmer summer months, from June haymaking through treading the grapes in October, to winter sowing in November. Such images are often romanticized as depictions of the peasant's contributory labors toward his beloved cathedral. But in fact the labors also formed a sort of "social calendar" in which certain

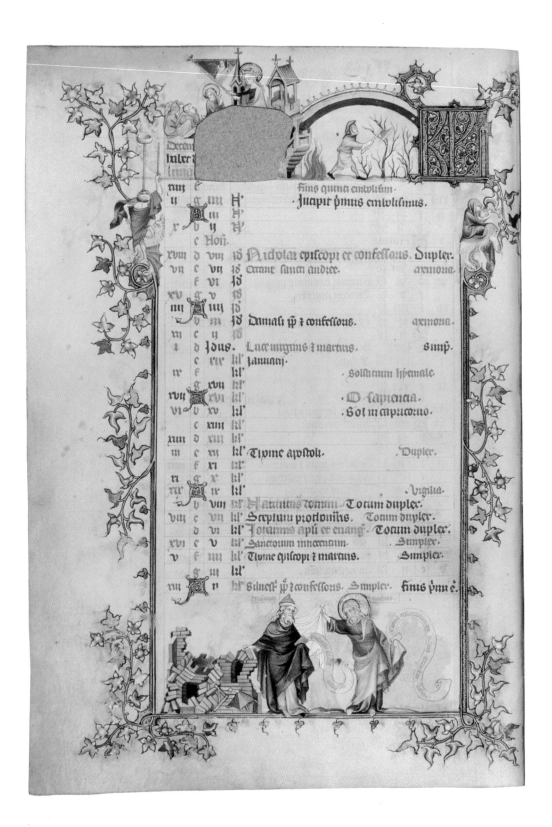

months, like May, were associated with more noble pursuits, like hunting and hawking. What proves that the sculptors and designers of these images were observing the present world around them and not just imitating inherited stereotypes is that differences in climate throughout Europe caused shifts in the arrangement of the labors. Those in Italy show the peasant already trimming the vine in March while his French equivalent is still warming himself by the fire. At Amiens the peasants would have seen themselves laboring on the well-watered fields of the Somme, crossing the socle clockwise year after year below the zodiacal signs. For we should not forget that the rise of Gothic art in Europe coincided with the rediscovery of astrology, which at the courts of kings as well as the surgeon's shop conditioned how people lived their lives in the present. The times to bleed and to marry were plotted by the turning patterns of the stars above, which were visible to the naked eye.

Another ever-moving cursus was the liturgical year, the order of saints' days, offices, and feasts that was prescribed by the church. The most complex and sophisticated reworking of the liturgical cycle occurs in the calendar of the Belleville Breviary, painted by the renowned Parisian illuminator Jean Pucelle (c. 1300–c. 1355) (FIG. 67). This complex program, worked out and written down by a Dominican theologian, is one of the few surviving instances of an iconographic scheme being recorded in a text as well as in the work itself. One of only two extant pages from the Calendar of the Breviary shows the month of December with its "red-letter days" listed below, but in addition to the figure cutting wood from the bare wintry trees at the top there are typological elements that, according to the written program, are designed to prove "the concordance of the Old Testament with the New." To this end, at the bottom of each of the twelve months a prophet hands an apostle a prophecy. So, for December, Zachariah unveils the prophecy, "I will raise up thy sons" (Zachariah 9:13), which in turn becomes an article of faith: "Resurrection of the flesh, life eternal." Each prophet also removes a stone from the Synagogue, so that by December all that remains of it is a pile of rubble. The architectural symbolism, reminding us of the spatial metaphors of the cathedrals, continues above, where the Virgin "by whom the door was opened to us" stands on top of a gate. She holds a pennant painted with an image representing an article of faith: a shrouded corpse rising from its grave. This rather arcane program was so successful that it was copied into the calendars of books belonging to the French royal family for generations, especially in Books of Hours, which, with their calendars, provided

67. JEAN PUCELLE (c. 1300–c. 1355) *December*, from the Belleville Breviary, c. 1323–26. Illumination on parchment, 9½ x 6¾" (24 x 17 cm). Bibliothèque Nationale, Paris.

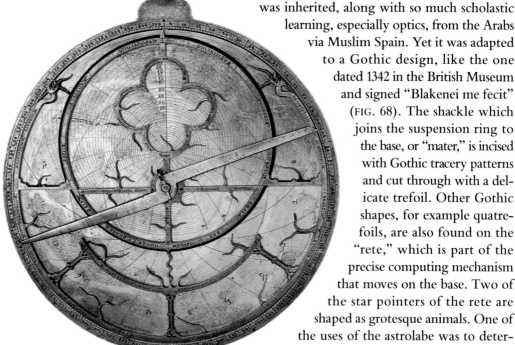

lay people with their own cycle of daily readings and prayers to be recited at various times during the day.

Time was often measured in terms of space, not only in common devices like sundials and the newly invented hourglass, but also in more complicated astronomical instruments used to calculate the position of the stars, like the astrolabe. The form of the astrolabe was inherited, along with so much scholastic learning, especially optics, from the Arabs via Muslim Spain. Yet it was adapted to a Gothic design, like the one dated 1342 in the British Museum and signed "Blakenei me fecit" (FIG. 68). The shackle which joins the suspension ring to the base, or "mater," is incised with Gothic tracery patterns and cut through with a delicate trefoil. Other Gothic shapes, for example quatrefoils, are also found on the "rete," which is part of the precise computing mechanism that moves on the base. Two of the star pointers of the rete are shaped as grotesque animals. One of the uses of the astrolabe was to determine the exact time of day or night from an observation of the altitude of the sun or one of the stars mapped on the rete. One of the most sophisticated computing instruments of the Middle Ages, the astrolabe was almost always as superbly crafted and as complex as any art object. The history of Gothic art, like Gothic architecture, should never be separated from the history of science and technology, of which it is an integral part.

68. BLAKENEI
Astrolabe, English, 1342.
Brass and other metals,
diameter 8½″ (21.8 cm).
British Museum, London.

In the 1330s, when the new light of Giotto and his followers was changing the shape of space, the invention of the escapement mechanism led to the appearance of the mechanical clock, able to strike the appropriate number of bells at the right hour and thus forever changing the perception of time. It allowed the day to be divided into equal hours. Public clocks appeared in the cities of western Europe in the course of the fourteenth and fifteenth centuries, and they transformed time. City councils, courts, schools, and workplaces all began to use the newly defined

hour to regulate work in a way that differed from the varying and unfixed canonical hours of liturgical time. The impact of this change upon the history of art still needs to be written, but it goes hand in hand with the new interest in measuring space that, both in Italy and the north, saw the rejection of the overlapping narratives of eschatological time. Just as the new clocks did away with the confusing and competing polyphony of different bells and sundials in favour of a single machine that could be used to regulate all other timepieces, so too the idea of events unfolding within a single, coherent, unified space became possible.

The clock was not simply a device to serve secular purposes. Churches soon came to house the new chiming mechanical clocks. One was built at Bourges cathedral in the 1420s by Jean Fusoris (c. 1365–1436). The new time was also appropriated by religious allegory, as in Heinrich Suso's *Clock of Wisdom*, or *Horologium Sapientiae*, a dialogue between the author and Lady Wisdom written in c. 1334 (FIG. 69). The aim of this Dominican tract was, like an alarm clock, "to waken the torpid from careless sleep to watchful virtue…hence the present little work tries to expound the Saviour's mercy as in a vision, using the metaphor of a fair clock decked with fine wheels and of a dulcet chime giving forth a sweet and heavenly sound." In a manuscript of this work illuminated in Paris in the middle of the fifteenth century, by which time the new hours had become standardized, the page and the picture move away from the Gothic layering of time. Wisdom, in her guise as Temperance, appears before the author amidst an exhibit of time-measuring devices. From left to right we see an astrolabe, a clock which chimes the hours from a bell suspended at the top of the page, another tall mechanical clock with five bells, and on a table five smaller portable timepieces, one of them spring-driven. Yet the machines depicted here are still enclosed within Gothic casements and buttresses, just as the text uses traditional theological tropes to develop an allegory about eternal values. To the left, the Dominican devotee gazes up from his book to contemplate the vision of Time and its wise ordering. Despite all its deep space and minutely delineated mechanical contraptions, this superbly structured page, like Heinrich Suso's text, is still contained within a Gothic visionary perspective.

Following pages

69. HEINRICH SUSO
(c. 1295–1366)
The Clock of Wisdom
(*Horologium Sapientiae*),
c. 1334. Illumination on parchment, whole page 14½ x 10" (37 x 25.5 cm). Bibliothèque Royale, Brussels.

Note that the astrolabe is one of the time-pieces in this exhibition of clocks, but that Lady Wisdom still holds an open book before the internal beholder. The time of the text and the turning page of the Holy Word are still fundamental and have not been superseded by the bells and clocks of measured time.

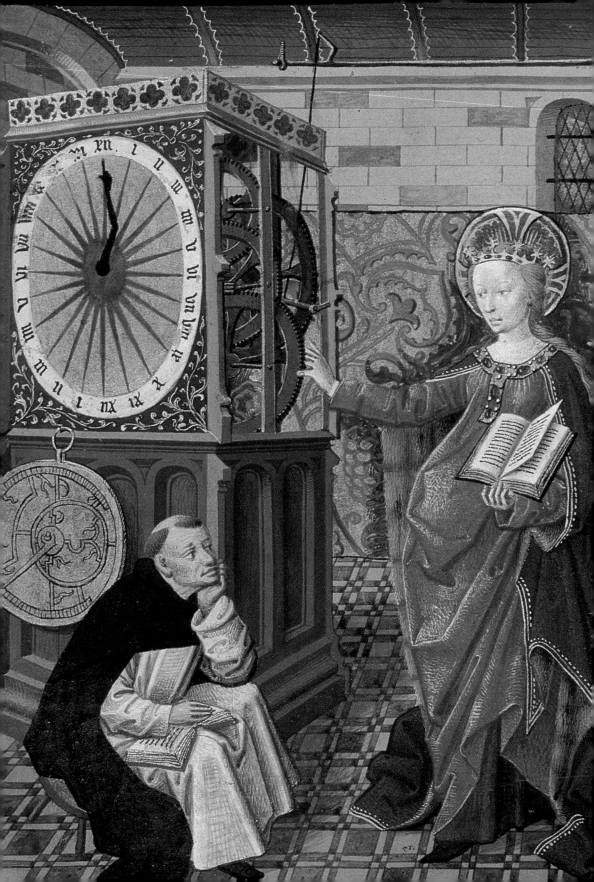

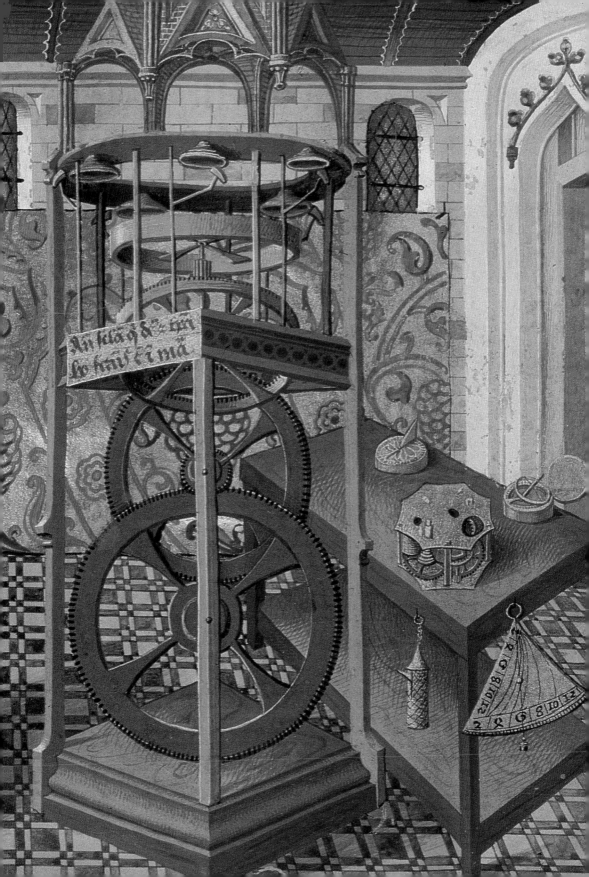

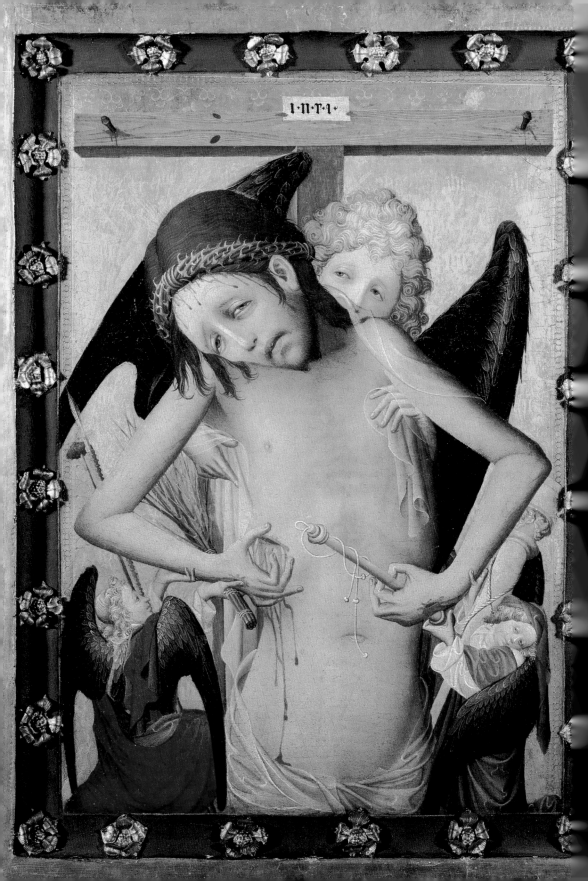

THREE

New Visions of God

N ew visions of God in Gothic art were stimulated most profoundly by his absence. Christ ascended to heaven leaving behind no bodily remains for his followers to venerate; so objects associated with his death, most especially the Cross, became the most powerful things in Christendom. According to legend St. Helen, mother of Constantine, had discovered the Cross in c. 300, but pieces of it flooded the west only after 1204, when the Crusaders, on their way to wrest Palestine from Muslim control, sacked the great eastern Christian capital of Constantinople. They brought back as booty large numbers of images, icons, and relics. One of these tiny fragments of the wood of the Cross, taken by the Latin emperor of Constantinople, Baldwin I of Flanders (r. 1204–05), was given to the abbey of Floreffe, in present-day Belgium, by his brother, Philip the Noble, Count of Naumur, and was later placed in a scintillating Gothic reliquary triptych (FIG. 71). While eastern Christianity had developed an image-centered theology, which gave the icon some of the power of its divine prototype, in the west the only objects that could be venerated as holy presences were relics. Whereas an image could make the absent present, the relic was presence itself.

Relics were believed to possess miraculous powers. The Floreffe Triptych was constructed only after the relic had dripped droplets of blood during the Office of the Invention of the True Cross on 3 May 1254. With thousands of "fake" particles of the Cross flooding the market and relic inflation rampant, it was important for the monks to have such a miracle occur in order to authenticate their own precious particle. The art that frames the relic constituted a kind of theater of devotion, staging the object in a way that would bring out its power. Relics had been the focus

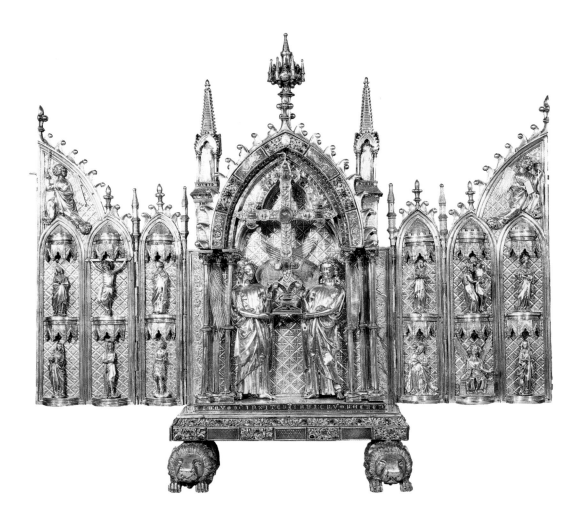

71. Reliquary of the Cross of Floreffe, after 1254. Silver and copper gilt, filigree, precious stones, and niello, open 28³/₈ x 35¹/₂″ (72 x 90 cm). Musée du Louvre, Paris.

This showcase, in the form of a miniature Gothic chapel with pinnacles and gables, opens to display a flowering golden Cross at the center, held aloft by two angels and flanked by smaller, three-dimensional scenes of Christ's Passion.

of spiritual strategies in the West for centuries, but what makes the Gothic period different is that the line between relic and the reliquary, like that between the icon and the picture, began to blur. In the Floreffe Triptych itself, the focus of veneration shifts from the thing itself to its staged simulacrum. Earlier medieval relics had attracted pilgrims, but those early pilgrims could only feel the presence of the saint hidden inside the casket, or at best glimpse part of the holy object through a stone grille. As time went by holy body parts came more and more to be displayed in transparent containers (FIG. 72), or, somewhat contrarily, were framed by so much richness that, as in the Floreffe example, they were almost obliterated.

What might be called the Gothic image-explosion of the thirteenth century, in which a repertory of new themes and images was developed, had little in common with the proliferation of pictures in the mass media of our own day. Holy images were far too

powerful to be circulated without it having first been determined for whose eyes they were made and for what specific purpose. Different kinds of images were developed for particular devotional functions by diverse social groups, such as lay confraternities (brotherhoods devoted to religious or charitable purposes), extra-religious movements such as the Beguines as well as religious orders, and cloistered monks and nuns. Nevertheless, one of the major developments of the period was that visions of God became available to ordinary people, not only within the institutional framework of the church, where cult images had always held an important place, but in the ambience of collective social experience itself.

Public Visions

Inside a cathedral, the nave was usually separated from the choir by a large stone choir screen, called a *pulpitum* or *jubé*, which excluded the lay public from the liturgy performed behind it. The screens at Chartres and Amiens were later removed, but at Naumburg a superbly carved example from the middle of the thirteenth century has remained intact (FIG. 73). Scenes from the Passion of Christ are carved in relief across the upper level; but it is the life-size figures over the projecting gabled porch that serves as the entrance to the choir that are most striking. Traditionally the three figures of the Crucifixion – Christ flanked by the mourning Mary and St. John – were placed atop the screen, but here they are brought down to the level of the worshipers. The anguished Virgin turns to the beholder as if to say "Look!", while on the other side St. John provides another point of emotional entry into the scene, drawing viewers closer to Christ. These statues do not just tell stories with their bodies, as do those on the exteriors of Gothic cathedrals like Rheims. Here, sobbing and tearful, wringing their hands in grief, they provide stations of emotional identification, faces with which one can empathize and onto which one can project feelings. Christ's sagging body, too, represents a new naturalism in the depiction of tortured flesh. It stands at the threshold between the priest's and the lay persons' space, allowing the clergy almost literally to pass through his body as they enter the sanctuary.

The cliché that the Gothic image gradually "comes to life" in the course of the thirteenth century contains an historical truth: people felt themselves to be in a more direct relationship with the living God because of the imaginative power of newly animated images. Even public depictions of Christ's crucifixion could burst into action and address the beholder, like the cross at San Damiano that spoke to St. Francis of Assisi (1182–1226). This moment

72. Left-hand crystal container and relic from the Three Towers Reliquary, 1370-90 (detail of FIG. 25, page 38). Chased and gilded silver, enamel and gems, height 36¼" (93.5 cm). Aachen Cathedral Treasury.

73. Naumburg cathedral, choir screen with the Crucifixion, c. 1245–60.

In addition to the powerful flanking statues of the Virgin and St. John, a series of superbly naturalistic narratives, in carved relief, runs along the top of the choir screen.

was later depicted as part of a frescoed narrative of the saint's life in the Upper Church at Assisi, part of the fresco cycle which some art historians still link to Giotto (FIG. 74). The crucifix (which still exists) is of the standard Romanesque/Byzantine type created in c. 1200; so this scene represents, within a Gothic image, the veneration of a Romanesque image. An older image was often more sacred than a new one. This scene also shows how different the experience of images was in Italy compared to northern Europe. Cult images in France and Germany tended to be three-dimensional altar statues or large-scale sculptures like those at Naumberg, whereas in Italy the Byzantine tradition of wall and panel painting was still the prevailing custom. Here miraculous images – the crucifixes that speak to, bleed before, and interact with Italian saints and mystics like St. Francis and later St. Catherine of Siena – tend to be not statues but two-dimensional paintings.

The image of the crucified Christ at San Damiano told the young Francis: "go and repair my house." Imitating Christ was fundamental to religious experience during the later Middle Ages and images provided the models for that mimesis. When he subsequently received the marks of Christ's crucifixion on his own body in the form of stigmata, Francis in turn provided a model for his followers. The saint has originally emphasized the vow of poverty, but within decades of the founding of the Franciscan order

74. St. Francis and the Talking Crucifix, c. 1295. Fresco, Upper Church, San Francesco, Assisi.

In Italy it was paintings, not statues, that most often came to life.

75. The Stigmatization of St. Francis, 1235–45. Barfüsser-kirche, Erfurt.

In Italian panel-paintings of this subject light flows from the hands and feet of the crucified cherubim to Francis's own extremities, to make him into a living imitator of Christ, but here the stained glass itself carries that idea of the transforming power of light.

in 1209, Franciscan churches much farther afield, like that at Erfurt in Germany, contained lavish stained-glass images, including the scene of his receiving the stigmata (FIG. 75). The Franciscans were in the forefront of using images to persuade and to transform their audiences. Francis had been the first to use the Christmas crib to "bring to life" the Nativity for pious beholders at Greccio. According to his friend and biographer Thomas of Celano he wanted to see Christ's mysteries "with his corporeal eyes." This is a radical reversal of the traditional power of the image. It no longer sought to go beyond the corporeal, but emphasized the power of ordinary sight as a means of apprehending the divine.

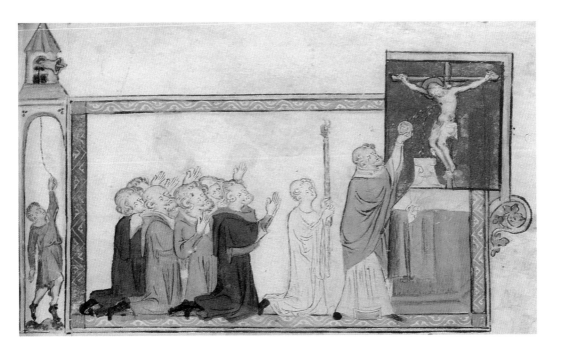

Most people came closest to God during the mass when, re-creating his death, his body was present in the consecrated host. This was not thought of as an image, but as something akin to a relic, something that possessed real power. After the introduction of the Feast of Corpus Christi in 1264, the veneration of the host increased. In an illustrated "how-to-do-it" guide to the mass, produced especially for lay people in England in the fourteenth century, pictures guide viewers through the various moments in the liturgy, and the text tells them what to do and what to think about at each moment in the service (FIG. 76). The climax of the mass in this book, as it was for most people during the period, was the elevation of the host, which came in the middle of the rite. The elevation of the circular wafer takes place after the words of the consecration and, as shown on the left, the ringing of the bell by an acolyte. As well as synchronizing these temporal events, the painter of this picture has depicted the spiritual significance of the moment by painting another image within the image, but going beyond the frame and setting it against a rich colored ground. This represents the transition to a higher mode of vision as the faithful perceive the body of the crucified Christ in the elevated host.

The mass was a multisensory experience involving the sight of the ritual and its rich objects and costumes, the sound of bells, the smell of incense, and the touch and taste of Christ's body.

76. The Elevation of the Host, from a layfolk's massbook, c. 1320. Illumination on parchment, 8 x 5" (20.5 x 13 cm). Bibliothèque Nationale, Paris.

The priest officiating at mass no longer faced the congregation as he used to, but turned his back to them to face the altar. This liturgical change is thought to have had an impact on the development of altarpieces and retables, which gave the priest and the congregation something to focus upon. In this miniature, however, the Crucifix represents what they should be thinking of at this moment, rather than a material image.

77. St. Thomas puts his fingers into Christ's wound. The Syon Cope, c. 1300 (detail). Embroidery, height of whole piece 4'9³/₄" (1.47 m). Victoria and Albert Museum, London.

Medieval textiles have not survived in large numbers, but churches were filled with the glistening threads of silks and gold that adorned the fronts of altars and changed with the flickering candlelight or, as in this liturgical vestment, moved along with the shifting bodies of those who wore them.

The urge to feel is strikingly realized in the scene of Doubting Thomas, whose fingers Christ thrusts into his own body, represented on a cope (FIG. 77). Today we see this as a beautiful example of *opus anglicanum*, the embroidery for which English women were famous throughout Europe, spread flat out in half-circular form in the museum. But this particular scene, at the top right, would have been visible flat on the left chest of the cope's wearer, joined to its pendant on the other side. This shows another scene of Christ's post-mortem appearance, in which Christ stands before Mary Magdalene and says "Do not touch me." If this was made for a female monastic community, as is suggested by its later ownership, the nuns would have seen a gender-distinction displayed across the body of their officiating priest. On one side, a woman follower of Christ cannot touch, but only see; on the other, a male follower has a far more intimate relation with God. Moreover, during the mass, when the celebrant's back was turned away from the congregation toward the altar, these two visions were invisible.

This increasing distancing of the celebration of the mass from the congregation meant that people sought other, more intimate, modes of devotional experience. Semi-public spaces and communal institutions were set up for the display of new image-types. In 1285 the Brotherhood of the Virgin, the Laudesi of the Dominican church of Santa Maria Novella in Florence, commissioned the Sienese painter Duccio di Buonisegna (active 1278–1319) to paint what the contract stipulated should be "a large panel...as beautifully as possible" and to "adorn it with the figure of the Blessed Virgin Mary, her almighty son, and others at the will and pleasure" of the patrons. He had to gild the panel at his own expense and "guarantee the beauty of the whole as of the details" (FIG. 78). This rare survival of a contract shows the confraternity seeking to establish a cult site, and Duccio's animation of the standard pictorial icon of the Virgin was so successful that it remained venerated in the chapel and lit with lamps for generations. For this is not an altarpiece, having nothing to do with the liturgy and no folding wings. Rather it is meant to be the focus of community devotion as a living presence in its midst. Like most of the new devotional image types, this was not a narrative image based upon an event in the Gospels, but one invented to dramatize a theological idea, Christ's humanity.

78. Duccio di Buoninsegna (active 1278–1319)
Rucellai Madonna, 1285. Tempera on panel,
14′7″ x 9′6″ (4.5 x 2.9 m). Uffizi, Florence.

In Italy the Virgin often appears as a magnificent painted portrait, a person who, although enthroned in heaven, also gazed directly upon the hopeful devotee from her two-dimensional golden world; in northern Europe she was more often an elegant courtly lady, swaying in stone and ivory with the Christ-child balanced on her hip. This sculptural version of the Marian image, the so-called "beautiful madonnas" of Germany and the golden and ivory

statuettes of Paris, presents a very different type of public image for veneration. This is how she appears to Philip the Bold and his wife Margaret of Flanders in the central trumeau, flanked by their life-size figures placed on boldly projecting corbels carved by the Netherlandish sculptor Claus Sluter (d. 1406), on the portal to the duke's chapel at the Carthusian monastery of Champmol, near Dijon (FIG. 79). Here the overhanging canopies and even

the platforms on which the donors stand seem props in a play, unrelated to the action of the figures beneath them, who break out of a columnar architectonic structure of the kind that had contained sculptural portal figures since the middle of the twelfth century. Even the Christ-child, a pudgy baby rather than the majestic doll of Duccio's panel, looks up to where (originally) angels carried instruments of his Passion. The two donors kneel as if at court, presented by the patron saints of the Burgundian dynasty, St. John the Baptist and St. Catherine. Sculpture, sharing the beholder's space as it does, and in its rich surface detail providing a tangible graspable reality, was still the most effective way of incorporating the beholder into the represented action. If this, like all Sluter's sculptural happenings, seems powerful and real to us, imagine its effect on the royal pair represented within it, as they passed through this portal to services in their private chapel.

Private Visions

Another transformation in image-culture during the Gothic period was the rise of the privately owned image, like the one being sold to a monk from a shop display in the miracle of "Our Lady of Sardanay" in the *Cántigas de Santa María* (FIG. 80). This vast compendium of 1,800 illustrations of Marian miracles, compiled for King Alfonso X of Castile and Leon (r. 1252–84), includes many involving miraculous public statues of the Virgin that come to the rescue of those in need. But this story is unusual in being about the desire of a woman to possess her own picture of the Virgin and Child. In the first scene an anchoress, living a strictly isolated and cloistered life in Damascus, asks a monk on his way to Jerusalem to bring her back a painting of the Virgin. After visiting the Holy Sepulchre he purchases an icon, in the third scene, from a shop selling both Marian icons and images of the Crucifixion. But, discovering that the painting could protect him from wild animals and robbers, in the fourth scene, he decides to keep it for his own order. He travels home by sea to avoid going through Damascus, but a storm forces him to turn back. He realizes that the Virgin herself is insisting that he carry her picture to its rightful owner, which he does in the final scene. Three aspects of this rich pictorial narrative are significant. First, the image comes from the Holy Land itself and the owner was a nun, a member of a group who, as we shall see, were especially important in developing new kinds of relationships with images. Second, unlike many instances in this manuscript, the image of the Virgin is not depicted as coming to life and moving out of its frame. It is powerful enough

Opposite

80. Miracles involving buying a panel painting of the Virgin, from the *Cántigas de Santa María*, c. 1280. Illumination on parchment, whole page 13 x 9" (33.4 x 23 cm). Escorial, Madrid.

Following pages

81. Diptych with Virgin and Child facing the Man of Sorrows, c. 1350. Tempera on panel. Karlsruhe, Kunsthalle.

The type of Virgin and Child here, though it looks fresh and spontaneous, was based on the *Glychophilousa* Byzantine type, in which the child touches his mother's chin, which suggests that both the Marian image as well as the Man of Sorrows facing it are based ultimately on an imported prototype.

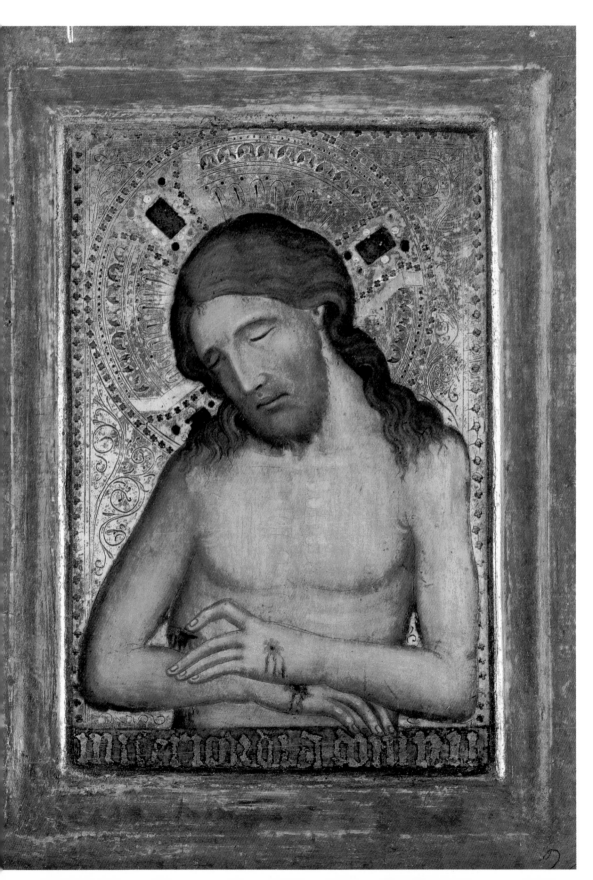

just as a picture. Third, like so many miraculous images, the panel in the final scene is placed on an altar and eventually becomes a public focus of veneration.

The type of small portable image that the nun asked for can be seen in one half of a diptych, produced not in the East, but in Bohemia during the later fourteenth century (FIG. 81). By this time it was common for a half-length Virgin and Child to be paired with another imported image-type, the Man of Sorrows. This represented Christ as dead, his eyes closed and arms crossed. The pose was made popular by a particular miracle-working icon in Rome. In its new combination, however, this image gained fresh power. The contrast between the Man of Sorrows and the sweet playfulness of the Child opposite is accentuated by the Virgin, whose sad stare seems to behold the future suffering of her son. She is a model for the *contemplatio*, or contemplation, that took place before the image, and the *compassio*, or compassion, that allowed the viewer to identify, through her, with Christ himself.

This need to enter into, not just behold, the events at Christ's Passion can be seen in many images used for devotional purposes. Especially important was the direct apprehension of the objects associated with Christ's bodily suffering. The instruments of his Passion had already been depicted as carried by angels in the public sculptures of cathedrals; and objects like the crown of thorns and the reed of the flagellation were visibly displayed in relics. These symbols of Christ's triumph over death later became objects of horrific fascination. Increasingly people sought to possess and contain their own tiny versions of these things, as in a devotional booklet made of ivory and painted with these signs of the Passion, known as the arms of Christ, or *arma Christi*, as though Christ had his own gruesome heraldry (FIG. 82). Like so many of the new image types this object was made and used in the Rhineland, where this new spirituality was fostered. As well as the crown of thorns, vinegar bucket, and the strangely floating wound, signs of certain charged actions

82. Devotional booklet showing the "arma Christi" (crown of thorns, spitting Jew, vinegar sop, and wound) c. 1330–50. Painted ivory, 4 x 2⅓" (10.5 x 6 cm). Victoria and Albert Museum, London.

appear, like the isolated hand that struck Christ. At the bottom he also faces one of his tormentors, a hideously caricatured Jew. Such fragmentation of the narrative, focusing upon close-ups and cutting out isolated objects, is almost cinematic in its effort to engage the person who holds these images in their hands, evoking in their memories the violence of the whole from its fragmented pieces. This increasing intimacy between people and images is probably linked to the growing value of commodities in the culture more generally, so that even bodily adornments like jewelry not only represented Christ's Passion with conventional types like the Man of Sorrows, but could also contain actual relics (FIG. 83).

A Man of Sorrows painted by Meister Francke (fl. early fifteenth century), an artist from Guelders who spent most of his life as a Dominican monk in Hamburg, is one of the most powerful instances of an image made for the purposes of empathy (see FIG. 70, page 103). This painting almost eliminates vision, since there is hardly any space across which it can take place. Touch seems to have taken over. Two small flanking angels gingerly hold up, in delicate little fingers, both their Lord's emaciated body and instruments of the Passion, which have been reduced to the size of playthings. Christ himself is like a limp stuffed toy, dangled before us by the black-winged angel, whose red-rimmed eyes remind us that for contemporary worshipers crying was yet another intensely ocular experience. Tears were meant to be shed before images like this, blurring their already fluid outlines even further. With one hand Christ fingers the wound in his side; with the other he holds a flimsy whip. With its two knotted strings, this tiny instrument is reminiscent of those little scourges that nuns gave each other as gifts for the purposes of self-mortification. Christ's sunken eyes look directly at the spectator, invitingly. Two tiny teeth in the downturned mouth evoke the mastication of his flesh in the mass. One can see why recent research has emphasized the erotic aspect of such encounters between beholder and image.

Looking at such a private image, however, was not only a means of emotional fulfillment. It could bring actual rewards in

83. Triptych reliquary pendant with Man of Sorrows, c. 1400. Gold, enamel, rock-crystal, and pearl, 1⁷/₈ x 2¹/₈" (4.8 x 5.3 cm). Schatzkammer der Residenz, Munich.

This minute triptych has wings of transparent rock crystal that can be opened and closed, emphasizing not so much the precious relic itself, as the images which had grown up around it.

84. Mass of St. Gregory, c. 1460. Hand-colored woodcut, 9⅞ x 7⅛" (25.2 x 18.1 cm). Germanisches Nationalmuseum, Nuremberg.

The rise of prints made from wood or metal blocks had enormous repercussions on the circulation of holy images. Instead of reducing the efficacy of cult images, as we might think, reproductions allowed duplicates to be made that carried some of the potency of the original. The Mass of St. Gregory, the Veronica Head of Christ, and St. Christopher were among the often-reproduced images that carried lucrative indulgences.

heaven. The trade in indulgences, the purchase of which could grant a devotee time off from purgatory, were linked to certain images. This is the case with a legend that became popular during the fifteenth century, the mass of St. Gregory (FIG. 84). This was supposed to record an actual vision experienced by Pope Gregory the Great (c. 540–604), who, during the elevation of the host, saw Christ as the Man of Sorrows surrounded by the instruments of his Passion. It is an image based on other images rather than upon texts and it is thought to have been promoted by the Carthusians, whose church in Rome contained an icon they believed had been commissioned by Gregory to commemorate the event. But a major reason for its popularity in all media is that it brought with it a Papal Indulgence clearly printed in the Netherlandish woodcut version, of 14,000 years to "anyone who sees and reflects on our Lord's weapons (the weapons by which he suffered and with which he was lamentably tortured by the ignorant Jews) and then kneeling says three Our Fathers and three Hail Marys." The arrival of printing in the mid-fifteenth century made it possible for far more individuals to own sacred pictures like this woodcut, which they could tack onto a wall or carry about with them as private "souvenirs" of God's presence and promises of their own future salvation.

Mystical Visions

Any image could become the focus for a mystical experience. In a tract written for a French nun in c. 1300, the three stages to a mystical way of vision are clearly represented within an elaborate Gothic framework (FIG. 85). In the first scene the Dominican nun, who is the silent addressee and witness in all these scenes, is told by her confessor to seek forgiveness for her sins. The second scene shows her kneeling before an actual image – an altar sculpture representing the Coronation of the Virgin. This moment of corporeal seeing occurs in the only scene in which language does not appear in the form of an inscribed scroll. The sun and

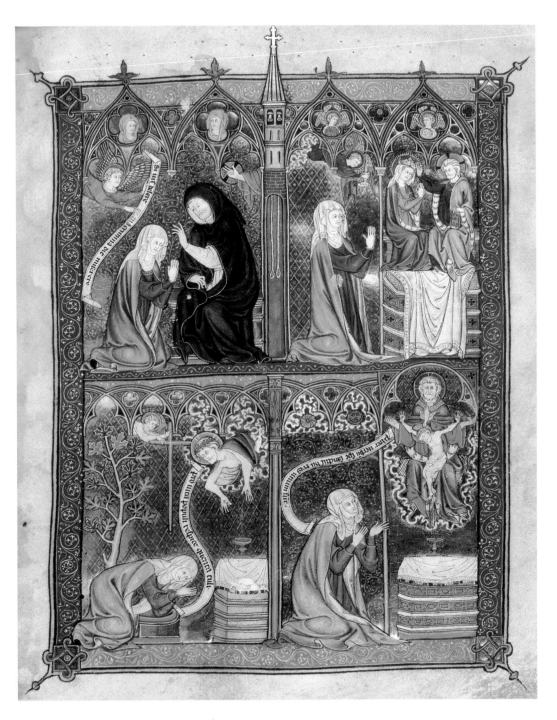

85. A nun experiences the three stages of
mystical experience, c. 1310. Illumination on
parchment , 10½ x 7¼" (26.6 x 18.4 cm).
British Library, London.

86. High altar retable, Cistercian monastery, Marienstatt, c. 1350. Gilded and painted wood.

Mystical visions could be stimulated, not only in private, but often by public images like this one, whose complex, half-glimpsed interiors and opening sections invited beholders to an ever-changing display.

moon held in the arches above signal that this is looking in time, whereas the higher modes of vision that follow take place outside time. In the third scene, below, the same nun prostrates herself before a vision in which Christ appears before her as a Man of Sorrows, dripping his blood directly into a chalice on the altar and saying, "Behold what I took on myself to save the people." Here the nun is not looking directly at Christ, since this scene represents the intermediate stage of contemplation. Only in the final scene does she look up to see God in a vision of the Trinity – in a configuration known as the "Throne of Mercy," in which the crucified Christ is held by God the Father and the spirit flies between them. The nun's hands are raised in a gesture of wonder, but what signals the higher status of this vision is the cloudburst around the

Trinity. What is remarkable about these visions, from the sculpted image of the Coronation, through the imagined contemplation of the Man of Sorrows to the mystical vision of the Trinity, is that all three are standard image-types in current art. Most mystics of the Middle Ages, in fact, saw visions in conventional terms.

A Coronation of the Virgin like that on the altar in this miniature also appears as the central element of the carved winged altarpiece which was made for the high altar of the Cistercian monastery of Marienstatt (FIG. 86). This structure, with its tiers of statues along the top and relic-holding busts of the holy virgins of Cologne at the bottom, represents another version of the heavenly Jerusalem. The iron grilles across the front and bottom also housed relics. The wings were probably kept closed most of the year, opening only

87. A nun kneels before the Crucifixion, from a panel painting of scenes from the life of the Virgin Mary, c. 1330. Tempera on panel, 25½ x 37″ (65 x 96 cm). Wallraf-Richartz-Museum, Cologne.

The focus on the Virgin in these narratives, used by the nun depicted here in the privacy of her own cell, would have been a means of identification with Christ through his mother.

for relic display on Sundays and major feast days. It is this ever-changing repertoire which made the experience of such altarpieces quite different from their display in the modern museum, where everything is made visible and thus transformation impossible. The church had to control the reception of relics and the altarpiece at Marienstatt was a way of staging their reception through partly displaying and partly hiding things.

Private images made Christ's passion much more accessible. A small panel from Cologne has spaces for relics above the central panel and between the narrative scenes on the wings in which everything is made visible (FIG. 87). The figure of the nun at the foot of the Cross looks up to her Saviour. She can see him directly, whereas opposite her Longinus points to his blinded eyes as his spear pierces Christ's side. Blindness was associated with sin and ignorance in this period just as clarity of vision was associated with truth and beauty. The nun donor is represented as much smaller than the holy figures to show that she is present only spiritually, not physically. A nun might also have had books in her cell, certainly a psalter or a Book of Hours, whose images repeated the same themes found in private panels and public altarpieces. Nuns were probably among those members of society with the

most sophisticated visual skills of comparison and juxtaposition, precisely because every aspect of their lives, from attending mass, private devotions, and prayer, was lived in the constant presence of images. These were stimuli to actions like self-flagellation and other forms of self-mortification, in which these women sought to make their own bodies sites for the performance of Christ's Passion.

Many nuns came from aristocratic families where they would have had access to powerful images of sexual rather than spiritual love. An embroidery given by the Malterer family to the cloister of St. Catherine's at Adelhausen when their daughter Anna became a nun there c. 1310–20 contains eight panels. A few of these show scenes that could be interpreted as symbolic of spiritual love, like the unicorn trapped by the Virgin, but others, like the narrative of the scholar Aristotle being enamoured of Phyllis to the extent that he lets her ride him like an animal, is an unusual one indeed for a monastic setting (FIG. 88). But of course such images could be read as warnings against the actions they portray. While clearly pointing to secular eroticism the motif visible in the first scene, of the old scholar putting his hand through the window to touch the object of his desire, is in fact based upon a biblical prototype in the Song of Songs where the beloved "put his hand by the hole in the door." Once again we are faced with a work of art which cannot be fixed in a specifically sacred or a secular context, but which moves evocatively between the two.

It is also important to realize that vision had its boundaries. Although nuns were at the cutting-edge of visual spirituality, orthodox limits were imposed upon the types of devotion and images used. In a psalter made earlier in the thirteenth century for an English nun, devotion to Christ crucified in the Throne of Mercy was

88. Aristotle and Phyllis, c. 1310–20. Wool embroidery, whole piece 26¹/₂" x 16' (68 cm x 4.9 m). Augustinermuseum, Freiburg.

carefully censored so as to keep God's face unseen by the two kneeling nuns and the beholder (FIG. 89). This would seem to reflect the theological teachings of those who stressed the scriptural dictum from St. John's Gospel that "no man has seen God at any time." A century later, when questions of seeing God's face became a matter of theological controversy, such qualms were laid aside. The issue focused on whether the blessed dead were able to see God "face to face" *before* the general resurrection and the Last Judgment. Pope Benedict XII (r. 1334–42) issued a papal bull in 1336 to the effect that even before souls had been reunited with their bodies, they "have seen and see the divine essence by intuitive vision, and even face to face." An English artist illustrated a copy of the papal decree about 30 years later, in an image which emphasized the hierarchy of vision and the invisibility of God (FIG. 90). On the bottom level a lay man and woman kneel on either side of the earthly spheres, representing the Christian faithful who believe even though they cannot see. A few rays of divinity are visible here, but they are not connected to those emanating from the higher spiritual levels above. Above are two saints, mediators between the earthly and the heavenly, St. Benedict and St. Paul, who experience "the light of God" themselves. In the topmost register the immense disembodied head of the Deity represents the direct "face to face" vision. As so often, the Gothic

89. The unseen Godhead presents the Throne of Mercy Crucifix to kneeling nuns, from a psalter, c. 1220. Illumination on parchment, whole page 11¼ x 7¾" (28.5 x 20 cm). Trinity College, Cambridge.

The Jews, identified by their pointed hats, can see Christ, but their subjugated position under the altar and almost outside the letter distinguishes their gaze as heretical compared to that of the nuns above. Sometimes depicted as blind, the Jews were thought by Christians to be unable to "see," which is why Synagogue is often personified as a blindfolded figure.

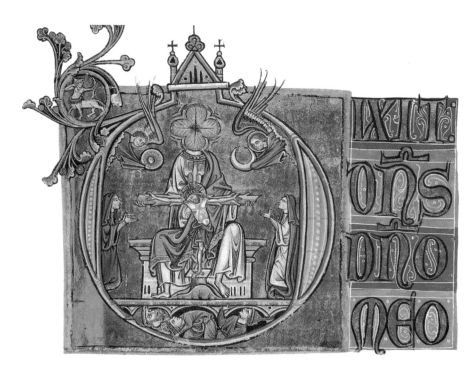

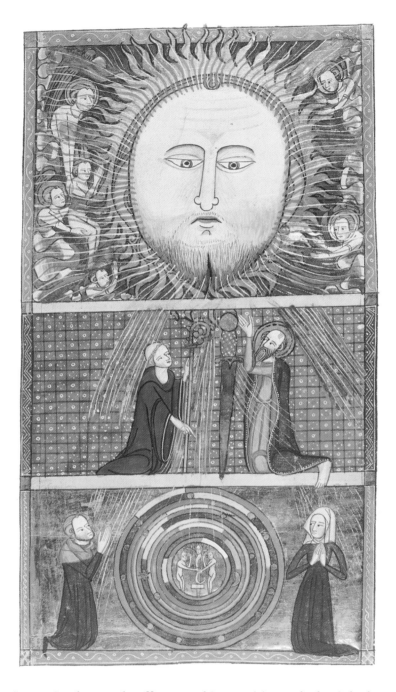

90. The Beatific Vision, the Vision of St. Benedict and St. Paul, and the vision of a layman and woman, from the *Omne Bonum*, 1360–75. Illumination on parchment, whole page 18 x 12¼″ (46 x 31.2 cm). British Library, London.

image simultaneously offers something to vision and takes it back, presenting a picture of a promised vision that the viewer will eventually see only after death.

For St. Bridget of Sweden (1300-73) the visionary experience was powerful precisely because it lay outside the official dogma

of the church. Mystics saw themselves as religious radicals, projecting themselves directly into salvation history, but it is also worth noting that the church often sanctioned their excesses as a model to the faithful. During a pilgrimage to Bethlehem in 1372 St. Bridget experienced a vision of Christ's birth at the cave of the Nativity. According to her description, "in the twinkling of an eye" the Virgin gave birth to the Christ-child, who emitted "an unspeakable light," elements visible in a small panel made four decades after the event (FIG. 91). For a Brigettine nun or anyone who looked at this painting, which was originally part of an altar and probably not used in private devotion, the saint, who is only slightly smaller than the kneeling Virgin, provided a mediating gaze within the scene. Unlike the nun in the earlier Cologne panel (see FIG. 87), the donor is no longer a tiny addition to the sacred event, but a life-size witness to it. The mystical image is here made public. Moreover, the viewer could, with the aid of St. Bridget's writings, imagine herself transported to the cave in Bethlehem, looking through St. Bridget's eyes at the Christ-child. New modes of subjectivity and notions of personal identity developed in the arena of spirituality, not only in images and manuscripts meditated upon in private, but also in altarpieces and statues visible to all.

91. Nativity with St. Bridget of Sweden, c. 1415. Tempera on panel, 35³/₈ x 23³/₄" (90 x 60.4 cm). Rosgarten, Konstanz.

This wing of an altarpiece shows St. Bridget as a participant in the vision she experienced at the site of the Nativity in Bethlehem. The three rays that break through the roof of the stable to illuminate both the Christ-child and the Virgin come from God's mouth and represent the Word. The candle held by Joseph represents the mundane light of the world as opposed to the divine, new-born light source.

Women's spirituality – both in nunneries and among pious groups of lay women – focused upon Christ as the object of his mother's gaze, first as a child in the Nativity and second as a corpse in the Pietà. An example of the latter subject, which was to become the most popular of the newly invented Gothic image types, from the Seeon Monastery near Salzburg is superbly structured so as to emphasize the Virgin's gaze as she tries to balance her big, awkward baby's corpse on her knees (FIG. 92). The two separate ideas, maternal love and death, that had been juxtaposed in earlier private panel paintings (see FIG. 81) are combined in the Pietà to form a three-dimensional cult-image that could be placed on the altar. The sense of heavy weight combined with the materiality of textures and liquid tears visible in the image made the

sense of touch all-pervasive in the Pietà. This is where our modern categories of public and private break down, since so many openly displayed images in churches became the focus of intensely individual devotions and private mysticism. Moreover, these were not just sites for female spirituality. Men, too, identified through Mary, with this brilliantly realized combination of visible maternal love and tactile pain.

The psychological power of such images is one of the most exciting areas of recent research in Gothic art, stimulated by our own image-saturated culture, the seductive strategies of advertising, and a nostalgia for a time when images could be so meaningful in people's lives. But it would be wrong to talk about the Gothic religious image as though the culture were homogeneous. A wider world of faiths existed alongside and often in subjection to the Catholic one. This can be seen by comparing two manuscripts, both of which focus upon women as devotional subjects and both of which were made for private lay use. The first shows the centrality of images within Christianity. It has an image within the picture, an

92. Pietà from the Seeon Monastery near Salzburg, c. 1400. Painted limestone, height 29½" (75 cm). Bayerisches Nationalmuseum, Munich.

93. The image at the center of the Christian world, from the *Hedwig Codex*, 1353. Illumination on parchment, 14 x 9³/₄″ (34.1 x 24.8 cm). J. Paul Getty Museum, Malibu.

The focus of this large framed image is another image. St. Hedwig stands clutching her beloved attribute, a small statue of the Virgin and Child. The owners of this manuscript, Duke Ludwig of Leignitz and his wife Agnes, gaze up at her from under two little canopies.

ivory statue of the Virgin and Child clutched by St. Hedwig of Silesia, founder of the Cistercian convent at Trebnitz, who had died in 1243 and whose life is related in words and pictures in a manuscript illuminated in the year 1353 (FIG. 93). Her beloved little image, which could not be prized from her hands at her death, was buried with her. In this full-page picture Hedwig is portrayed standing within a canopy, grasping her statuette and herself venerated as an image by two kneeling donors, Duke Ludwig I and his wife Agnes, for whom the manuscript was made.

Another German illuminated manuscript, framed within Gothic arches, shows women playing a crucial role in spiritual life. But this page is from a Haggadah, the book used in the Jewish ritual meal, or *seder*, celebrating the Passover (FIG. 94). Like the synagogue in Prague, which was built in a purely Gothic style in c. 1290, such works are evidence that the Gothic style was not exclusively Christian. Of course, Gothic art was virulently anti-Semitic, but it is often forgotten that Jews, despite their antipathy to religious representations, nonetheless left behind a rich artistic legacy from this period in both Spain and Germany. This particular Haggadah has none of the biblical illustrations often found in these manuscripts. Instead the images and texts relate to the book's function in the Ashkenazi rite. Things would appear backwards here to any Christian, for one starts the ritual readings for the *seder* meal at the "back" and turns the pages toward the "front." But to the Jewish woman for whom this manuscript was made, and who is represented in the lower border holding the only ritual text with which women were able to become involved, her Christian neighbors were the ones who had got it backwards. For this particular Jewish community from the Middle Rhine, who probably hired a local Christian artist to paint their Jewish text, vision had a very different resonance. Not only in the large Hebrew letters but in the images, too, which show women with open books arguing and talking with older scholars, the emphasis is not visual but verbal. If the image is at the center of the Christian world that is represented by St. Hedwig and her statue, the Word, and the Word alone, is at the center of this other Gothic world.

94. The word at the center of the Jewish world, from a Haggadah of the Ashkenazi rite, c. 1430. Illumination on parchment, 13⅞ x 10⅛" (35.2 x 25.6 cm). Hessisches Landes-und Hochschulbibliothek, Darmstadt.

The focus of this large framed image is the large initial word-panel which contains the Hebrew word *az* that begins the prayer recited on the first night of Passover, "how many the wonders you have wrought." Under canopies all around this are a number of women pointing to books and arguing with patriarchs, including a woman in blue who probably represents the book's owner. She looks out at the beholder from the bottom of the page as if taking us through her book.

FOUR

New Visions of Nature

C athedrals have often been described as though they were great greenhouses in which the first naturalistic flora and fauna of Western art were grown. But nature had quite a different set of associations for people during the Middle Ages. At Strasbourg cathedral the north portal is carved with a variety of things from the natural world – flowers, apples, bodies – but each of these elements is rendered in a distinctive manner (FIG. 95). While the apple held by the male figure and the oak leaves that run alongside him are highly naturalistic, his own body is highly artificial, with sharp, exaggerated features. This figure represents the world. Crowned and elegant, he holds out an apple as ripe and round as his own fleshy cheeks to tempt the foolish virgins who are barred from entering the heavenly gates beside him. It is only when we step around to the left that we notice his whole backside is eaten away by snakes and toads that squirm around his rotting spine. Man was not just an observer of nature. As part of the fallen world, he was implicated in its beautiful growth and also in its decay and death.

Beside this human form, so lovely from the outside but so rotten within, is a world of natural beauty in the form of a lush band of foliage, carved so as to appear like a vine trained around the arch itself. Below on the socle are quatrefoils representing the labors of the months, from January feasting to Maytime flower-picking. But the stone flowers above always retain their bloom. The contrast in these sculptures would have clearly announced to a medieval observer the doctrinal denunciation of the vanity of earthly things. And these wonderfully carved figures, the originals of which are now preserved in the cathedral museum, alert us to the fact that in Gothic art "naturalism" was not a style that

95. Strasbourg cathedral, west front, right portal. The King of the World and the Foolish Virgins, c. 1280–1300.

depicted all things uniformly within a singular stylistic vision, like Impressionism. Rather there were different degrees of "natural" that a sculptor or painter could deploy, applicable to different categories of persons and things. So, while a stone flower might have been carved by observing an actual flower, the human body was structured out of the schematic shapes of the divine geometer. The fallen human body was far too loaded with taboos and dangers to be portrayed with the verisimilitude of a leaf. Adam and Eve, the last and most God-like of things created, were also the last to be naturalistically represented in art.

In looking at art of the Gothic period, it is always a mistake to equate what is natural with what is real. For both Abbot Suger at the beginning of our period and Nicholas of Cusa at the end of it the real lay beyond the apparent realm of the senses. Nevertheless, Gothic art exhibited the same trends toward detailed observation and scrutiny of appearances that is evident in the theology, poetry, and scientific literature of the period. Nature was, it is true, still seen as the work of God. According to the Franciscan St. Bonaventura "the work of the supreme artist is more excellent than any human art could be." Even so, the emergence of Gothic art has been thought, by both historians of art and historians of science, to inaugurate a fundamental change in the European attitude toward the natural environment. Nature ceased to be a series of symbols and became a series of things, regarded not through the typological glass of infinity, but through the lens of Aristotelian optics. Yet during the Middle Ages as today, nothing was "natural," everything was constructed; when we examine developments in the representation of the vegetable world and the animal world, including the human body itself, we will be examining not so much what was before people's eyes as what it was they wanted to see.

Flowers and Gardens

At Soissons cathedral, which was begun at the end of the twelfth century, contemporary with Chartres, a capital surmounting one of the slender columns and shafts of the choir has been carved with two rows of celandine leaves, curling gently toward the eastern light (FIG. 96). These seem superimposed upon the stone, as though the urge to put nature within the sacred space had priority over any architectural unity. This treatment of capitals was to develop along more standard lines at the cathedrals of Laon and Notre Dame in Paris, where the upward curves of the acanthus turn into leaves and buds. This trend culminated in the 1230s

in the capitals of Rheims cathedral, where at least thirty different plant and flower species have been identified. These species were not zoologically classified by contemporaries, however: each of them would still have been recognized and named in the local vernacular. Probably this was where the peasant might "read" most easily in the stones.

When people lived in close proximity to plants and their livelihood depended upon the seasonal growth of crops and vegetables, to feed both themselves and their animals, such sculptural features were hardly "decorative" elements as we think of them today. In Romanesque art, human figures are often found struggling in a haunted tanglewood of trees and vines. By contrast Gothic art presents a more benign nature, one which forms bowers and backgrounds, a nature which people could stand back from to observe at a distance or pluck from the ground to view from close-up. The plant-life of the cathedrals was not antithetical to their theological message; rather, it represented the new importance given to perception and sensation in the experience of the divine, which increasingly came to be represented through God's creation.

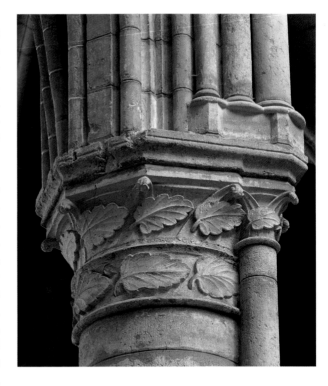

96. Soissons cathedral, capital with leaves, 1192–1212.

The use of flowers and plants as signs of the sacred is an ancient tradition, but what lies behind the adoption of foliated capitals in the interiors of Gothic churches is a radical revaluation of the status of a work of art. As a visual effect, of course, the budding shoots that curl upward in the capitals of Early Gothic churches add to the total effect of upward, sprouting growth. One of the earliest eighteenth-century theories of the origins of Gothic was that the columns, shafts, and pillars stretching up to overhanging vaults developed out of the tall forests of the north (FIG. 97). While this is a romantic fantasy, the importance of greenery to Gothic forms cannot be doubted. During certain times of the year churches would be filled with flowers and leaves. In England, too, the stiff-leaf foliage of the late twelfth century gave way to the more varied naturalistic types found at Southwell minister. At Amiens cathedral the band of richly carved foliage running

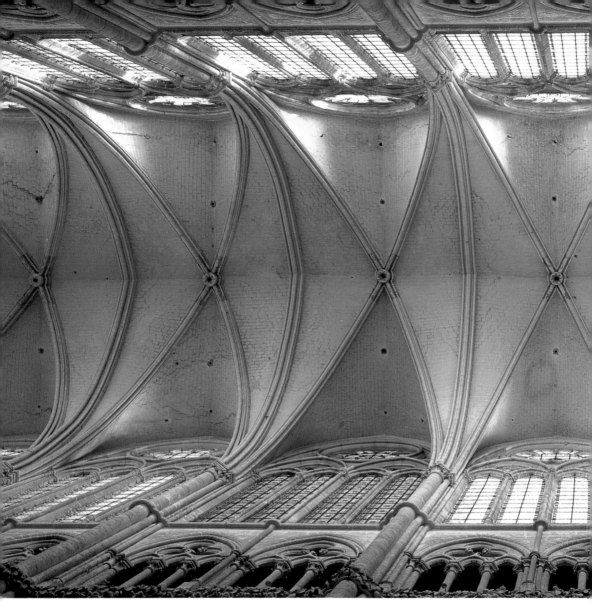

97. Amiens cathedral, triforium and clerestory (detail), c. 1235.

The cold geometry of these stones as they appear today would have been different in the late thirteenth century when the colored glass in the windows and polychromy on the pillars, and especially the color green, would have brought the interior to life.

along the whole width of the nave makes it appear that people have hung garlands over the stones, which we know occurred on the Feast of St. Firmin, when the exterior and interior of the cathedral were bedecked with flowers and greenery in memory of a miracle in which the saint had caused the trees to blossom in the midst of winter.

The concept of the "decorative" cannot be applied to these instances of naturalistic detail. Nor can they be seen as simple observations, devoid of meaning. The choice of plants and flowers carved on cathedrals was often related to local agriculture, customs, and associations with certain saints. This is not to say that the color

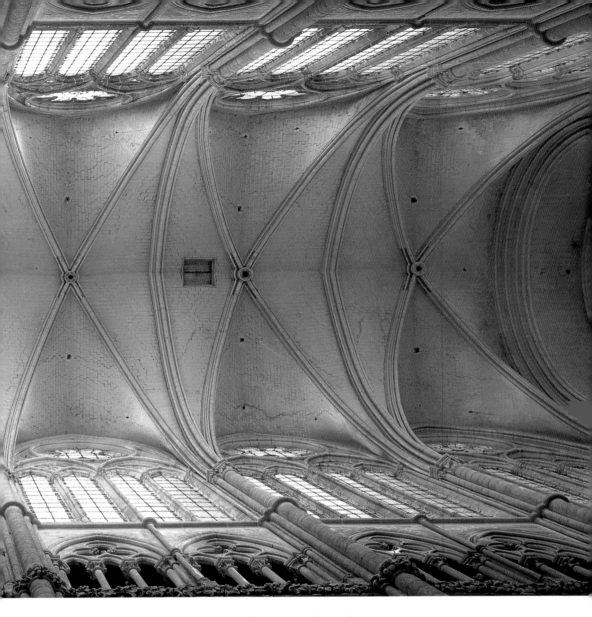

and fragrance of flowers were not in themselves enjoyed. As Thomas Aquinas's teacher, Albert the Great, wrote in his treatise *On Plants* "flowers such as the violet, columbine, lily, rose, iris...not only delight by their scent but refresh the eye with their beauty." One of the clearest indications that Gothic art did not follow a single linear progression is that the most naturalistic forms are found in the earlier phases of thirteenth-century sculpture, around the time of the "classical" phase at Rheims, whereas the Perpendicular and Flamboyant churches of the fifteenth-century contain flowers and plants carved in stone that have been pressed once again into wonderful ornate abstractions.

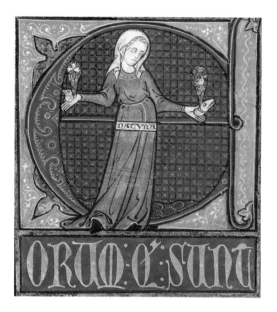

Above

98. The figure of "Nature" from Aristotle's *Physics*, c. 1300. Illumination on parchment, whole page 16³/₄ x 10¹/₂" (42.5 x 26.6 cm). Bibliothèque Mazarine, Paris.

Part of a manuscript made for the university of Paris, where the study of Aristotle had earlier been banned, this initial, like contemporary sculpture, combines abstracted decorative nature (in the triple-leaved flowers of the outer corners) with more specific observation (in the flower growing from the figure's hands).

Nature was not just a thing, but a force. As depicted in a Parisian manuscript of Aristotle's *Physics* (which in Greek means "nature"), it represents the precise meaning of the word in the technical language of the natural philosopher, "the source or principle of all movement" (FIG. 98). The rediscovery of this text via Arabic translations, along with other treatises on natural science, meant that scholars had a new model of nature, different from that suggested in the Bible. In the Parisian manuscript Lady Nature holds in her hands the four elements of earth, air, fire, and water, which are represented by parts of animals and plants. Their growth from her fingers suggests the dynamic movement of earthly things. If the scholastic philosophers like Albert the Great and Thomas Aquinas attempted to make this new scholastic natural science at one with the tenets of Christianity, the Gothic artist had to graft the shoots of a new naturalism onto the venerable series of stereotypes he had inherited.

This new vision of nature was attractive in royal and aristocratic courts and even more so in the growing towns, where the modern attitude to nature as something from which one is estranged first developed. Still based on the archetypal Garden of Eden, the private garden was a luxury of the aristocracy, just

like the artificial gardens contained in tapestries, miniatures, and jewels. These objects increasingly assumed the forms of nature. To appreciate a beautiful gittern, or medieval guitar, carved from a single piece of boxwood, one has to imagine it in performance, in the hands of a minstrel singing at the English court in the early fourteenth century, swaying to songs of love blooming with the flowers of spring (FIG. 99). The sides of the instrument are divided into panels of vine, hawthorn, and oak leaves in which tiny hunters stalk their prey and scenes appear that are based on calendar images of the labors of the months – a man knocking acorns from a tree to feed pigs, for example, as the image for December. Lyrics of the period celebrated in flowing music and words what is here lovingly carved in wood: "I am as happy as a bright bird on a briar when I see that gracious one, most gracious in hall. She is white of limb, of limb and face she is fair, and the flower, the flower of all." Yet here, too, the monstrous and the magical are never far removed from the natural. The gittern is actually shaped as a dragon with bright green eyes, bat-like wings, and sharp teeth that bite.

This same combination of magical fantasy and organic nature can be seen in a fourteenth-century Herbal, a treatise on the medicinal use of plants, produced in Provence (FIG. 100). Its images suggest the notion of the "secrets of nature," which only the artist or alchemist is able to extract, a world in which everything possesses magical power. On most pages the images of the plants are isolated like specimens in the middle of the frame and sur-

99. Gittern carved with foliage and figures, c. 1290–1330. Wood, length 24″ (61 cm). British Museum, London.

100. The licorice plant and the magical production and mining of lapis lazuli, from a herbal, c. 1320. Illumination on parchment, 11½ x 8¼" (29.3 x 21 cm). Biblioteca Nazionale, Florence.

The glistening blue stone, created by the natural forces of the sun and guarded by the supernatural forces of the dragon, is being extracted from the earth by the man with the pick-axe on the right-hand page. It was one of the most well-known luxury pigments used in Gothic art.

rounded by strange figures and creatures that allude either to the horticultural aspects of the plant or its medicinal uses. Here the licorice tree on the left is not drawn from nature, but copied, like the text, from an earlier exemplar. Opposite is an image of a rock glistening in the earth, the brilliant blue lapis lazuli, which was important to artists as well as doctors. The semi-precious stone was thought to cool internal heat and, when powdered and mixed with milk, to cure fevers and blindness (when applied to the eyes). But the wonderful image here describes not its uses, but its extraction from the earth. A dragon was thought to protect the stone, whose special powers were believed to be created by the rays of the sun acting upon it deep within the earth. Here is a good example of how "nature" was considered, even by the scientific community, as inherently magical, a mixture of natural and supernatural elements. Albert the Great (c. 1200–80), the German philosopher and doctor of the church, thought that antique cameos had been created by the stars or sunlight, since their beauty seemed beyond human skill. Given this animate earth, full of portents and signs taken for wonders, is it surprising that people were loath to see things as they appeared in the dull light of day, but wanted them, even in non-sacred contexts, to be filled with supernatural significance?

The garden, an artificially constructed nature whose purpose was aesthetic as well as economic, was a convention of love-poetry which is sometimes thought to have been imported from Muslim Spain. In Arthurian romances a garden is the site of erotic encounters and in the most popular poem of the period, the *Roman de la Rose*, it becomes the stage for a complex allegory of love. But by the fourteenth century the garden had become a subject that could transform even interior spaces into sunny simulacra of nature. The Chambre du Cerf in the palace of the popes at Avignon, painted in 1343, is not a representation of landscape for its own sake, as is sometimes claimed (FIG. 101). It shows the activities that took place in nature for privileged groups that were not, like the peasant, bound to the land. Figures engaged in hunting and fishing stand out against the deep green of a forest. For popes, kings, and nobles, the untamed forest was usually not something beautiful to be enjoyed in itself, but space to be exploited for the hunt and for its rich resources. The natural in nature was too wild, too loaded with negative associations to be a subject for artists, who always sought to tame nature by making it artifice. This urge to domesticate the wild is an important aspect of secular decoration, in wall paintings and tapestries of the period, which turned

101. Scenes of country life, 1343. Fresco. Chambre du Cerf, Papal palace, Avignon.

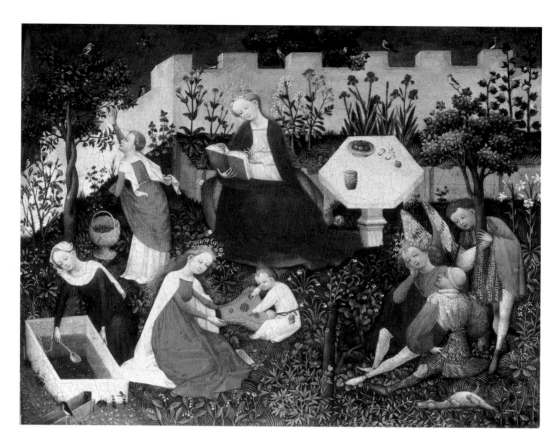

102. MASTER OF THE MIDDLE
RHINELAND
Virgin in a Garden, c. 1410.
Tempera on wood, 10³/₈ x
13¹/₈″ (26.3 x 33.4 cm).
Städelsches Kunstinstitut,
Frankfurt.

what was outside inside. It is also interesting to note that aside from communal monastic plots for growing herbs and medicinal plants, the private garden seems to have developed first in an urban setting, in the free towns of Italy and Germany.

A ravishing little panel from the Middle Rhine, painted c. 1410 in the style that art historians have long referred to as International Gothic because it was so ubiquitous, is full of so many carefully observed varieties of plants and deliciously painted sensual delights that its sacred character might at first not be apparent (FIG. 102). It is an elaborate fantasy based upon the notion of the Virgin as an enclosed garden, or *hortus conclusus*. Within this walled retreat sacred symbols become objects of courtly artifice. The Virgin thumbs the pages of a book, while her attendants pick cherries, spoon water from a pool, and watch over the Christ-child, who plucks at St. Cecilia's psaltery. Golden haloes have been replaced by flower garlands. The three male saints, seated in the shade of a tree, have reduced their demonic combatants to the status of pets. St. Michael's devil sits glumly at his feet while St. George's dragon basks belly-up in the sun. Both sacred and secular traditions of

Gothic art here are once again conflated. It is not known for whom this little picture was made, but one can imagine that it belonged to some rich city-dweller, perhaps a merchant, for whom nature had already, in this miniature garden, become something like the distant, even nostalgic, reverie that it would become for modern art-lovers.

Beasts and Birds

A well-known Gothic image, often thought to exemplify the new relationship to nature, is the drawing of a lion from the model book of Villard de Honnecourt (fl. 1230-35). On it the artist has proudly inscribed "note well that this was drawn from life" (FIG. 103). The word used for drawn is *contrefait*, which at that time had some of the associations of our term counterfeit – the production of something false. In the Gothic era artists did not lay claim to a personal vision or perception. An artist was a maker, an artisan, and the things he made were all fakes in the sense described by Hugh of Saint-Victor when he wrote that "the human work, because it is not nature but only imitative of nature, is fitly called mechanical, that is, adulterate." Villard was not, in fact, sketching from life, since this lion-taming narrative was a commonplace found in medieval encyclopedias. Like the ornamental lion's head, which he adds in the top corner, this depiction relates more to earlier lions in art than to any actual animal the artist might have seen. What is important, however, even if Villard did not draw the lion "from life," is that he added the inscription saying that he did. It suggested that there were things in the world worth recording and that the image-maker could vouch for their appearance. Precisely because medieval artists

103. VILLARD DE HONNECOURT (fl. 1230–35)
The "Lion drawn from life," from a model book, c. 1235. Pen drawing on parchment, 9½ x 6¼" (24 x 16 cm). Bibliothèque Nationale, Paris.

104. Beasts and marginal hunting scenes on a fragment from the destroyed *jubé* of Chartres cathedral, c. 1220. Stone, 42 x 47″ (107 x 121 cm).

The choir screen at Chartres cathedral, destroyed in 1763 and now preserved only in fragments, was carved with narrative scenes such as the Nativity as well as these animal scenes. It provided a second facade within the cathedral and demarcated the choir enclosure, reserved for the canons, from the nave, where lay people gathered.

did not copy the world before their eyes, Villard had to add this text to authenticate his presence before something, just as, in the rest of his album, images of buildings like Laon cathedral have inscriptions to attest to his having seen them, even though many scholars believe he was copying them from other drawings.

A superb lion once stood within Chartres cathedral, carved on the now-destroyed choir screen which separated the lay area of the nave from the sacred choir enclosure (FIG. 104). It and other animals on the screen were isolated in roundels, separated by lush carved foliage, much as they appeared in contemporary bestiary manuscripts. The scenes in the corner sections include a hunt and a terrified knight fleeing a giant snail, perhaps suggesting a clerical critique of secular values. This argument gains strength from the fact that these naturalistic roundels were never seen by the people, since they were carved only on the inner side of the choir screen and were, therefore, visible only from the canons' perspective. They clearly denoted the "nature" that

lay beyond the canons' sacred enclosure – a world full of vanity and violence, ruled by the lion and the dragon.

Dante Alighieri (1265–1321) was a poet whose visionary perspectives provide a poetic equivalent for many of the ideas of space, time, and nature that have been discussed in this book. Although the *Divine Comedy* ends on the mystical fourth level of seeing in the light-filled transcendence of the *Paradiso*, it begins in the *Inferno*, in the "dark wood where the straight way was lost" and where abide three symbolic beasts, including a lion (FIG. 105). A Sienese illuminator depicted the sequence of events. First, Dante wakes from sleep in the wood and sees the distant sun shining on top of a mountain. On the next level he starts to climb and

105. Dante's dream in the dark wood and his meeting with the beasts at the beginning of the *Inferno*, from the *Divine Comedy*. Illumination on parchment, 14¼ x 10" (36.3 x 10 cm). Biblioteca Communale Augusta, Perugia.

meets the three beasts. First he sees the leopard, lust, in the middle of the page, followed by the lion, pride, and then our eyes turn right to where the wolf, covetousness, forces him to turn away from the mountain. The psychological impact of each moment upon the visionary spectator is carefully distinguished and although the repetition of his figure might seem "unnatural" to us today, it was an effective way of creating a sense of unfolding action. This page demonstrates how powerful the visual device, usually termed continuous narrative, could be. So successful was this way of seeing that some Italian painters were still using it at the beginning of the sixteenth century.

The English philosopher who taught at the universities of Paris and Oxford, William of Ockham (c. 1285–1347), based his philo-

106. Model book with animals, c. 1400. Ink on parchment. Pepys Library, Magdalene College, Cambridge.

In addition to the fact that all the animals are observed without much attention to relative scale, the artist mixes up the real and the mythological realms by including a curly tailed dragon. While he might have copied the twisting lion/cat from an actual feline, his observation of dragons was probably taken from a tapestry or shield.

sophy on visual experience, taking the eye as the primary organ of knowledge. In his philosophical system, known as "nominalism," the only real existents were "absolute things." The visual equivalent of nominalism would seem to be the model book, for example, a collection of English drawings in which the artist has even inscribed the animals, not as universals, but as individual instances of "a sheep," "a horse," and "a cat" (FIG. 106). But it would be wrong to see such a direct link between philosophical theories of vision and the practice of artists. This menagerie is still, in effect, a collection of universals. Superimposed on the page without any sense of scale, they can easily be transcribed into any context where a horse is necessary. The beast above the cat and mouse might be a lion seen from an unusual angle and a dragon with a curling tail provides a magical touch. It has been suggested that this model book was used in a glass-painter's or an embroidery workshop, which would account for these schematic qualities. The dating of such collections is problematic because they were often added to and developed over an artist's lifetime, even over generations. In this case the line drawings are superseded by a later series of brilliantly colored bird-drawings in an altogether more naturalistic mode. This fragmentation of representation in the model book is a crucial aspect of the Gothic artist's attitude to nature, since it suggests the composite construction of a new world out of particular fragments rather than any attempt to see it as a totality.

It is in the margins of illuminated manuscripts that a more coherent view of nature first becomes manifest. The naturalistic flowers which are pressed into the margins of later fifteenth-century books have their forerunners in a unique Latin treatise on the seven vices produced in Genoa toward the end of the fourteenth century, which reveals a new attitude to birds and insects (FIG. 107). In a hunting and hawking scene, the illuminator has filled the margins with various birds, not isolated on the page like specimens, but in flight. Nature's violence and cruelty is visible at the top of the page as ravens and vultures attack rotting carrion. Sweeping partridges and ducks, each species carefully distinguished in its flight-type and flock-pattern, are seen from a distance. Other pages feature minutely drawn shellfish and crustaceans and insects seen close-up, suggesting an entomological fascination with the tiniest of God's creatures.

The invention of eyeglasses, probably in the late thirteenth century, allowed people to peer at nature through a new kind of lens. The chapterhouse at Treviso presents one of the most "scholastic" of all Gothic fresco cycles, being an idealized portrait

gallery of members of the Dominican order. But it also represents an achievement of scholarship, of the technology needed to study, which included not only desks, books, and pens but recently invented optical instruments like lenses (FIG. 108). Cardinal Nicholas of Rouen peers at his text, as though looking at a minute marginal drawing, through a single lens. Other figures in the series perform the age-old scholarly activity of comparing one text with another. In fact, even this act of comparison suggests the new intensity of visual scrutiny that greeted the world as well as the word in the fourteenth century. But for the artist, who had little contact with philosophical controversies about the status of objects, the conflict between the world of the book versus the world of things was made concrete in his own practice. For when called upon to make a picture, he referred neither to people nor events. Nor did he need people to model for him. He had all his models, many of them inherited or stolen from others, within the valuable pages of his model book.

Model books were crucial vehicles for the transmission of Gothic ideas, found throughout Europe, in England (see FIG. 106) as well as in Italy, where their naturalism is most pronounced. Even for the advanced Lombard artists of the north Italian courts, the word still controlled the image, making nature into a rebus, as exemplified in the marvelous figured alphabets of Giovannino de' Grassi (d. 1398) and his followers (FIG. 109). These appear in model book format, though more as delightful inventions by the artist than copies after nature. Here hairy wildmen, a popular theme in secular art, make up the letter *k*, fighting knights create a *q,* and *r* is an amazing agglomeration of animals and even insects! It is significant that the animal and the human do not commingle. Their bodies, though fantastically and acrobatically intertwined, are clearly separate. This keeps these delicate drawings within the realm of the natural and in line with courtly decorum. It separates them from another tradition in Gothic art, also crucial for understanding the new vision of nature – the monstrous, which is intimately bound up, not with the animal, but with the human.

Opposite
107. Hawking scene with marginal birds, from a Genoese treatise on the seven vices, c. 1370. Illumination on parchment, 6½ x 4″ (16.5 x 10.2 cm). British Library, London.

108. TOMMASO DA MODENA *Cardinal Nicholas of Rouen,* c. 1351–52. Fresco. Chapterhouse, Treviso.

109. GIOVANNINO DE' GRASSI (d. 1398)
The Gothic letters *h* to *l* and *p* to *r* from a model book , 1390. Illumination on
parchment, whole page 10¼ x 7¼" (26 x 18.5 cm). Biblioteca Civica, Bergamo.

The *q* with two horsemen was later copied again in the engraved alphabet of the
German artist, Master E. S., in the 1460s, suggesting the long popularity of these
inventive designs.

Bodies and Borders

At the church of the Assumption of the Virgin at Aosta, images do not only lead our gaze upward. Looking at a wooden carving in the choir, we descend to the lower bodily quarters, so redolent of sin and sexuality, and even inside the body itself (FIG. 110). Among the visions of Gothic art are thousands of inglorious human backsides that stare down at us from the roofs of cathedrals in the form of gargoyles, hundreds of naughty nudes displaying themselves at the edges of the word in illuminated manuscripts, and those startling bodily members carved in wood on misericords (supporting shelves on the backs of church chairs) that make their mockery right in the center of the great churches. This grotesquerie is an important aspect of Gothic art, one which in many ways shows continuity with the earlier Romanesque tradition. There too monstrous, half-human beasts and distorted bodies, twisted in stone and paint, are signs of the lower, bestial side of human nature. But the Gothic monster is different, partly because the human body itself, shown without any reptilian scales or hybrid splitting, becomes emblematic of the horror of the flesh. To view these images in this way is to look at them through the eyes of the clergy. They can also be seen as derivations from folklore, containing associations for other, less orthodox, communities. The meeting of mouth and anus on a misericord in Aosta cathedral joins together the two openings through which people eat and defecate, suggesting the cycle of replenishment of the earth, and the carnivalesque body, let loose for a short time, even inside the church, at the "Feast of Fools." These inverted figures are also to be placed within the crucial aspect of image-magic in Gothic art. They look us directly in the face, exercising their traditional apotropaic function of warding off evil. The most liberated bodies in Gothic art are not those that enact the repeated typologies of sacred history or stand imprisoned in their cathedral niches, but these far more complex and ambiguous bodies at the margins.

These polymorphous bodies do not appear only at the edges of monumental sacred art or in the margins of Gothic manuscripts. They are also found on the most expensive luxury objects. A small silver gilt and enamel

110. Aosta cathedral, acrobatic figure licking himself, c. 1480. Wooden misericord.

This carving would have been visible only to the canons of the church in the choir stalls. Misericords were used during the long hours of liturgical performance, which is why they were called "mercy-seats." The often very physical nature of the imagery is perhaps linked to the parts of the clerical anatomy with which they came into contact.

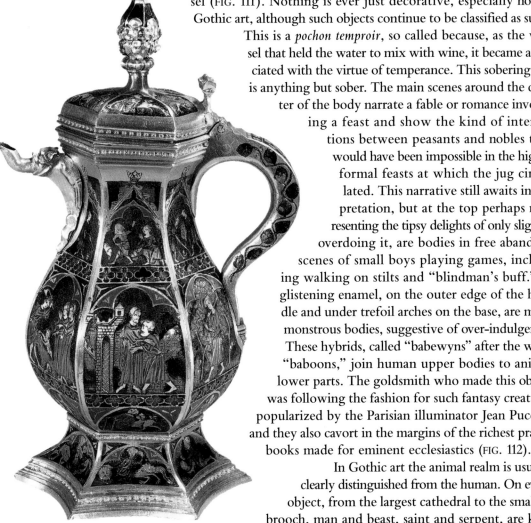

ewer is as laden with symbolic significance as any liturgical vessel (FIG. 111). Nothing is ever just decorative, especially not in Gothic art, although such objects continue to be classified as such. This is a *pochon temproir*, so called because, as the vessel that held the water to mix with wine, it became associated with the virtue of temperance. This sobering jug is anything but sober. The main scenes around the center of the body narrate a fable or romance involving a feast and show the kind of interactions between peasants and nobles that would have been impossible in the highly formal feasts at which the jug circulated. This narrative still awaits interpretation, but at the top perhaps representing the tipsy delights of only slightly overdoing it, are bodies in free abandon, scenes of small boys playing games, including walking on stilts and "blindman's buff." In glistening enamel, on the outer edge of the handle and under trefoil arches on the base, are more monstrous bodies, suggestive of over-indulgence. These hybrids, called "babewyns" after the word "baboons," join human upper bodies to animal lower parts. The goldsmith who made this object was following the fashion for such fantasy creatures popularized by the Parisian illuminator Jean Pucelle; and they also cavort in the margins of the richest prayer books made for eminent ecclesiastics (FIG. 112).

In Gothic art the animal realm is usually clearly distinguished from the human. On every object, from the largest cathedral to the smallest brooch, man and beast, saint and serpent, are kept distinct. It is only in the monster, or babewyn, that their bodies connect. This was the very period in which "nature" was first used by the makers of canon law to define normative acts and acts "against nature" – such as sodomy and masturbation – in which people were thought to become like beasts. Many of the hybrid creatures, half-man and half-goat, that one sees in so many delightful settings in Gothic tapestries, Bibles, and psalters are visions of illicit couplings that could not be talked about, but could be pictured.

The human body was the last of God's creations to succumb to the naturalistic trend in Gothic art. Perhaps this was because it was a fallen body, stained with the sin of Adam and Eve, whose

111. Ewer with scenes of a romance and marginal monsters, 1320-30. Silver gilt and translucent enamel, height 8⅞″ (22.5 cm). National Museum, Copenhagen.

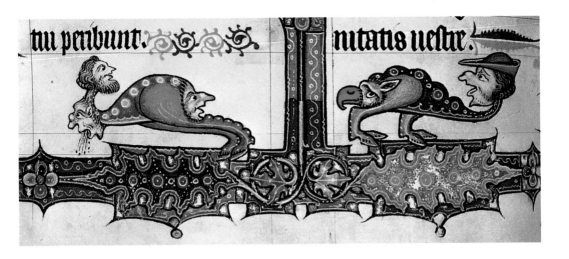

tu peribunt. nitatis uestre.

nakedness signaled sin. Although artists could represent souls naked, these were anodyne baby-bodies, not fully developed men and women. At Bourges the female nude, based on an antique Venus, had regained her flesh only to be damned in the eternal flames. Adam, as carved for the inner south transept of Notre Dame in Paris, represents the male equivalent of that damned body, tense, delicate, and ungainly (FIG. 113). Whereas the classical statue of Apollo was built upon the balance of abstract proportion and muscular mass, the Gothic Adam is the father of all flesh. Here he stands embarrassed at the moment of the Fall, when "the eyes of them both were opened and they knew that they were naked." Originally, along with a pendent statue of Eve, he faced the Deity placed in the central gable. This is thus a guilt-ridden body, hiding its newly discovered sexuality behind a large bush, which, sprouting between his legs, actually serves to emphasize what it hides. From the transept below, the delicacy of Adam's features, resigned and inward-looking, would have been difficult to see; but the clarity of his defensive gesture and the enormity of his sin would have been obvious.

Gothic sculptors were always struggling to bring to life the very flesh which, according to the theologians, was already consigned to death. Ironically, the first human form to be delineated with naturalistic detail was the corpse. Only when it had become food for worms could the human body become a subject for art. One of the reasons why artists and sculptors had a poor grasp of human anatomy was that the church forbade the dissection or analysis of corpses. But at the universities of Bologna and Paris this was to change. Embracing a displayed corpse with the elegant gestures of a courtly lover, Guido de Vigevano, physician to the

112. Monsters in the lower margins of a Cluniac psalter, c. 1320. Illumination on parchment, whole page 13½ x 9" (34.7 x 23 cm). Beinecke Library, Yale University.

Typical of some of the most inventive and obscene marginal monsters produced in the eastern counties of England at this period, these two multi-headed creatures appear in a personal prayer book made for a monk.

Queen of France, slices open its abdomen in one of a sequence of illustrations showing the gradual evisceration of a corpse for the purposes of anatomical teaching (FIG. 114). Placed within a Gothic frame and viewed from above as though lying flat on a dissecting table, it seems already half skeletal. In this treatise the doctor explains that "because it is forbidden by the church to perform an anatomy on the human body…I will show you the anatomy of the human body plainly, by correctly painted figures, just as they are in the human body, so that that which is beneath will appear manifestly in the picture and better than it can be seen in the human body, because when we perform an anatomy of a man, we have to hurry on account of the decomposition." The image is not only clearer than the messy reality, it is also less smelly.

Guido de Vigevano himself probably died of the bubonic plague, or Black Death, that swept through Europe in 1348–49, taking what some estimate as a third of the population with it. His royal patients fared no better. The wife of the Dauphin of France, Bonne of Luxembourg, succumbed in 1348. She had spent many hours contemplating death as it appears in her lavishly illuminated Book of Hours. One of its most magnificent openings illustrates a poem called a "very marvelous and horrific example" (*moult merveilleuse et horrible exemplaire*) also known as the Legend of the Three Living and the Three Dead (FIG. 115). Here the court illuminator, Jean Le Noir, created for her a superb contrast between life and death. The three young horsemen on the left have a macabre vision of their own futures in the three cadaverous counterparts on the right. Each one is more decomposed than the last. The first gray ghoul has his eyes closed and his hands crossed as on a deathbed. He is the one who says "What you are we were and what we are you will be!" The second has already lost his eyes to the worms, though some flesh still clings like tattered rags to his eloquent body. The third figure, farthest to the right, is a gaunt thing of bones, its mouth gaping in mocking laughter, but its limbs lacking all movement. The margins, which show the arms of Bonne, are filled with ravishingly naturalistic birds; and a figure in the top corner recoils at the stench given off by the flesh below, as though he too had seen the vision. The plague may, in fact, have had something to do with the rise of interest in nature, since

113. *Adam,* from the south transept of Notre Dame cathedral, Paris, c. 1250. Stone, height 6′ 7¼″ (2 m). Musée de Cluny, Paris.

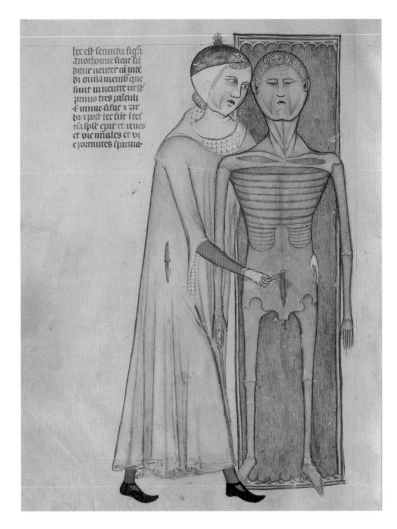

114. Italian illuminator working in Paris. The second figure in the *Anatomy of Guido de Vigevano,* 1345. Illumination on parchment, whole page 12½ x 8¾″ (32 x 22.2 cm). Musée Condé, Chantilly.

the countryside represented a safe pastoral escape from the urban squalor that was thought to harbor the pestilence.

Much has been made of the year 1348 and the impact of the Black Death upon artistic production in Europe. While it is true that a number of important artists died in the first epidemic, the pestilence recurred throughout the rest of the century. Its impact was more complex and drawn out, which perhaps explains why it is towards the end of the century that its psychological impact can be seen, in delayed reaction as it were, among those who survived. Death was definitely "à la mode" in the courts of Europe during the later fourteenth century. It was celebrated in courtly poems and pageants. It was also celebrated in towns and cities, where the theme of the Dance of Death was popular. Here skeletons led the different orders of society in a ghoulish graveside gambol, most

115. Jean le Noir (fl. 1331–75)
The Three Living and *The Three Dead,* from the Psalter and Book of Hours of Bonne of Luxembourg, before 1349. Grisaille, color, gilt and brown ink on vellum, 5 x 3½" (12.5 x 9.1 cm). The Metropolitan Museum of Art, the Cloisters Collection, New York, fol. 321v and fol. 322r.

Il com la matiere no conte
Ill furent si co Duc ou conte.
Uns noble home de grit avoir.
Et de genial com fil a Roy.

famously in a series of wall paintings at the Cemetery of the Innocents in Paris. It was as if artists were able to think of putting nature into their images only in its decay, capturing the fleeting moment, not of life, but of its opposite.

Cardinal de la Grange, Bishop of Amiens, who had been an adviser to King Charles V, started his tomb in the church of St. Martial in Avignon before his death in 1402. Nearly fifty feet (15 m) high, this immense steepled structure began at the bottom with his rotting carcass (FIG. 116). Above was his robed effigy proper and then six more figured tiers, including one in which the cardinal kneels before the Virgin. The tomb enacted the ascent he hoped to make from earth to heaven and is an important early example of what is known as a "transi" tomb, one that depicts the transition from flesh to bones. There was originally a series of heads in varying states of putrefaction above the cadaver, representing two cardinals, a king, a pope, and a bishop. The beautifully sweeping curve of the inscription began with the word *spectaculum*, announcing that this was a spectacle for all the world. These are the words spoken by the corpse and by the skull chorus that framed it: "Poor man, why are you proud, for you are made of ashes, and will revert to a foul cadaver, food for vermin just as we are." Corpses were not considered properly dead until they had been reduced to bones. The cardinal had his flesh buried at Amiens cathedral. At Avignon it was only his bones that lay under the rotting flesh represented in stone. Like so many of the powerful nobles of the day, the cardinal sought to have his body divided up after death so as to profit from prayers said on their behalf at a number of different sacred sites. Although Pope Boniface VIII tried to legislate against what he called the "horror" and "abomination" of the division of corpses, the practice continued to be popular, especially

116. Transi from the tomb of Cardinal de la Grange, 1402. Stone, 33" x 6' (84 cm x 1.8 m). Musée Calvet, Avignon.

117. ANDRÉS MARÇAL
DE SAX (fl. 1393–1410)
*Scene of the Martyrdom
of Saint George*, from the
Retable of St. George,
c. 1400. Tempera on
panel, whole altarpiece
21'9" x 18' (6.6 x 5.5 m).
Victoria and Albert
Museum, London.

in northern Europe, where the living corpse continued to haunt
the imagination of artists for another century.

In an age before analgesics or anesthetics death was sometimes
better than life. The living body was often torn apart by terri-
ble, unrelenting pain. Gothic artists registered these agonies by
depicting the excruciating suffering of the saints. In the later Mid-
dle Ages people were attuned to the body as a theater of torment,
a site of incredible horror. In their large multipaneled altar-
pieces, Spanish painters of the International Gothic style were espe-
cially adept at evoking the rich textures and glowing surfaces of
flesh as it was torn from bone and the lining of skin as it was ripped
away by grinning, grotesque executioners (FIG. 117). By the flick-
ering of a thousand candles, bodies like that of St. George glistened

118. Opicino de Canistris (1295-1355)

Africa whispering into the ear of Europe, c. 1340. Pen drawing on paper, 11 x 7¾" (28 x 20 cm). Biblioteca Apostolica, Vatican City.

The straight ruled lines and tiny inscriptions that cover the various layers of this drawing are part of Opicino's obsessive desire to interconnect things, bodies, and borders into a prophetic vision of the world. At the top of the "boot" of Italy he has emphasized his own birthplace, Pavia, projecting himself into this highly organized, but incomprehensible, universe.

in all their gory glory and provided a locus of identification for all those whose sick bodies ached and who could enter into the voluptuous sufferings of the saints. Such images of death were produced in a culture ravaged by constant war and quite used to the public spectacle of corporal punishment meted out to miscreants in the public squares of towns. While the naked sexual body was consigned to the margins, the naked, sadistically tormented body, whether of Christ or the saints, was given center stage.

The body as a site for fantasy and projection in Gothic art is most apparent in the drawings of Opicino de Canistris (1296–1355), who worked as a scribe at the papal court in Avignon. Two manuscripts contain a series of his fantastic, feverish designs which he

made, in secret he tells us, after a strange illness struck him on 31 March 1334. His writing hand grew weak and he was unable to continue his work as an official papal scribe; "in spiritual work however this same hand proved stronger than before: since then I have drawn all these pictures without any human help." These words appear on large parchment sheets filled with cosmological diagrams, including startling self-portraits preserved in the Vatican Library. In a smaller, diary-like book made of paper, Opicino keeps track of other visions in which he sees the map of Africa and Europe as two human figures (FIG. 118). Opicino has combined the new geographical knowledge of coastal outlines obtained by contemporary Italian map-makers with cosmological symbols stretching back into the earlier Middle Ages. Europe becomes a woman whose ear is Portugal and whose sexual organs are the city of Venice, gouged out by the sea in the form of an obscenely gesturing fist. Opicino takes the medieval aptitude for seeing one thing in terms of another to its extreme. The Mediterranean Sea becomes a hideous devil, the Atlantic Ocean a devouring wolf. Rather than projecting his fantasies upward into an eternal, light-filled heaven, Opicino seems almost to have transported himself there to look down upon the copulating continents of sin, superimposing on their outlines fragments of his own body. His birthplace, Pavia, in northern Italy, is always emphasized. Here it is marked by a minute repetition of the larger composition, except that Europe is now a male figure, as it often appears in other drawings. Rather than see these manic marks as evidence of the artist's schizophrenia (as has been suggested by one scholar), it is surely more fruitful to place them in the tradition of mystical visions. Not glorious visions by any means, they provide a chillingly detailed, if warped, view of a natural world in which the dragon has ultimately triumphed.

The dizzying drawings of Opicino deserve a place in the history of Gothic art because they display no confidence in its system of signs and symbols. They mark, rather, its confusion and collapse. Opicino's art brings us face to face with an individual struggling to make sense of an over-determined universe. Although the Gothic visionary perspective has been helpful in exploring some of the structuring themes of this fascinating period in Western art, it is important to remember that perceptions are rooted in subjectivity. Vision, whether it be of God or nature, is always, as Opicino's art makes so evident, ultimately personal.

FIVE

New Visions of the Self

According to the household accounts of Edward I's wife, Eleanor of Castile, in February 1289 William de Farendon, goldsmith, was paid £6 8s 4d for making "images in the queen's likeness when she fell sick." Was this because, after weeks of fever, she already sensed that the illness might be her last? Was she making preparations for one of the monumental effigies that would grace one of her three tombs? Or was there a more magical purpose behind this taking of the image, some hope that it might take away the sickness with it? Representations of people in the Gothic period tended to involve more complex strategies than the modern notion of portraiture would suggest.

After her death in November that year the queen's viscera were buried at Lincoln, near where she had died, her heart at the London Blackfriars church, and her bones at Westminster Abbey, where a beautiful bronze effigy by another goldsmith, William Torel (active 1275–1300), surmounts her canopied tomb (FIG. 119). But this is hardly a "likeness" such as might have been taken from a woman of 49 years in her death agony. It is as ideal and tranquil a face as that of any saint carved on a cathedral jamb. Even Eleanor's gesture of holding the cord around her neck is taken from her publicly signified self, her seal. This is a resplendent, heraldic self, wearing a gown and mantle, her head resting on two superimposed cushions diapered with the arms of Castile. Three hundred and fifty gold florins were bought from Lucca merchants to gild this glorious image, which is less that of a person than a *persona* (from the Latin for mask). Tomb sculpture represents a particularly rich form of self-presentation in the Gothic period, but most often, as here, it is social rather than subjective identity that is carried into eternity.

119. WILLIAM TOREL (fl. 1275–1300) Effigy of Queen Eleanor of Castile, 1290 (detail). Bronze. Westminster Abbey, London.

Portraits and Performers

Historians have debated whether our twentieth-century concept of the individual existed in the Middle Ages. What people talked of discovering when they looked within themselves was not an essential identity, but what they called the soul, or the self. This inner self was not sought because it was in any way unique, but because it allowed one to see one's likeness to God. In terms of the world outside, the role or status of a person defined them in the eyes of others. When the Gothic artist was called upon to delineate people it was this public persona or mask that was the object of portrayal. Three years after the death of Eleanor, Edward I was negotiating with Philip IV of France (r. 1285–1314) for the hand of his sister Blanche. He sent ambassadors to see Blanche and assess her physical appearance, not only her face but her whole body, including legs and feet, which were described to him in a written account couched in poetic

120. Rheims cathedral, life-size corbel head, from the east tower of the south transept, c. 1270.

clichés of the day. He did not send an artist to take her portrait since the genre of diplomatic portraiture did not yet exist; and it was more important to measure a future wife's parts against the ideal stereotype than to record the changing vagaries of her appearance. In an age when any surface blemish or physical deformity was seen as a sign of sin, on one's own part or on the part of one's parents during conception, external appearances were fundamental. It was an age not only of extreme spirituality, but also of massive superficiality.

As with the delineation of nature, the most striking early examples of portraiture appear in Gothic art at its edges. This can be seen in a series of what were originally 162 life-size masks carved at Rheims cathedral, high up on the towers and hidden behind buttresses, so that they can hardly be made out from below. Whereas other large exterior sculptures on the buttresses at Rheims have been broadly carved to take account of the great distance from which they would be seen, these heads seem carved for God's gaze alone. Only with the aid of a zoom lens can we see them from the viewpoint of the carvers who made them (FIG. 120). This series of carefully studied physiognomies, scowls, grimaces, and grins contains some of the most individual faces to have survived from the thirteenth century. And yet, unlike Eleanor's blank gaze,

the faces cannot be linked to any individuals in history. Historians have argued that they represent the nameless faces, the signatures in stone, of the masons who labored on the thousands of sculptures for the cathedral. Others have suggested that they represent different psychotic and pathological states as medievals understood them. The mask is itself a weapon or disguise that can serve to ward off evil, a traditional role of such corbel faces in Romanesque art. But the Gothic grimace is here not that of a monster, but of a man.

These heads are also part of a vision of social distinction that permeates the cathedrals and which, contrary to our expectations, associates individuality not with those in power but with the powerless, the lower orders. The "little people," as they were called in tax records, were represented as smaller, squatter, and uglier. Gothic art, like Gothic poetry, presented characters in terms of social stereotypes, as tall elegant courtiers or as hideously ugly peasants. The masks at Rheims might be understood as part of this mapping of social distinctions. The faces of the monstrous masses have their place on the cathedral, individualized alongside the more abstracted effigies of saints and kings.

One of the most sophisticated sign-systems developed in order to make social distinctions was heraldry; invented to mark personal, dynastic, and family identity. Although the sixth Great Seal of King Edward III of England (r. 1327–77), made in 1340, sets the monarch within a complex traceried throne reminiscent of church or shrine architecture, the most important signs are not those of his body, but the two shields which hang within little illusionistic chapels (FIG. 121). Armorial display was common in the royal palaces of Europe, in chapels and on everything from clothing to tableware. Contemporary chroniclers and preachers, such as Peter of Blois (1135-1212), criticized the nobility for the vanities of empty display: "they embroider their saddles and blazon their shields with scenes of battle and tourney, delighting in a certain imagination of those wars which, in very deed, they dare not mingle in or behold."

Edward III's enemy, Charles V of France (r. 1364–80), has been linked to the rise of portraiture in the modern sense of the term. Charles was a learned king who had many classical works translated into the vernacular for the first time. Perhaps it was from these works,

121. Sixth Great Seal of King Edward III of England, March–June, 1340. Wax, diameter 4⅝" (11.7 cm). British Library, London.

The metal matrices from which such royal seals were taken have only rarely survived, but they were among the most outstanding examples of the metalworker's art of the whole Gothic period.

based on the political writings of Aristotle, that he constructed a new visual role for the ruler. In the widely known *Secret of Secrets*, thought at the time to be by Aristotle, the philosopher tells the young Alexander that royal majesty is a matter of appearing before the people in precious vestments. The king is there to be seen and, in soliciting the gaze of his subjects, both all-seeing like God and seen by all. Part of the ideology of Valois kingship was a enormous investment in royal images, in statuary, paintings, and manuscripts. Charles was presented in multiple images, recognizable by his bulbous nose and broad face and no longer an ideal type. In late Gothic art the ruler's body was visible to the gaze as it had never been before. Charles had life-size effigies of himself and his wife placed on one of the doorways of the old Louvre palace (FIG. 122). The homely demeanor of the king, a genial face with a slight double-chin and a massive nose, is remarkable. Of all the portraits of this much-depicted monarch – his likeness is to be found on linen in the Parement de Narbonne, now in the Louvre, and in the many manuscripts once housed in his library there – this is the most unflinching in its honest rendering of the king's fleshy body. The sculptor has also paid careful attention to clothing. Charles is wearing a surcotte, which biographers tell us he preferred to the tight courtly fashions of the age, partly because of his fragile health. Like patron saints of a church, Charles and his wife act here as the patron saints of a non-sacred space. Since the time of St. Louis the kings of France had been developing their pseudo-sacred selves. It was only possible in the spectacle of images.

Kings, too, had their visions and what better way to see the superb panel known as the Wilton Diptych (after the house in which it was preserved) than as a personal vision of King Richard II (FIG. 123). St. Edmund, king and martyr, St. Edward the Confessor and St. John the Baptist present the kneeling monarch in the left panel to the azure assembly of the Virgin and Child, attended by angels, on the right panel. The left scene is set in an earthly forest, the right in the flowering garden of heaven. Once again the artist, who

was probably one of the king's painters, has lavished more care on the delineation of the personal emblems and insignia of the king than on his actual personality. There was no need for the latter, since this donor image was meant for the eyes of the donor himself. The monarch wears around his neck the white hart badge which Richard adopted in 1390 as his personal insignia. It reappears on the reverse of the left panel. Both it and the French insignia of broom-cods (seed-pods) are woven into the king's iridescent gold mantle. The white hart badge is also worn by each of the eleven angels, who thus become royal retainers. One of them holds the banner of St. George. The event commemorated here has been conjectured as Richard's coronation in 1377, his seeking divine sanction for a crusade in the mid-1390s, or his meeting with the French king in 1396. But need it refer to a specific historical moment? Surely it is an outstanding example of a private image, a portable diptych that would follow the king on his travels. Every time he knelt before it he would be transported among the timeless company of Christ, the Virgin Mary, and the angels.

Mirrors and Lovers

Courtly love was, like its spiritual counterpart of devotional mysticism, a vision-centered discourse, though the object of its desire was not the Lord, *dominus*, but the lady, *domina*. In Gothic art the lover's gaze structures images, and things specifically created for a luxurious courtly environment where lovers' glances were exchanged. Cupid's arrow entered through the eye and many love poets, including those in the most elaborate illustrated collection of German lyric poetry, the so-called Manesse Codex, focused upon the gaze of lover and beloved (FIG. 124). Konrad von Altstetten associates the fulfillment of love's desires with summer and the flowering of the rosebush from his loins in what is both a wonderful sexual pun on his physical arousal at the look of his lady and a reference to the Gothic image of the Tree of Jesse, which sprouts from the Old Testatment prophet in the same place. The falcon on his glove is another image of the rapture of capture, although it is unclear who is the falcon and who the prey. Images associated with courtly love are made, like this one, not for the eye of the preacher or the peasant, but for the sophisticated courtier.

This same allusive play with signs is visible in Gothic ivories produced in Paris in the fourteenth century for ladies' toilettes. Sometimes they form the backs of mirrors. These are not, as was once believed, critiques of sexuality. It is becoming increasingly clear, once one realizes for whose gaze these scintillatingly

Opposite
122. King Charles V, statue carved for the church of the Celestins, Paris, before 1370. Stone, height 6′4½″ (1.95 m). Musée du Louvre, Paris.

Following pages
123. King Richard II kneeling before the Virgin (the Wilton Diptych), 1395–99. Tempera on oak panel, each panel 14½ x 10½″ (36.8 x 26.7 cm). National Gallery, London.

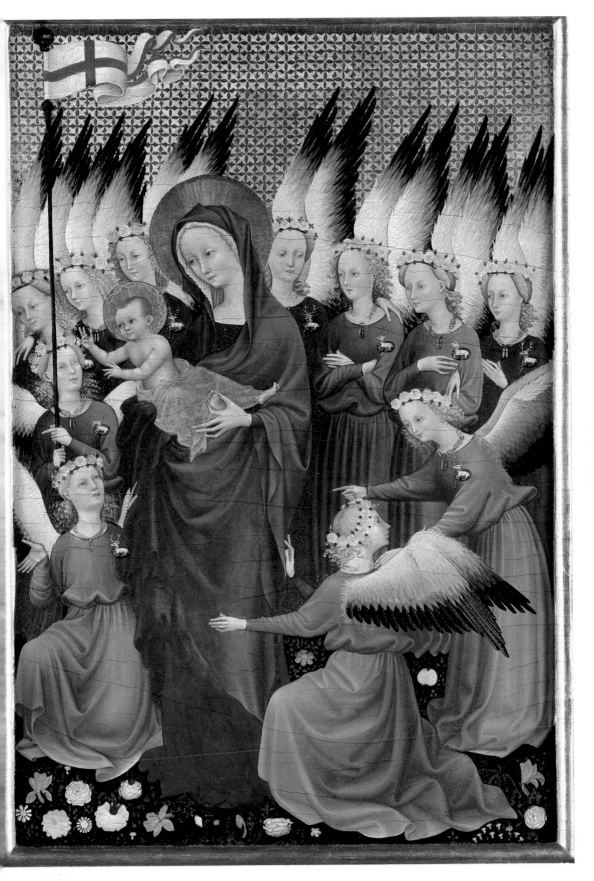

124. The Lady embraces the poet Konrad von Altstetten, from the Manesse Codex, c. 1300. Illumination on parchment, 9¾ x 13¾" (25 x 35 cm). Universitätsbibliothek, Heidelberg.

carved objects were made, that they are celebrations of or witty warnings about sexual pleasure. All games, whether falconry, hunting, or chess, become amorous allegories of desire. The real aim of the chess game here is conquest of the lady's body – indicated in the design of one wonderful ivory by a young man whose legs, crossed in triumph, clasp the erect pole that divides the tent (itself sexually suggestive). Visual emphasis is also given to the lady's crotch by deep, jagged Gothic folds. A servant even points at it (FIG. 125). Behind the male player an attendant holds a falcon, while the lady's servant holds a chaplet or ring, a sign of her favors and her ultimate penetrability. The contemporary carving of a female body at Bourges cathedral (see FIG. 61) signaled sin and death; here, for a different audience, it takes part in a joyous sexual game.

The most extensively illuminated and popular vernacular poem of the period was the *Roman de la Rose*, begun by Guillaume de Lorris (d. c. 1235) and finished by Jean de Meung (c. 1240–c. 1305). Here the garden of love becomes a setting for a complex allegory of the sexual act in which love's pleasures become equivocal for the yearning lover. Both poets were influenced by optical theories of the time and there is a long digression on the function and meaning of mirrors. The mirror had traditionally been an emblem of the vanity of *luxuria*, but it is *oiseuse*, or idleness, who looks into her mirror in this work. Early in the poem the association between mirroring the self and love is evoked in a description of Narcissus and Echo, subtly illuminated by a Parisian artist (FIG. 126). In the miniature we see Echo, whose love for Narcissus was not answered, asking God that the hard-hearted Narcissus might one day be tormented and burned by love himself. Returning from hunting and leaving his horse, the young man bends down by a pool to drink and there he "saw his face and nose and mouth, clear and sharp." Falling in love with his own reflection, he pines away and dies of love. The artist has attempted to represent the reverse mirror reflection in the square pool, creating

125. Mirror back showing lovers playing chess, c. 1300. Ivory, diameter 4½" (10.8 cm). Musée du Louvre, Paris.

126. Narcissus and Echo, from the *Roman de la Rose*, c. 1380. Illumination on parchment, whole page 11½ x 8¾" (29.5 x 22.5 cm). Bodleian Library, Oxford.

a symmetry suggestive of the closed circuit of his desire. But the point of the narrative is not that Narcissus has fallen in love with himself, in the modern sense of the word narcissism, but that he has been so captivated by an image that he forgets everything else. His sin is really idolatry, not self-love, indicative of the way in which, even by this time, the mirror was associated less with notions of the self and more with the creation of an alternative, illusory, reality.

The celebration of the role played by sight in love, in which the mirror loses its negative association with vanity, occurs in a tapestry representing "Sight" from the Five Senses Tapestries that were made for a member of the le Viste family of Lyons – probably Antoine le Viste – at the end of the fifteenth century (FIG. 127). Though few have survived into the present, tapestries like these were the most sought-after, expensive, and important of the Gothic luxury arts in the later Middle Ages in northern Europe. From inventories we know that King Charles V had 200 tapestries, far outnumbering the number of paintings in his possession. They were carried from castle to castle, providing warm hangings against draughts and a sumptuous setting for court spectacles. Their densely patterned floral grounds of "millefleurs" provided the backdrop for stories from the Bible, classical epics, and chivalric romances. Rulers even took them into battle. Most came in sequences that could create a theme for a room, transforming bare walls into an exotic setting or, as with le Viste's series (sometimes called "La Dame à la Licorne"), a space for erotic experience.

The pictorial language of love, its complex heraldic symbolism, and its playful allusion is played out to perfection in this series of tapestries, made as an engagement present in which the patron could present his future betrothed with an art of love based on his future expectations of sensuous pleasure. The lover, Viste himself, is not present as a person in the tapestries, but in each of them he is represented by his heraldic emblems, the lion and the unicorn (the latter renowned for its *vistesse*, or swiftness, in old French, and thus a family emblem for the *Vistes*). Only a beautiful lady, according to the traditional bestiary story, could tame this enigmatic animal. Thus, in the Sight tapestry, the lady herself does not look in the mirror, but makes the unicorn, playing like a pet in her lap, admire his own reflection. The way in which the lady's clothing illusionistically re-creates within the medium of tapestry

itself other expensive types of woven and embroidered threads and the sophisticated way in which natural forms, leaves, and sexual symbols like rabbits are sprinkled into an otherwise flat field, exhibit the most refined expression of Gothic art as a reflection of the self, albeit in the smiling unicorn's own self-satisfied gaze. From Sight to Touch, where the lady fondles the unicorn's horn in obvious allusion to their eventual union, these tapestries indicate the importance of the interweaving of family power, in the heraldry and crests, with individual pleasure. In the sixth tapestry the lady stands beneath a pavilion of blue damask powdered with tears. The motto "*Mon seul desir*," is written around its top. While we think of the self as present only in a portrait, for Viste and his contemporaries the individual was just as visible in an armorial shield, or a bearded unicorn.

Artists and Viewers

To jump from the gaze of courtly luxury and fantasy two hundred and fifty years back to that of the monk and artist Matthew Paris (d. 1259) looking up to the object of his love, the Virgin Mary, might seem an abrupt transition (FIG. 128). But it is important to address, in the final part of this book, the issue of the maker's

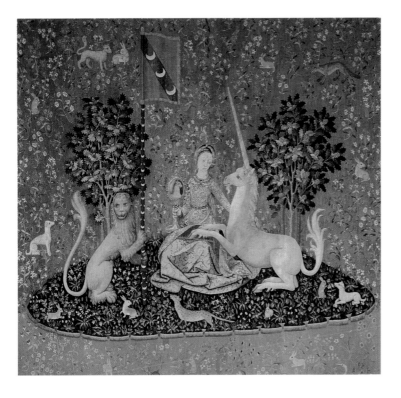

127. "Sight," from the Five Senses Tapestries, c. 1500. Wool and silk, 10′2″ x 10′10″ (3 x 3.3 m). Musée de Cluny, Paris.

look and place the gaze of the artist within the Gothic image. Kneeling in the lower margin, below a framed image of the Virgin and Child which prefaces his chronicle, Matthew is still half in a Romanesque world where barriers between the seer and the seen are paramount. He is excluded from the space of the divine and his eyes do not even move up to the object of his gaze. Because his self-image is not a self-portrait he has to label himself for posterity in capitals alongside. There is no brush in his hand, no sense that this is an image he has made with his eloquently gesticulating hands: in the monastic setting where Matthew spent his life the artist was still a servant of the divine will, like the Romanesque

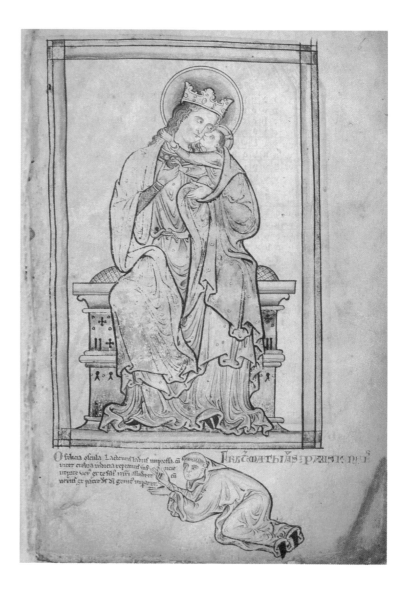

128. Matthew Paris
(d. 1259)
Self-portrait kneeling before the Virgin and Child, from the *Historia Anglorum*, 1250–59. Illumination on parchment, whole page 14 x 9¾" (35.8 x 25 cm). British Library, London.

artist Theophilus, who said that the artist could do nothing that did not come through God. Everything came from God. It was during the course of Matthew Paris's lifetime that art production moved from the monastic realm to that of the professional urban craftsman and the court painter.

A stained-glass image of a professional artist, a sculptor deep in thought, appears at Chartres cathedral at around the same time (FIG. 129). He is watching as another mason works at a jamb statue lying diagonally in the building site. In this gesture, which can signal contemplation or the humoral disposition of the melancholic type, is the notion of the artist as viewer. This representation separates the act of thought from the act of representation, partly because of the traditional association between the artist and the manual worker. The artist is always the first beholder of a work of art, watching it develop from chiseled stone or emerge on a wall or panel. He is part of the history of its reception even as its maker. His gaze is often difficult to interpret, partly because of the myth that the Gothic craftsman was a self-effacing interpreter of the ideas of others. The stone carver initially was just another mason, working in the mason's lodge. But in the course of the thirteenth century specialization became more common. The maker of sculptures become known as an *imagier*, or image-maker, as distinct from a painter. The various craft guilds of Paris (see FIG. 42) were codified in the *Livre des métiers* of c. 1268, which distinguished those who made ivory prayer beads from those who made ivory crucifixes, for example. Certain guilds were more exalted than others. The guild of "painters and sculptors of images" enjoyed exceptional privileges, such as being allowed to hire more apprentices and to work at night, because they made luxury objects for the most powerful lords, but also because, as the statutes state, they were in service to "Our Lord and to his Saints."

Clearly the conditions and status of artists were improving. The notion of art as a form of manual labor, which prevented it from being one of the academic "liberal arts," was being eroded as gifted artists entered court service and served municipalities by organizing the building of cathedrals. It was architects, or master-masons, who in the course of the century gained most in status. The builders of Amiens had their names recorded in an inscription and Hughes Libergier (d. 1263), the architect of the church of St. Nicaise at Rheims, had himself depicted with the tools of his trade and holding a model of the church. Pierre de Montreuil (d. 1267), one of the later architects of Notre Dame in Paris, was even referred to as "doctor of stones" on his tomb, as though he were a university master.

129. Chartres cathedral, window showing masons and sculptors, c. 1220.

The lowest four panels of the window narrate the story of the life of St. Chéron. They are typical of the so-called "trade windows" at the cathedral, depicting particular groups of workers who donated money to the building program. On the left, four masons build walls and cut stones; to the right, four more specialized workers carve jamb statues.

In Italy these changes were even more rapid. Andrea Pisano (c. 1290–1348), who was both an architect and a sculptor, worked on a series of reliefs depicting the liberal and mechanical arts for the Florence Campanile, which had been designed by Giotto between 1334 and 1337 when he was *capomaestro* of the Opera del Duomo. The lozenge-shaped reliefs on all four sides celebrate inventions in various fields. The seven mechanical arts are accompanied by representations of the practical arts of painting, sculpture, and architecture (FIG. 130). Here the painter leans to look closer at his panel from a small stool and a triptych stands above on a plinth. Half of the composition, carved on another block, is an elaborate triptych in a Gothic crocketed frame, as though representing an empty space waiting to receive his ideas.

In his handbook on painting (c. 1400) Cennino Cennini (b. c. 1370) describes this as "the nicest and neatest occupation in our profession...really a gentleman's job, for you may do anything you want to do with velvets on your back." This painter has the concentration of a writer, his hand, like a stylus on a page, raised up to a high level. His vision is concentrated in action. There is no longer the split between thought and act that was visible at Chartres; both are now part of the process of painting which, in the city of Florence at least, was about to be legitimized as an intellectual art. In describing Giotto in the *Decameron*, Boccaccio (1313–75) wrote that "he had a mind of such excellence that there was nothing given by Nature, mother and mover, together with the continuous whirling of the skies, of all things which he, with style or pen or brush, could not paint so like, that it seemed not so much similar, but rather the thing itself, so that often, in things done by him, the optical sense of men was deceived."

The elevation of the status of the artist in the course of the Gothic period does not mean that the Romantic notion of artistic self-expression was born at this time. It meant that artists, as they attained a higher status,

130. ANDREA PISANO (c. 1290–1348) An artist painting a panel, c. 1340. Relief formerly on the north side of the Campanile of Florence cathedral; today in the Museo dell' Opera del Duomo.

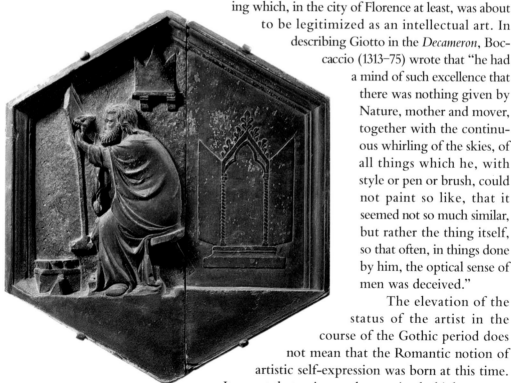

took on the trappings and symbols of courtly life. The self became an object of representation – artists included themselves as producers within the works they created. They thus became another type of internal viewer like the donor or patron, except that more often they look out at the viewer as if to stand between the image and the reality outside. They became, like the visionary St. John of the Apocalypse, mediators between the world and the image. This is the case with another architect-sculptor, Anton Pilgram of Vienna (1455–1515), who twice represents himself in St. Stephen's cathedral. On the large carved pulpit he opens a window and looks out from within his work, holding his compasses (FIG. 131). Under the great organ loft he stresses his role as architect, his upper body and head project through an illusionistic window. Here he

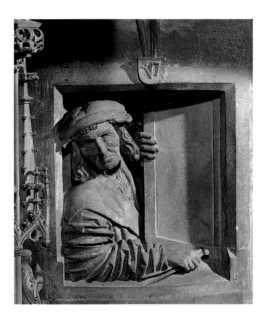

131. ANTON PILGRAM
Self-portrait, 1510. Stone, under life-size. St. Stephen's cathedral, Vienna.

integrated into the architecture as an atlas-like supporter, bearing the faceted stones, balanced like plates in a conjuring trick, and the weight of the ribbed vault of the great flamboyant Gothic organ loft on his shoulders. This is a playful pun on the earlier atlantes who had held up Gothic cathedrals (see FIG. 21) and announces the fact that the building is not only physically held up by human ingenuity, but created by it.

If architects were able to insert themselves into their buildings, painters, traditionally inferior in social status, did so only gradually. St. Luke was the patron saint of the painters' guild and pictures of him painting the Virgin's portrait are so full of everyday details, workshop practices, and techniques that we have to remind ourselves that they are not self-portraits of the artist at work. In the example given here (FIG. 132), the divine model is not simply another human being in the same space and time as the painter; she is placed in another room, separate from the artist-beholder just as she had always been. She is even viewed through a frame, as though in a diptych, and turned at an oblique angle. She could be painted on the wall. She is the reality which the painter is busily copying. What is more, his image is identical to what he sees before him, except that following the conventions of much earlier fifteenth-century panel-painting, the artist has placed St. Luke's painted Virgin against a gold background. Ironically, the fashion that had been set by the great Flemish artists of the "Northern Renaissance," like Jan van Eyck (c. 1390–1441), was to place the Virgin in a domestic setting and not against

132. MASTER OF THE
AUGUSTINERALTAR
St. Luke painting the
Virgin's portrait, 1487.
Tempera on panel,
height 4'5½" (1.36 m).
Germanisches National-
museum, Nuremberg.

Although showing the
influence of painters usually
described as part of the
"Northern Renaissance,"
this panel also makes
evident how many of the
new spatial and pictorial
innovations had to be
integrated with the
traditional workshop
patterns and centuries'
old conventions of Gothic
image-making.

such an abstract ground. In this respect this painting within a painting is still in the Gothic tradition.

Gothic art, as has been stressed here, is an art of multi-media combinations, in which whole environments are constructed by teams of masons, sculptors, and painters, often working together. In the course of the fifteenth century one particular medium gained ascendancy, which was to change not only the way in which people in the future would conceive "art," but also the way in which images would come to embody people's visual experience. This new medium was panel-painting. Of course, panel-painting had existed earlier and we have seen a number of examples serving as new types of devotional icons in the fourteenth century. What makes the later increase in panel-painting in Italy and in northern cities like Tournai and Bruges significant is that, along with the invention of printing and its spread from Germany to all parts of Europe in the last quarter of the fifteenth century, it represents the triumph of the two-dimensional over the three-dimensional. Gothic art, rooted in a plastic, three-dimensional attitude to space, gave way in the Renaissance to the tyranny of a two-dimensional illusion of three dimensions. This might sound like the reverse of the usual explanation. The standard story is that Gothic art is flat, unnatural, and linear and that it is overtaken by the three-dimensional, naturalistic, and spatial narratives of Renaissance painting. As I hope to have shown, just as the medievals knew that the world was not flat, there is no reason to assume they thought of their images in that way either. Gothic artists disclosed a world of incredible intensity and colour, constructing richly embellished three-dimensional objects into which people could enter psychologically. The Gothic tradition, as it continued well into the fifteenth century in most parts of Europe, should be seen not as a backward system that was later replaced by a better perspectival one, but as one way of seeing and knowing the world which was in some places gradually replaced by another.

The later fifteenth century saw a transformation of the relations between viewer and picture as well as between the artist and his product, a new autonomous vision which, first in Italy in the theories of Alberti (1404–72) and then in the great paintings of Flemish artists, posited that a painting was an illusion, a view through a window in which the viewpoint of the spectator was identical with that of the artist. This is to simplify what was obviously a much more complex social and political transformation of art and its various functions. Many people have described how perspective both liberates some aspects of vision and tyrannizes in other ways – the viewer's gaze, now reduced to a single point of

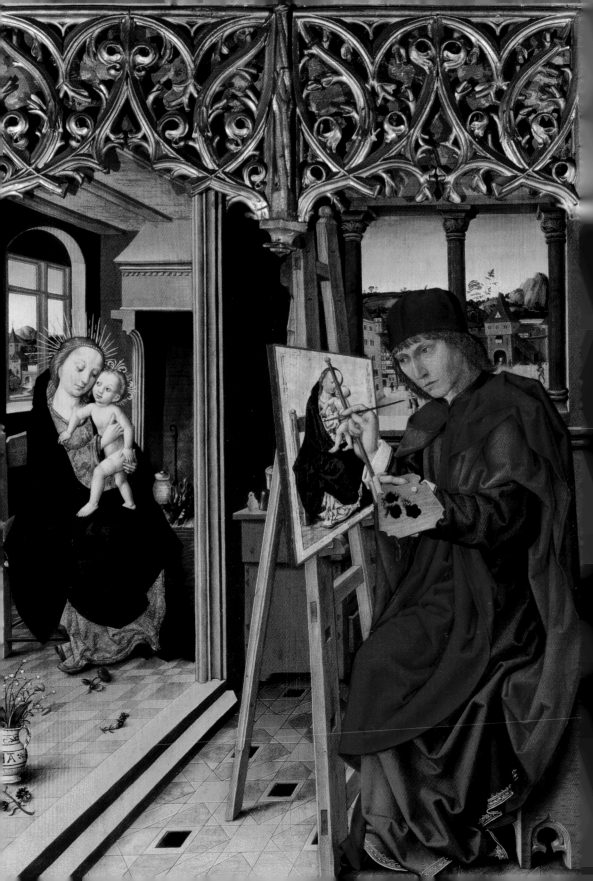

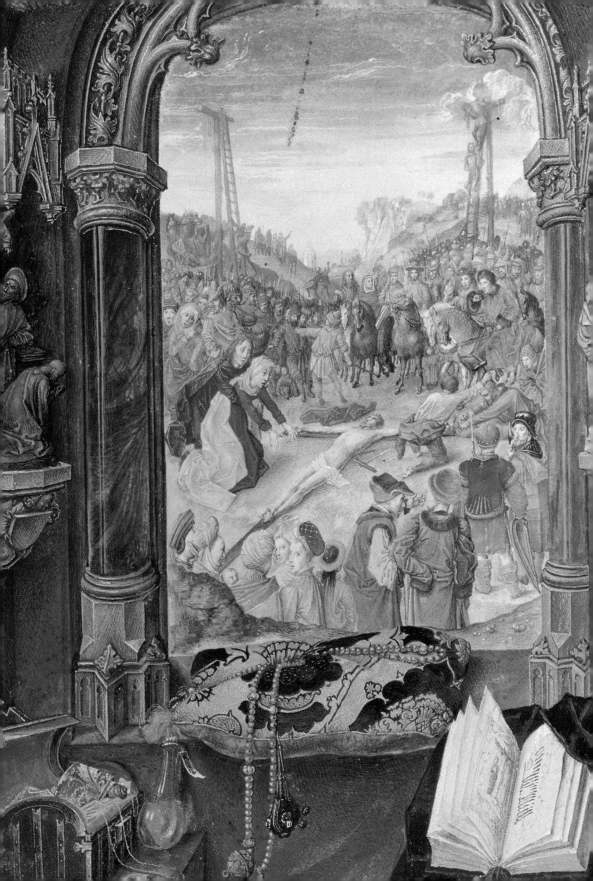

vision, is trapped within the system. But there is another loss, too, that comes with the new space of illusionism. It is best seen on a page of the Hours of Mary of Burgundy (FIG. 133). Like so many of the Gothic images we have examined in this book, this painting is a vision transcending the barriers of time and space. It is framed by the finials and canopies of a Gothic structure which leads our eyes to a powerful narrative of the nailing to the Cross. But our eyes are stopped almost before we get to that distant happening: one of the holy women turns to us with a brilliantly naturalistic glance, surprised by our static gazing on the scene from our window. Our eyes stop in the foreground where the paraphernalia of the person who owned the book is strewn. This is Mary of Burgundy, whose portrait appears earlier in the manuscript. The patron provided the most consistent image of self in the Gothic image, but now she too has quit the scene, leaving only the surface created by the painter.

The spectacular interpenetration of image and viewer is lost as the spectator withdraws from what is no longer a "seen," but a scene, separated from the viewer by the window. Just as the painter is no longer so emotionally involved with what he is painting, the viewer is no longer implicated in what she is seeing. Mary of Burgundy has left the picture, leaving the pages of her prayer book flapping in the breeze from the hill of Golgotha outside. This image opens up a world of painting as illusion, begins half a millennium of image-making, but closes off the possibility of painting as vision. Painting becomes reduced to the appearance of things, and the multiple perspectives, projections, and fantasies open to the makers and interpreters of Gothic images are restricted by the brilliant replication of the real. Art itself becomes the surface of the mirror, one in which we do not find ourselves reflected or embedded, but, henceforth, excluded. We have had to wait for the advent of computer-imaging and virtual reality for images once again to have become as dynamic and interactive as they were in the glorious visions of Gothic art.

133. NICOLAS SPIERING (fl. 1455–99)
Christ laid on the Cross, from the Hours of Mary of Burgundy, c. 1480. Illumination on parchment, 8¹/₄ x 6¹/₂" (22.5 x 16.3 cm). Österreichische Nationalbibliothek, Vienna.

	Historical Events and Intellectual Life	Art and Architecture
1150-1200	**1170** Assassination of Thomas à Becket in Canterbury cathedral **1173** Canonisation of St. Thomas à Becket **1180** Accession of Philip Augustus as King of France **1182** Birth of St. Francis of Assisi Capture of Jerusalem by Saladdin	**1137-40** St. Denis, west front and choir **c. 1150** Chartres cathedral, west portals **1175** Canterbury cathedral rebuilt by William Sens **1180-1212** Soissons cathedral
1200-1250	**c. 1200** University of Paris founded **1202-04** Fourth Crusade **1204** Capture and Sack of Constantinople by the crusaders, founding of the Latin empire of Constantinople **1209** Foundation of Franciscan order by St. Francis of Assisi **c. 1214** Birth of Roger Bacon, Franciscan monk and scientist, in England **1215** King John of England forced to sign Magna Carta, codifying individual, social, and commercial reforms **1220** Election of Frederick II as Holy Roman Emperor. Relations with the papacy deteriorate throughout his reign **c. 1220** Oxford University founded **1223** Death of Philip Augustus **1225** Birth of St. Thomas Aquinas, pre-eminent Catholic theologian of the Gothic period **1225-35** *Roman de la Rose* (part I) written by Guillaume de Lorris (d. c. 1235) **1226** Death of St. Francis of Assisi	**1211-41** Rheims cathedral, choir and transepts **c. 1220** Chartres, Miracles of the Virgin window Canterbury cathedral, Trinity chapel **1220-30** Amiens cathedral, west front and nave **c. 1220-30** *Bible Moralisée* **1228-53** San Francesco, Assisi **c. 1230** Rheims, Virgin of the Annunciation **c. 1230-33** Rheims, Visitation group **c. 1230-40** William de Brailes *Last Judgment* **1230-50** Wells cathedral, sculpture on the west f **c. 1235** Amiens cathedral, triforium and cleresto **1235-40** The Bamberg Rider **1241-48** Sainte Chapelle, Paris **c. 1245-55** Rheims, Angel of the Annunciation **c. 1250** Rathaus, Lübeck
1250-1300	**1250** Death of Frederick II **c. 1268** The *Livre des metiers* (regulations of the city's guilds) published in Paris by Etienne Boileau **1271-95** Marco Polo journeys to China **1274** Death of St. Thomas Aquinas **1275-80** *Roman de la Rose* (part II) written by Jean de Meung or Clopinel (c. 1240-c. 1305) **c. 1292** Death of Roger Bacon	**c. 1260** Saint Louis Psalter **c. 1267** Birth of Giotto di Bondone **1278** Duccio di Buoninsegna in Siena **1285** Duccio: *Rucellai Madonna* **1288-1309** Palazzo Publicco, Siena **1290-93** William de Torel: tomb of Eleanor de Ca **1294** Building begun of Santa Croce, Florence
1250-1315	**c.1300** Birth of St Bridget of Sweden **1303** Pope Boniface VIII imprisoned **1304** Birth of Petrarch **1307** Dante begins the *Divine Comedy* **1309** Papacy forced to leave Rome, which is in the hands of the Holy Roman Emperors. Establishes papal court at Avignon in southern France	**1305-10** Giotto di Bondone: frescoes in the Aren Chapel, Padua **1306-45** Pietro Lorenzetti active in Siena **1308-11** Duccio di Buoninsegna: *Maesta*

Historical Events and Intellectual Life	Art and Architecture	
1314 First public clock (in Italy)	1317 Life of St. Denis (MS)	
1328 Death of Charles IV of France. Edward III of England asserts dynastic claim to throne of France, and precipitates Hundred Years' War (1330-1453)	1330 Abbey church of St Peter, Gloucester, begun	1315-1350
1348-49 Epidemic in Europe of bubonic plague (the Black Death)	1330-34 Taddeo Gaddi: Baroncelli chapel, Santa Croce, Florence	
1349 Death of William of Ockham	1334-42 Papal palace, Avignon	
	1338-40 Ambrogio Lorenzetti at work on the frescoes in the Palazzo Publicco, Siena	
	before 1339 Psalter of Robert de Lisle	
	1343 Wall-paintings in the Chambre du Cerf, Avignon	
	1346-52 Tommaso da Modena: chapter hall of S. Niccolo, Treviso	
1356 English defeat the French at the Battle of Poitiers	c. 1365 Master Theodoric: murals in the chapel of the Holy Cross, Karlstein castle	
1364 Accession of Charles V as King of France	c. 1373 Designs for the Apocalypse tapestries commissioned from Jean de Bondol, painter to the King, by Louis I of Anjou	1350-1400
1373 Death of St Bridget of Sweden		
1374 Death of Petrarch		
1377 Papal court returns to Rome	1385 Claus Sluter enters the service of the Dukes of Burgundy	
1377 Death of Edward III, accession of Richard II, King of England	1386 Birth of Donatello (Donato di Nicolo)	
1380 Death of Charles V, King of France	1399 Tower of Strasbourg cathedral begun	
1399 Death of Richard II, King of England		
1400 Death of Geoffrey Chaucer, author of The Canterbury Tales	c. 1400 Revelations of St. Bridget of Sweden	
	c. 1402 Tomb of Cardinal de la Grange	
1403 Christine de Pisan writes the Livre de la Mutation de Fortune	c. 1410 Salle de Fortune manuscript (Paris) Master of the Middle Rhineland Virgin in a Garden	
1415 The religious reformer Jan Hus is burned at the stake as a heretic in Konstanz on the Swiss border	c. 1415 Très Riches Heures of the Duc de Berry by the Limbourg brothers	
English defeat French at the Battle of Agincourt		1400-1450
1416 Death of Jean, Duc de Berry		
1417 Great papal Schism ended by election of Martin V as Pope	c. 1420 Meister Francke Man of Sorrows	
1431 Joan of Arc burnt at the stake by English forces in France	1434 Jan van Eyck paints The Arnolfini Marriage	
	c. 1443 Work begun on the house of Jacques Coeur, Bruges	
1432 The Council of Basel discusses church reform		
1435 Leon Battista Alberti writes Della Pittura	1445 Work begun on the choir of St. Lawrence, Nuremberg	
1446-50 Gutenberg invents movable type and printing press		
1451 Downfall of Jacques Coeur	1471 Birth of Albrecht Durer	1450-1500
1453 Fall of Constantinople to the Turks	1489 Bendict Ried begins work on Prague castle	

Bibliography

The following is a short list of some standard works on Gothic art and culture:

GENERAL

Age of Chivalry: Art in Plantagenet England, 1200–1400 (exh. cat.; London: Royal Academy, 1987–88)

AVRIL, F. X., BARRAL I. ALTET, AND D. GABORIT CHOPIN, *Les Royaummes d'Occident* (Paris: Gallimard, 1983)

HENDERSON, G., *Gothic Style and Civilization* (Harmondsworth: Penguin, 1967)

KIMPEL, D., AND SUCKALE, R., *Die gotische Architektur in Frankreich 1130–1270* (Munich: Beck, 1985) *L'Architecture gothique en France 1130–1270* (Paris: Flammarion, 1990)

Die Parler und der Schöne Stil 1350–1400: europäische Kunst unter den Luxembourgernische Kunst unter den Luxembourgern (exh. cat.; Cologne, 1978)

RECHT, R., AND CHATELET, A., *Automne et Renouveau, 1380–1500* (Paris: Gallimard, 1988)

SAUERLÄNDER, W., *Le Siècle des cathédrales* (Paris: Gallimard, 1989); *Das Jahrhundert der grossen Kathedralen* (Munich: Beck, 1990)

WHITE, J., *Art and Architecture in Italy: 1250–1400* (3rd ed.; Harmondsworth: Penguin, 1992)

WILLIAMSON, P., *Gothic Sculpture 1140–1300* (London and New Haven: Yale University Press, 1995)

INTRODUCTION

CAVINESS, M., "Images of Divine Order and the Third Mode of Seeing," *Gesta*, 22 (1983)

FRANKL, P., *The Gothic, Literary Sources and Interpretation during Eight Centuries* (Princeton: Princeton University Press, 1960)

LINDBERG, D.C., *Theories of Vision from Al-Kindi to Kepler* (Chicago: University of Chicago Press, 1976)

MÂLE, E., *L'Art religieux du XIIIe siècle en France* (Paris: 1898 with numerous reprintings); *Religious Art in France: The Thirteenth Century* (Princeton: Princeton University Press, 1983)

VIOLLET-LE-DUC., E., *Dictionnaire Raisonné de l'architecture française du XIe au XVIe siècle* (10 vols; Paris, 1859–68)

ONE

ABOU-EL-HAJ, "The urban setting for late medieval church building: Reims and its cathedral between 1210 and 1240," *Art History*, XI (1988)

ERLANDE BRANDENBURG, J., *La Cathédrale* (Paris: Fayard, 1990); *The Cathedral: the social and architectural dynamics of construction* (Cambridge: Cambridge University Press, 1994)

FRUGONI, C., *A Distant City: Images of Urban Experience in the Medieval World* (Princeton: Princeton University Press, 1991)

HILLS, P., *The Light of Early Italian Painting* (New Haven and London: Yale University Press, 1987)

WILSON, C., *The Gothic Cathedral. The Architecture of the Great Church 1130–1530* (London: Thames and Hudson, 1990)

TWO

DOHRN-VAN ROSUM, *Die Geschichte der Stunde: Uhren und moderne Zeitordungen* (Munich: Hanser Verlag, 1992); *History of the Hour: Clocks and Modern Temporal Orders* (Chicago: University of Chicago Press, 1996)

FASSLER, M., "Liturgy and Sacred History in the Twelfth-Century Tympana at Chartres," *Art Bulletin*, LXXV (1993)

GUREVICH, A.J., *Categories of Medieval Culture* (London: Routledge, 1985)

PANOFSKY, E., *Abbot Suger on the Abbey Church of St. Denis and its Art Treasures* (2nd ed.; Princeton: Princeton University Press, 1979).

BASCHET, J., *Les Justices de l'au-dela. Les représentations de l'Enfer en France et en Italie, XIIe–XVe siècle* (Rome: 1993)

THREE

BELTING, H., *Bild und Kult–Eine Geschichte des Bildes vor dem Zeitalter der Kunst* (Munich: Beck, 1990); *Likeness and Presence: A History of the Image before the Era of Art* (Chicago: University of Chicago Press, 1994)

GAUTHIER, M-T., *Les Routes de la Foi: Reliques et reliquaires de Jérusalem à Compostelle* (Paris: Bibliothèque des Arts, 1983)

GUTMAN, J., *Hebrew Manuscript Painting* (New York: 1978)

HAMBURGER, J., "The Visual and the Visionary: The Image in Late Medieval Monastic Devotions," *Viator*, 20 (1989)

VAN OS, H., *The Art of Devotion in the Late Middle Ages in Europe 1300–1500* (London and Amsterdam: 1994)

FOUR

BEHLING, L., *Die Pflanzenwelt der Mittelalterlichen Kathedralen* (Cologne: Graz, 1964)

CAMILLE, M., *Image on the Edge: The Margins of Medieval Art* (London and Cambridge, Mass: Reaktion Books, 1992)

MURDOCH, J., *Album of Science: Antiquity and the Middle Ages* (New York: Scribners, 1984)

NORDENFALK, C., "Les Cinq Sens dans l'art du Moyen Age," *Revue de l'art*, 34 (1976)

POUCHELLE, M.C., *Corps et chirurgie à l'apogée du Moyen-Age* (Paris: 1983); *The Body and Surgery in the Middle Ages* (London: 1990)

SCHELLER, R.W., *Exemplum: Model-book drawings and the practise of artistic transmission in the Middle Ages, ca.900–ca.1470* (Amsterdam: Amsterdam University Press, 1995)

WHITE, L., JR., "Natural Science and Naturalistic Art in the Middle Ages," *American Historical Review* 52 (1946)

FIVE

ALEXANDER, J.J.G., *Medieval Illuminators and Their Methods of Work* (London and New Haven: Yale University Press, 1992)

BARRAL Y ALTET (ed), *Artistes, artisans et production artistique au Moyen-Age* (3 vols; Paris: Picard, 1986–90)

CAMILLE, M., "The Body and the Self: Unwriting Late Medieval Bodies," in *Framing Medieval Bodies* (ed. S. Kay and M. Rubin; Manchester: Manchester University Press, 1994)

CORNELIUS CLAUSSEN, P., "Nachrichten von den Antipoden oder der mittelalterlichr Künstler über sich selbst," in *Der Künstler über sich in seinem Werk* (Hamburg: Acta humaniora, 1992)

MARTINDALE, A., *The Rise of the Artist in the Middle Ages and Early Renaissance* (New York: McGraw Hill, 1972)

Picture Credits

Title pages: see page 112
page 9 detail of figure 9
1 Bibliothèque Nationale, Paris (MS lat. 10525 fol. 85v)
4 © Angelo Hornak, London
5 The Pierpont Morgan Library/Art Resource, New York
6 © Angelo Hornak, London
7 Scala, Florence
8 The Pierpont Morgan Library/Art Resource, New York
9 By permission of The British Library, London (Additional MS 10292, fol. 7v)
11 Bodleian Library, Oxford (MS Ashmole 1522, fol. 153v)
13 Scala, Florence
14 © Angelo Hornak, London
page 27 detail of figure 18
15 Drawing courtesy Christopher Wilson from *The Gothic Cathedral* by Christopher Wilson, published by Thames & Hudson, London, 1990
16 Master and Fellows of Trinity College Cambridge (MS R.16.2. fol. 25v)
17-19 © Angelo Hornak, London
21 James Austin, Cambridge
22 © Angelo Hornak, London
24 Musées de la Ville de Strasbourg
25 © Domkapitel Aachen (Foto Ann Münchow)
26-27 © Angelo Hornak, London
28 By permission of The British Library, London (Egerton MS 2781, fol. 1v)
29 © Angelo Hornak, London
30 Caisse Nationale des Monuments Historiques et des Sites, Paris/SPADEM/DACS, London © 1996
31 Scala, Florence
32 AKG London, photo Eric Lessing
33 Studio Fotografico Quattrone, Florence

34 Florian Monheim, Düsseldorf
36 Michael Jeiter, Morschenich, Germany
37 Stuart Michaels, Chicago
38 By permission of The British Library, London (Additional 28681 fol. 9)
39 CADW: Welsh Historic Monuments, Cardiff. Crown copyright
40 Paul M.R. Maeyaert
41 Zefa, Dusseldorf
42 Bibliothèque Nationale, Paris (MS fr. 2091 fol. 97r)
43 Pavel Stecha, Černošice, Czech Republic
44 Scala, Florence
46 left: Michael Camille
46 below: Paul M.R. Maeyaert, Mont de l'Enclus-Orroir, Belgium
47 Herzog-August-Bibliothek, Wolfenbüttel (MS 1.3.5.1. Aug. 2 fol. 146r)
48 Giraudon, Paris
49-53 © Angelo Hornak, London
Page 71 detail of figure 66
54 Foto Ritter, Vienna
55 Ostereichisches Nationalbibliothek, Vienna (Cod. 2554 fol. 1 recto and verso)
56-57 © Angelo Hornak, London
58 Scala, Florence
59 Bibliothèque Nationale, Paris (MS fr. 2813 fol. 473v)
60 Bayerisches Staatsbibliothek Munich (Cod. gall. 11 fol. 53)
61 Angelo Hornak, London
62 Fitzwilliam Museum, Cambridge (MS 330 fol. 3)
63 Fernando António Rodrigues Cruz, Amadora Portugal
64 Scala, Florence
65 By permission of The British Library, London (Arundel 83, fol. 126v)
66 Angelo Hornak, London
67 Bibliothèque Nationale, Paris (MS lat. 10483, fol. 6v)
68 Copyright British Museum (1853, 11-4-1, 326)
69 Bibliothèque Royale Albert 1er, Brussels (B.R. ms IV III fol. 13v)
Page 103 detail of figure 86
71 RMN, Paris

Index